A World of Our Own

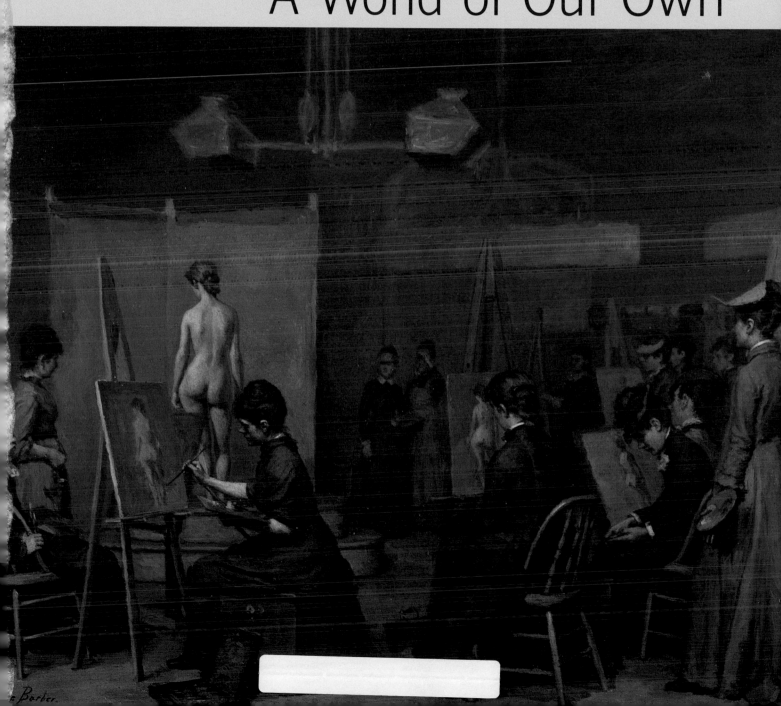

A World of Our Own

Women as Artists

FRANCES BORZELLO

With 245 illustrations, 108 in colour

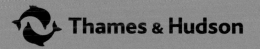
Thames & Hudson

For Nicholas and Anna

page 1 Alice Barber Stephens, *The Women's Life Class at the Pennsylvania Academy of the Fine Arts*, c. 1879
pages 2–3 Natalia Goncharova, *In the Studio of the Artist*, 1908 (detail)
pages 4–5 (background) Ekaterina Khilkhova, *View of the Women's Section of the St Petersburg School for Auditors*, 1855 (detail)

First published in the United Kingdom in 2000 by Thames & Hudson Ltd, 181A High Holborn, London WC1V 7QX

British Library Cataloguing-in-Publication Data
A catalogue record for this book is available from the British Library

ISBN 0-500-23776-X

Printed and bound in Italy
by Officine Grafiche De Agostini

contents

THE ADVANTAGES OF BEING A WOMAN ARTIST:

Working without the pressure of success.

Not having to be in shows with men.

Having an escape from the art world in your 4 free-lance jobs.

Knowing your career might pick up after you're eighty.

Being reassured that whatever kind of art you make it will be labeled feminine.

Not being stuck in a tenured teaching position.

Seeing your ideas live on in the work of others.

Having the opportunity to choose between career and motherhood.

Not having to choke on those big cigars or paint in Italian suits.

Having more time to work after your mate dumps you for someone younger.

Being included in revised versions of art history.

Not having to undergo the embarrassment of being called a genius.

Getting your picture in the art magazines wearing a gorilla suit.

Please send $ and comments to: **GUERRILLA GIRLS** CONSCIENCE OF THE ART WORLD
Box 1056 Cooper Sta. NY, NY 10276

WHEN RACISM & SEXISM ARE NO LONGER FASHIONABLE, WHAT WILL YOUR ART COLLECTION BE WORTH?

The art market won't bestow mega-buck prices on the work of a few white males forever. For the 17.7 million you just spent on a single Jasper Johns painting, you could have bought at least one work by all of these women and artists of color:

Bernice Abbott	Elaine de Kooning	Dorothea Lange	Sarah Peale
Anni Albers	Lavinia Fontana	Marie Laurencin	Ljubova Popova
Sofonisba Anguisolla	Meta Warwick Fuller	Edmonia Lewis	Olga Rosanova
Diane Arbus	Artemisia Gentileschi	Judith Leyster	Nellie Mae Rowe
Vanessa Bell	Marguérite Gérard	Barbara Longhi	Rachel Ruysch
Isabel Bishop	Natalia Goncharova	Dora Maar	Kay Sage
Rosa Bonheur	Kate Greenaway	Lee Miller	Augusta Savage
Elizabeth Bougereau	Barbara Hepworth	Lisette Model	Vavara Stepanova
Margaret Bourke-White	Eva Hesse	Paula Modersohn-Becker	Florine Stettheimer
Romaine Brooks	Hannah Hoch	Tina Modotti	Sophie Taeuber-Arp
Julia Margaret Cameron	Anna Huntingdon	Berthe Morisot	Alma Thomas
Emily Carr	May Howard Jackson	Grandma Moses	Marietta Robusti Tintoretto
Rosalba Carriera	Frida Kahlo	Gabriele Münter	Suzanne Valadon
Mary Cassatt	Angelica Kauffmann	Alice Neel	Remedios Varo
Constance Marie Charpentier	Hilma af Klimt	Louise Nevelson	Elizabeth Vigée Le Brun
Imogen Cunningham	Kathe Kollwitz	Georgia O'Keeffe	Laura Wheeling Waring
Sonia Delaunay	Lee Krasner	Meret Oppenheim	

Information courtesy of Christie's, Sotheby's, Mayer's International Auction Records and Leonard's Annual Price Index of Auctions.

Please send $ and comments to: **GUERRILLA GIRLS** CONSCIENCE OF THE ART WORLD
Box 1056 Cooper Sta. NY, NY 10276

Why Women?

All women artists are different from each other. Not just in the personality that makes some determined to succeed and others upset by the smallest obstacle. But in their circumstances too. The family they are born into, the ideas in their circle, the helping hand of an outsider, the attitudes of the age all affect their progress and make it impossible to construct a standard profile of a woman artist. And yet in one way they are all united. All of them, shy or spirited, encouraged or hindered, operated in a profession where they had no part in making the rules. Their similarity is not in their being women but in the fact that they had to work – and still do to an extent – in a world whose assumptions and standards were set by men. However seriously women took themselves as artists, they were never seen by others as artists plain and simple, they were seen as women artists, bearers of society's views on a woman's place, potential, nature and role. It is this difference from the men who made up the majority that makes it possible to discuss them as a group.

Women artists were outsiders in a male profession. Unlike the female singer, dancer or actress, the female artist of the past had no place lying vacant for her to fill. Since the seventeenth century, composers, choreographers and playwrights have produced works that needed female interpreters and have fallen on female talent with delight. There was a point to their skill which was understood by all. But women artists were intruders in the art world, a world of men which claimed to be open to everyone of talent but which in practice made few moves to welcome women. As the eighteenth-century artist Katharine Read put it: 'I cannot help looking on myself as a creature in a very odd situation; 'tis true we are all but strangers and pilgrims in this world, and I ought not to think myself more so than others, but my unlucky sex lays me under inconveniences which cause these reflections.'[1]

Guerrilla Girls, *The Advantages of Being a Woman Artist,* poster, mid-1980s

INTRODUCTION
Remarkably resilient

'The minute I sat in front of a canvas I was happy.
Because it was a world, and I could do as I liked in it.'

ALICE NEEL

Some time ago I came on a portrait of Maria Constantina, Countess of Suffolk, in the Ranger's House in Blackheath, south-east London. With its striking glance and pose of relaxed elegance, this three-quarter portrait of an English aristocrat looked completely at home among its eighteenth-century companions. What made it stand out was the label attributing it to the Scottish artist Katharine Read. That is, it had been painted by the woman who, despite the 'inconveniences', had succeeded in training and practising in a profession run by and for men. How had she managed it?

Research into the lives of women artists has analysed the 'inconveniences'. It has revealed how social, religious and medical beliefs about women's capabilities affected the way they were treated; documented the hostile attitudes that endowed women's art with an aura of the inconsequential and second rate; shown how the exclusion of women from art world institutions removed them from contemporary debates as well as from the records. It has taught us that, despite the evidence that women's training, subject matter and success depended on specific circumstances that changed from family to family, country to country and decade to decade, men saw women's work as evidence for unchanging female qualities and judged everything they produced as fixed and female, so that when a woman produced a painting that impressed them, they said she painted like a man.

But none of this answers the question of how they managed it. Seeing women solely as inhabitants of a patronizing, hostile or indifferent art world,

victims of what today is called institutional sexism, ignores half of their experience, the half that got on with the everyday job of being a practising artist. Katharine Read faced all the normal difficulties of being a woman artist in a male profession. Since she could not draw from the nude model as part of her course of study, her knowledge of anatomy was sometimes a bit peculiar, as the Countess of Suffolk's long and hose-like right arm shows. She was denied entry to some art collections when studying in Italy, thus making her visual vocabulary that little bit more impoverished than that of her male contemporaries. Yet despite this, she became a working artist who trained in France and Italy, set up in London as a portraitist of women and children of the upper classes, and enjoyed some success until she fell out of fashion.

One of the problems of the ground-breaking research that has revealed the 'inconveniences' faced by women, as Katharine Read so restrainedly put it, is that it has dictated our approach to women artists. These days it is a heresy to discuss women artists without referring to the fact that they were excluded from life classes, had to give up work on marriage, were judged differently from men. This way of seeing women has become an orthodoxy which sits like spectacles over our eyes as we look back into the past. Ironically the research into the conditions women faced has turned them into victims instead of the survivors they so clearly were.

Because my ideas were formed by feminist art historians and I am respectful of their research, concentrating on the what-it-was-like of women artists' lives made me feel uneasy, as if I were flying in the face of deeper truths. So before I am accused of chanting 'dadadada' against the arguments of scholars with my eyes shut and my fingers in my ears, I want to state that the situation of a woman working in a profession that was not of her making was unfair from beginning to end. If she was not ignored or patronized, she existed as a sort of female Rorschach blot on which those around her mostly male, but female, too – projected their thoughts, arguments, fears and prejudices. But revealing

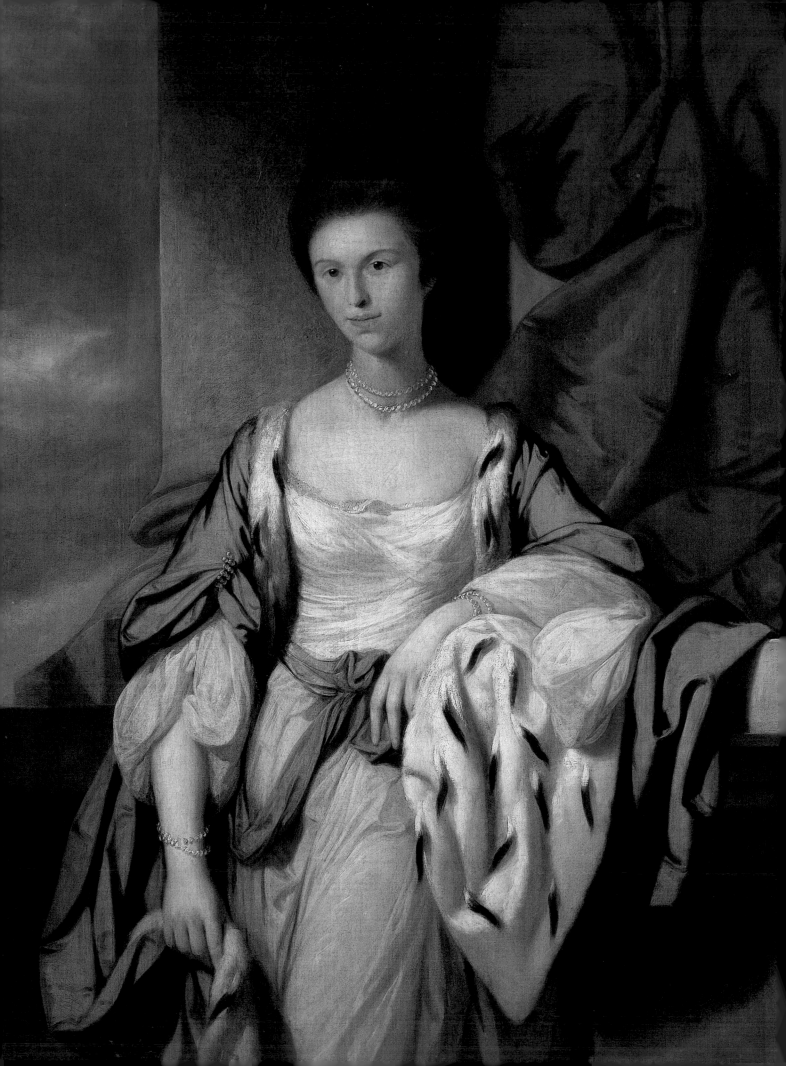

the unfairness women faced in its full horror does not account for the fact that they kept on working as artists.

The chronicle of art world hostility to women is indisputable, but, by concentrating on the unfairness, only one side of the women's experience comes into view. Reconciling being a woman with being an artist could be as hard as learning to use two hands to play the piano. But it could also be done and often was. Somehow, in concentrating on the problems, a far less dramatic truth about the women has got lost: that most of the time their lives were a matter of just getting on with the job.

Concentrating on the problems ignores the fact that there were active encouragements for them to enter the art world. However strong the beliefs about a woman's place, there was no actual taboo against her entering the profession. And however strong the prejudice against her artistic potential, there was always the lure of the myth that talent would out, which all artists believed, at least at the start of their careers.

Concentrating on the problems ignores the fact that the practice of art offered women an enticing prospect. At the least, satisfying employment. At best, creative fulfilment, celebrity, financial reward, a chance to stand out from the crowd, status and freedom. Many women attained these desirable goals.

Concentrating on the problems ignores the fact that many women found ways around them. Even though academic training was barred to them for centuries, they found ways to get the training they desired. Even though the most respected artists were those who produced ambitious narrative scenes from history, the fact that male artists worked in a variety of genres showed women that they could make their way as artists even with their diluted training. Even though precedent was against them, women managed to set themselves up as artists. In centuries when travelling, boasting of one's talent and running a business ran against perceptions of conventional feminine behaviour, women found a way to do them all.

Katharine Read, *Portrait of Maria Constantina, Countess of Suffolk, c.* 1765

In short, concentrating on the problems hides the fact that the women understood that the prevailing views about women's roles, capabilities and nature affected what they could do and how they were treated, and they went from there. They were, in fact, remarkably resilient.

Which brings us back to Katharine Read and her 'inconveniences'. Rather than concentrating on the problems, is there perhaps a different way of making sense of her career? Could she, and other women artists, quite simply have faced up to the prejudices of the art establishment and pressed ahead regardless? They knew they did not make the rules but they responded to them as best they could: where they could, they adopted, and where they could not, they adapted. At worst it led to timidity, but at best it encouraged flexibility and ingenuity. Their determination to succeed despite their difference from the male majority is what makes their adventures in art so interesting.

Women have always practised as artists. Historians have established their names, located their works and started the search to put flesh on their biographical bones. Some are household names, like the Impressionist Berthe Morisot. Some, little known today, were famous in their own time, like the eighteenth-century pastel portraitist Rosalba Carriera. Some are less than dazzling – reliable journeywomen who produced what was asked of them.

This book attempts to fill the gap between the fact of the art world's hostility to women and the fact that many women flourished there. It shows how women surveyed the art world and worked out how to get themselves trained, selected the likeliest field for success, set up studios, looked for patrons, found ways to publicize themselves, and basked in recognition of their talent. In short, despite the proven catalogue of unfairness and prejudice, they managed a life in art, not as grovelling supplicants, but by negotiating the system for their own ends. It shows how instead of being defeated by their difference, they treated it as a fact of life they had to work around.

I have organized my story around a suggestion that there were leading beliefs in each period that affected the way that women saw themselves. Until the eighteenth century, women artists tended to fall into one of two categories: working woman or prodigy. In the eighteenth century, they were able to benefit from a culture that valued the charming and accomplished woman. In the nineteenth century they were fuelled by self-belief. In the twentieth century they tried to be artists, not women. And with feminism they set out to change the art world.

Although presented chronologically, this book is not a history of female artists. There are plenty of those. It is a cluster of examples of what it was like for a woman to work in a male-dominated profession. I take the hostility and difficulties for granted, as the women did themselves, and try to show through the women's own words and experiences how they managed.

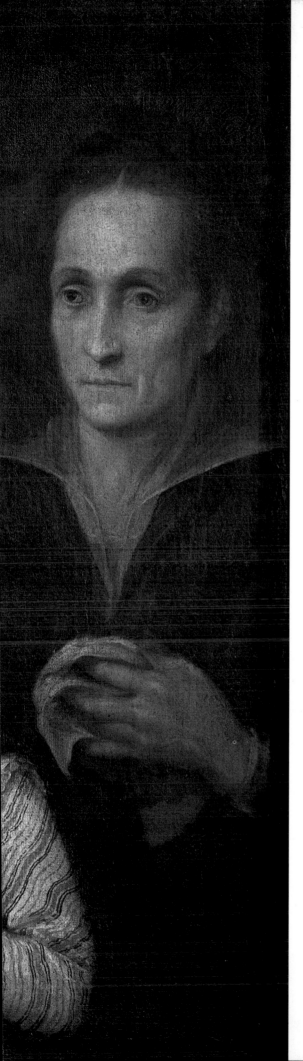

1500–1600
Out of the shadows

'Their little hands so tender and so white'

GIORGIO VASARI

The revolution in theory and practice that male
artists enjoyed during the Renaissance was
of a completely different order from that
experienced by women. Men wanted to earn
acclaim through large and ambitious narrative
works based on the ability to draw the body,
the so-called history paintings that carried art's
highest status. Women, on the other hand,
had to fight for basic training and then for
a chance to practise before they could even
begin to attempt to rival the men. Although
excluded from apprenticeship, women managed
to find ways to get an education, to set up
a business and to promote their careers.
Unable to draw from the nude model, most
women artists at this time concentrated on
portraiture and devotional panels where this
lack of skill was irrelevant. Yet by the end of
the sixteenth century they were producing large
altarpieces, and Lavinia Fontana had painted
the first female nude by a woman artist.

CAST OF CHARACTERS

Artists whose experiences form the basis of this chapter.

SOFONISBA ANGUISSOLA was born
c. 1532 in Cremona, Italy. She must have
shown an early talent for art because she
was sent with her sister Elena, who later
became a nun, to study with Bernardino
Campi from 1546 to 1549 and Bernardino
Gatti from 1549 to 1552. She spent the
years 1559–73 at the court of the Spanish
Queen Isabella as lady-in-waiting, and
many paintings have survived from this
period. She married Don Fabrizio de
Moncado in 1569 and Orazio Lomellino
in 1579, continuing to paint in her
married homes in Genoa and Palermo.
She died in 1625 in Palermo. Her sisters
Lucia (who died young in 1565)
and Anna Maria (who died after 1585)
were described as painters by Vasari.

LAVINIA FONTANA was born in Bologna
in 1552 and taught by her father Prospero
Fontana. She was famous by the time
she was in her twenties, and worked in
a variety of genres throughout her life.
Over one hundred portraits, and religious
and classical paintings are known. Her
marriage in 1577 to a minor painter
Gian Paolo Zappi, and the ensuing
eleven children (not all survived), did
not stop her career. Her patrons were
grand families, the gentry of Bologna
and the papal court of Pope Paul V.
She died in Rome in 1614.

CATHARINA VAN HEMESSEN was born in
the Netherlands in 1528 and was taught
to paint portraits and religious works by
her father, Jan Sanders van Hemessen
of Antwerp. In the 1550s, she married
the musician Chrétien de Morien, and in
1556 the couple went to Spain in the train
of Queen Mary of Hungary who set up
a court there. Though several signed and
dated portraits survive, little is known
about her, including her date of death.

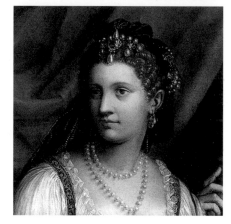

FEDE GALIZIA was born, perhaps in
Milan, *c.* 1578 to a miniature painter.
She painted portraits, religious works,
histories and still lifes, but there is little
information about her life. She was
recorded by the historian/painter
Lomazzo in 1590 as a copyist, and by
the historian Paola Morigia (whose
portrait by her survives). The Habsburg
Emperor Rudolph II commissioned work
from her. Her will is dated 1630.

(previous pages) Lavinia Fontana,
Portrait of an Italian Family,
early 17th century.
(this page from left) Sofonisba
Anguissola, *Self-portrait at the
Clavichord*, *c.* 1555–56 (detail).
Prospero Fontana or Lavinia Fontana,
Portrait of Lavinia Fontana, *c.* 1595
(detail). Fede Galizia, *Judith with the
Head of Holofernes*, 1596 (detail).
Catharina van Hemessen, *Self-portrait*,
1548 (detail).

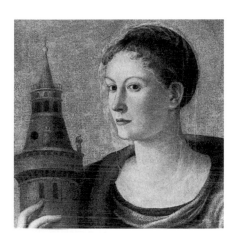

BARBARA LONGHI was born in Ravenna in 1552 and remained there all her life. She was taught by her father Luca Longhi and assimilated the influences of others as she matured. She assisted her father on altarpieces, was famous as a painter of portraits, although only one is known today, and is survived by many panel paintings of the Virgin and Child, done in a calm and graceful style. She died in Ravenna in 1638.

PLAUTILLA NELLI was born into an upper-class Italian family in 1523, entered the convent of Sta Caterina di Siena in Florence in 1537 when she was fourteen and became prioress before 1568. It is not known whether she learned to paint before or after entering the convent, but she herself taught four women after becoming a nun, two of whom were nuns themselves. She accepted outside commissions as well as painting works for her convent church (her *Last Supper* is stored in Sta Maria Novella, Florence). She died in 1588.

PROPERZIA DE' ROSSI was born *c.* 1490. Her father was a citizen of Bologna and presumably educated, but it is not known how she became a sculptor. She early gained a reputation for carvings of elaborate scenes on peach stones for the Bolognese nobility, graduating to larger public carvings. Her personal life is a disparate collection of facts: charges of disorderly conduct in 1520–21 and again in 1525 for throwing paint in the face of an artist; records of payment for work on the church of S. Petronio; and inclusion in the records of a hospital for indigents, where she died *c.* 1530.

This is a book about how women managed to express their talent in a world that was not set up for them to do so. So the first question to ask is, what was the likelihood of a woman becoming an artist in 1500? And the answer is, not very likely at all. For women to consider entering the profession, role models were needed and these were few and far between. This meant that outside the family situations of artist-parent or doting wealthy parent, there was little chance of a woman becoming an artist.

The fifteenth century was a time of change for artistic theory and practice. Two texts published early in the fifteenth century stand for the old and the new – *The Craftsman's Handbook* by Cennino Cennini, a practical guide to artistic techniques, and *On Painting* by Leon Battista Alberti, a revolutionary argument for raising the status of art and artists. In contrast to Cennini's acceptance of artists as craftsmen, the modernizing Alberti claimed that art was not merely a manual practice but involved imagination and brains: 'Any master painter who sees his works adored will feel himself considered another god.'[1]

How much encouragement could women find from these treatises? The answer is not much. Except for the odd comment, these two treatises ignore women. The more old-fashioned and craft-based Cennini went so far as to see them as the enemy of art, writing that 'there is another cause which, if you indulge it, can make your hand so unsteady that it will waver more, and flutter far more, than leaves do in the wind, and this is indulging too much in the company of woman.'[2] The more aspiring Alberti, intent on raising the status of art from craft, mentions them in his argument for the importance of painting:

> Finally L. Paulus Aemilius and not a few other Roman citizens taught their sons painting along with the fine arts and the art of living piously and well. This excellent custom was frequently observed among the Greeks who, because they wished their sons to be well educated, taught them painting along with geometry and music. It was also an honour among women to know how to paint. Martia, daughter of Varro, is praised by the writers because she knew how to paint.[3]

However slight the reference, Alberti does at least present the possibility of a woman painting, and his argument to elevate art from craft to something altogether more intellectual benefited would-be women artists by adding an aura of elegance to a practice previously viewed as manual work. Further support came from Castiglione's *The Book of the Courtier* published in 1528, a conduct manual for gentlemen which also recommended art as a suitable activity for upper-class women. As long as she kept her 'soft and delicate tenderness,

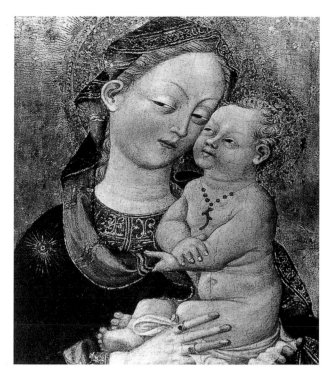

Caterina dei Vigri (attributed), *Madonna and Child*, c. 1456–63. The artist entered the convent of Corpus Domini in Ferrara in 1427, when she was about fourteen. She became abbess of the Corpus Domini convent in Bologna in 1456. Her paintings owe more to her passionate piety than to her training, which was probably that of a young patrician.

with an air of feminine sweetness in her every movement, which, in her going and staying and whatsoever she does, always makes her appear a woman, without any resemblance to a man, she was free to adorn herself with the finest accomplishments recommended for gentlemen.'[4] Since painting was one of these accomplishments, and since *The Courtier* was an immensely influential book, it lies at the root of the idea of art as a genteel activity for ladies, an idea which since then has existed side by side with the idea of art as a professional activity for women. This was both good and bad as far as women were concerned: good because it encouraged the idea that women could paint, but bad in that it endowed them with that aura of amateurism that would haunt women artists for centuries. Amateurs play a role in the history of women artist that has no equivalent among the men. Their importance lies in their access to training, which occasionally took them over the border into professionalism, and in the way they helped to establish the idea of women as artists in people's minds.

Role models are important in establishing the normality of a woman being an artist. The naming of women artists begins with the classical female painters. The Marria, or Marcia, mentioned by Alberti appears as one of several female artists in Boccaccio's *Concerning Famous Women* of 1413. It is not until the mid-sixteenth century with Giorgio Vasari, painter and architect, that the names of contemporary women artists are put on the map. In his *Lives of the Artists,* he gives accounts of several living or recently deceased Italian women artists. Here for the first time in a respected and much read work, which was to set the pattern for similar works in other countries, was the evidence that women operated as artists, not only in ancient Rome or classical Athens, but in Bologna, Cremona and Flanders. The accounts of their training, their talent, their patrons and their successes helped normalize the notion of a female artist, and offered role models to would-be women artists. These role models made it easier for a woman to see herself as an artist, easier for her family to consider it a possibility.

Environment could also play a part. The northern Italian city of Bologna, whose university had accepted women since the thirteenth century, was known for its group of intellectual women, and the city's fifteenth-century saint, Caterina dei Vigri, had painted and illustrated manuscripts in her convent. Several sixteenth-century women artists were born and worked in Bologna, among them Properzia de' Rossi and Lavinia Fontana. It would be interesting to discover whether their examples encouraged any women outside the familiar circle of artist's daughter or well born amateur to take up art.

Visual images of women artists are as rare as written references. Illustrations of the classical artist Marcia (Alberti's Martia) painting her self-portrait occur in a handful of manuscript illustrations from the tenth century onwards, but few women would have seen them. Except for the occasional appearance of a woman as the female personification of Design in the works of allegorically minded artists, the woman artist was virtually invisible in paintings of the period. It was left to the women themselves to provide the visual evidence of their existence in the self-portraits that emerged from their hands as the century progressed.

At this early stage it is difficult to evaluate attitudes to women artists, and one is left to read between the lines of the few existing documents. Vasari's description of female ambition presents art as masculine: 'Nor have they been too proud to set themselves with their little hands, so tender and so white, as if to wrest from us the palm of supremacy, to manual labours, braving the roughness of marble and the unkindly chisels, in order to attain to their desire and thereby win fame.'⁵ His rationale for their desire to practise as artists only serves to underline its unusualness: 'But if women know so well how to produce living men, what marvel is it that those who wish are also so well able to create them in painting?'⁶ Attitudes to women in intellectual and aristocratic circles were complicated, as can be seen from the debate about their moral and physical capacities and qualities in Book III of *The Courtier*: they could be inferior or superior to men but they could never be equal. One particular belief, that women had an innate lack of originality and imagination, had a huge effect on their training and the reception of their work.

TRAINING AS ARTISTS

Both men and women were involved in an artistic revolution in the sixteenth century, but it was not the same revolution. The male revolution was connected to the new ideas about art, and expressed itself through the stress on drawing convincingly from life, mathematical knowledge to help with the new science of perspective, rivalry with the great artists of the past and of the day, and respect for the artist as creative genius. All these ideas constituted the revolutionary modern art of the Renaissance, and encouraged male artists to stand on the shoulders of their predecessors and to use their training to experiment. The women artists' revolution was of a different order. First they had to get themselves trained to a professional standard, then to practise and be accepted. Ambition to compete with the men was not lacking, but it was not until the end of the century that women developed the confidence to produce large-scale figure paintings. This was the world that the aspiring woman artist entered in the early sixteenth century.

(above) The classical artist Marcia painting her portrait, from *Le Livre des Femmes Nobles et Renommées*, 1404.
(right) *Artist at Work in His Studio*, 16th century. The artist works on a huge canvas while his male apprentices grind and mix colours, copy, paint portraits, and draw a classical bust.

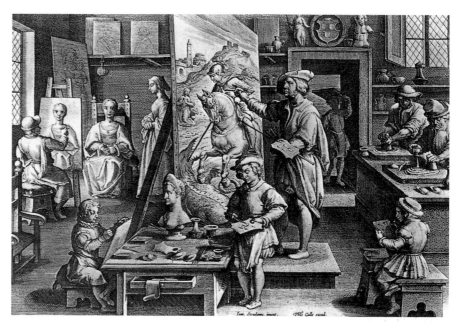

An artist's training was a long and serious business. Cennini writes:

Know that there ought not to be less time spent in learning than this: to begin as a shopboy studying for one year, to get practice in drawing on the little panel; next to serve in a shop under some master to learn how to work at all the branches which pertain to our profession; and to stay and begin the working up of colours; and to learn to boil the sizes, and grind the gessos; and to get experience in gessoing anconas, and modelling and scraping them; gilding and stamping; for the space of a good six years. Then to get experience in painting, embellishing with mordants, making cloths of gold, getting practice in working on the wall, for six more years; drawing all the time, never leaving off, either on holidays or on workdays. And in this way your talent, through much practice, will develop into real ability. Otherwise, if you follow other systems, you need never hope that they will reach any high degree of perfection. For there are many who say that they have mastered the profession without having served under masters. Do not believe it, for I give you the example of this book: even if you study it by day and by night, if you do not see some practice under some master you will never amount to anything, nor will you ever be able to hold your head up in the company of masters. 7

By the sixteenth century this practical approach had been joined by an interest in a more elevated kind of academic instruction influenced by Alberti's ideas. Instead of concentrating on the practical techniques of art, Alberti stressed its importance to society, recommending a hierarchy of subject matter in which the most admired subjects were those taken from history, the classics and the Bible, great moments which made a moral point through the actions of the characters.

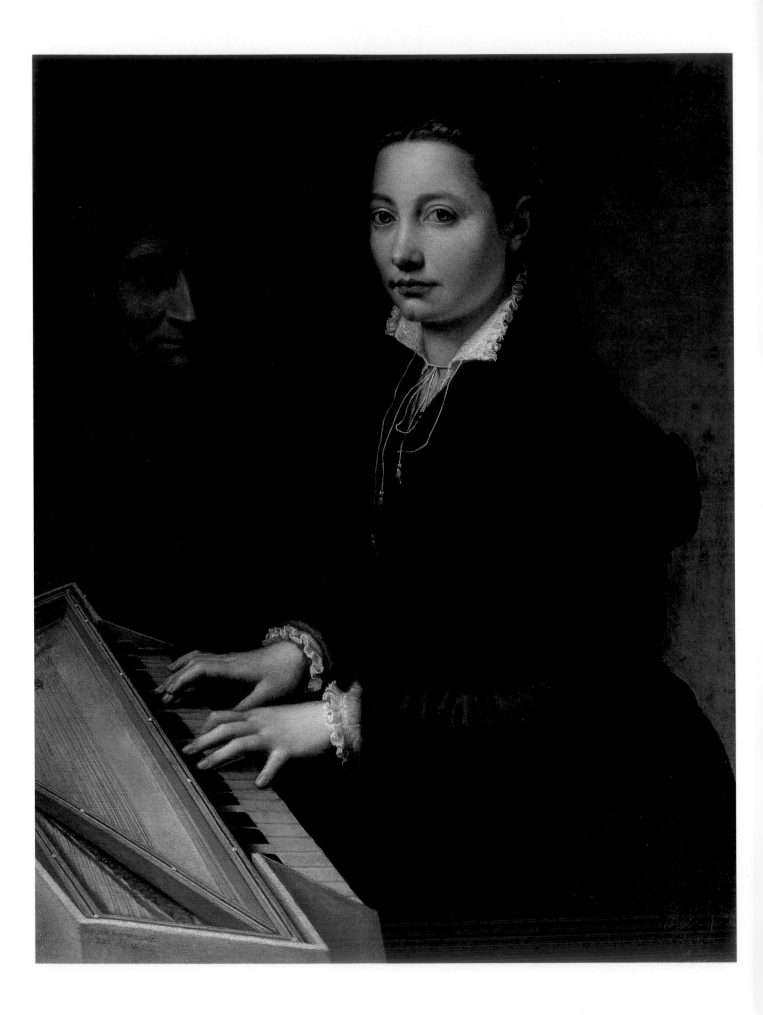

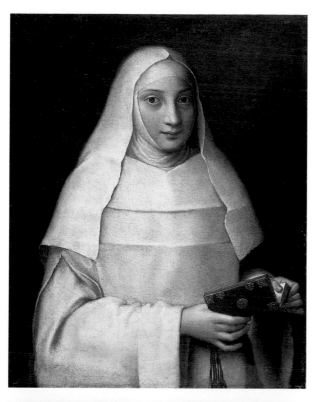

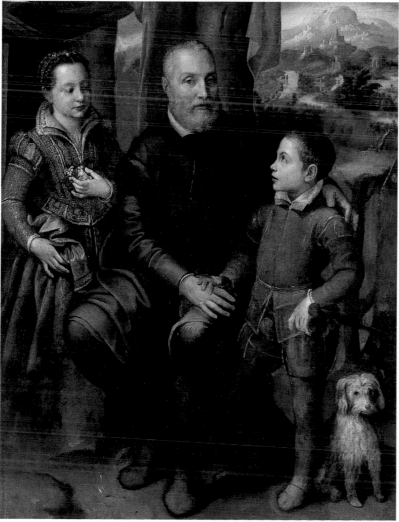

SOFONISBA ANGUISSOLA AND HER FAMILY

The first born in a family of six daughters and one son, Sofonisba Anguissola was renowned in her own time as a portrait painter of great distinction. She and her sister Elena were sent by their father to study 1546–49 with the painter Bernardino Campi; Sofonisba then studied under Bernardino Gatti (Il Sojaro) 1549–52. Sofonisba went on to make a lifelong career as an artist, but Elena entered a convent before she was twenty and no works by her survive.

(opposite) Sofonisba Anguissola, *Self-portrait at the Clavichord*, 1561. This self-portrait, painted two years after she arrived at the court of Spain to serve as lady-in-waiting to Queen Isabella, is a fine example of the artist as a woman of accomplishment. It was important then for women artists to fit into a ladylike mould, and here, soberly but elegantly clad, she displays her skill as a musician, her skill as a painter implicit. This pattern of woman artist as musician was taken up two decades later by Lavinia Fontana and recurs throughout the centuries.

(above left) Sofonisba Anguissola, *Portrait of the Artist's Sister in the Garb of a Nun*, c. 1551. Sofonisba may have painted this portrait when Elena took her final vows. Whether she continued to paint or teach, as several artist-nuns did, is unknown.

(left) Sofonisba Anguissola, *The Painter's Father, Amilcare Anguissola, with His Son Asdrubale and Daughter Minerva*, c. 1557–58. In this wonderful family portrait, Sofonisba displays her ability to paint fabrics and to suggest a mood of familial tenderness. The background landscape adds richness and romance to the image. Vasari described this painting as 'breathing and absolutely alive' (8.46). Amilcare, a nobleman of Cremona, was very active in finding patrons for Sofonisba, and his correspondence with Michelangelo reveals that he requested the great painter to guide her in the practice of her art. Asdrubale was the subject of a famous drawing by Sofonisba, *Asdrubale Bitten by a Crayfish*, late 1550s, which her father sent to Michelangelo.

Originality of design became a matter of pride among the most ambitious artists, and Alberti's belief in painted enactments of historic moments led to a stress on drawing from life as the basis of mastery.

On the surface, it must have seemed impossible for a woman to learn to be an artist. In the first place, there was little chance for her talent to show itself. Castiglione might recommend drawing for ladies, but the education of most women below the highest rank was devoted to producing a good wife and mother. Even if a talent for drawing had emerged, there would have seemed little point in developing it. Cennini could have been addressing women when he warned against following 'other systems' since other systems were all that were available to them. And they were barred from Alberti's system because drawing from the nude male model was forbidden them.

However, while there is no question that it was difficult for women to gain a foothold in the art world, it is clear that they were not faced with a monolithic wall of hostility. We are not talking fairness of course, but it does seem that there were one or two situations where a girl's talent could be developed. Although there were routes to follow for a man who wanted to be an artist and no map at all for a woman, art training was more flexible than it seemed on the surface. Even when excluded from the training programmes of apprenticeship and academy, women could learn through private tuition, from an artist-father, in a convent or from friendly advice.

Apprenticeship, the most common training pattern for boys, was outlawed for girls aside from the daughters of artists who could train in the family workshop. Some apprenticeships had to be paid for, and it would have been a rare parent willing to spend money on the education of a daughter destined for marriage and motherhood. An exception is the nobleman Amilcare Anguissola who sent his two eldest daughters, the celebrated Sofonisba and Elena, who was later to become a nun, to spend three years in the household of the painter Bernardino Campi.

The one sure way for a woman to get a training that approximated to that of male apprentices was to be the daughter of an artist, in nearly every case in this period a man, but occasionally a woman. Three of Lavinia Fontana's eleven children were taught to paint by their mother, including a daughter who died before she did. Sofonisba Anguissola probably taught her three younger sisters. As well as learning a variety of skills to fit them for doing the preliminary work that the more experienced artists in the shop would complete, the girls were taught to produce works in the style of the studio and to copy portraits or versions of admired works. There was a particular call for copies of portraits, and artists would delegate the job of copying to assistants as part of their training: it was always quicker for the artist and cheaper for the client to copy an existing painting than to create a painting from scratch. For the most part, young women were

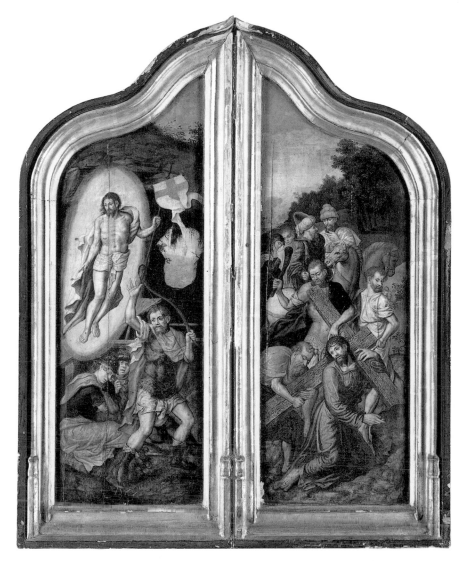

(above) Jan van Hemessen, *The Mocking of Christ*, 1544. (above right) Catharina van Hemessen, triptych wings, *The Resurrection* and *Christ Carrying the Cross on the Road to Calvary*, mid-16th century. It is possible to see the father's influence in the facial types and poses of his daughter's work.

trained to make a product, like an acceptable Madonna and Child or a good likeness, but no more. The work of daughters can be hard to distinguish from that of their fathers. The earliest works of the Antwerp artist, Catharina van Hemessen were versions of the small panels of religious subjects for which her father and teacher Jan van Hemessen was famous. Though this is often taken as a sign of female inferiority, it is always the case with apprentices: early works by Raphael are marked by the elegant bonelessness and tiny pursed mouths of the figures and faces of his master Perugino. The best artists, women as well as men, eventually achieved their own style. Lavinia Fontana was trained by her father Prospero, but by the end of the century as her work matured, it took on influences from other sources of the day. The question of copying offers a good example of the muddled attitudes women had to face. Although copying was an important part of workshop output, it was also seen as a particularly suitable pursuit for women, capitalizing on their innate inability to be original and desire to be obedient.

25

Women in workshops were often taught to engrave and etch. Engraving was thought to be particularly suitable for them, since it did not involve the messy materials of painting and sculpture, and several women practised this relatively clean and small-scale artistic form. Vasari says that Properzia de' Rossi devoted herself to copper-plate engraving at the end of her career and that the engraver Giovanni Battista Mantovano's daughter Diana engraved so well 'that it is a thing to marvel at.'[8] Although de' Rossi's background is a mystery, Diana Mantovana fits into a recognized pattern, trained by her father to work in the family business along with two of her brothers. It is quite possible that while there may be no more stars awaiting discovery, there are numbers of journeywomen trained to practise everything from engraving to goldsmithing in the family shop who are destined to remain unsung.

Under the Albertian model of education, knowledge of the great sculptures of the past was necessary to artists, and casts, small statues and busts became the required furnishings of a studio. A workshop education gave a young woman access to these. There is a sixteenth-century engraving by Agostino Veneziano of Baccio Bandinelli's academy in Rome showing young men admiring and copying male and female statuettes – the famous drawing from casts that was so important in educating the young artists' eyes to the pattern of a perfect body. An engraving of Bandinelli's academy in Florence done two decades later by Enea Vico includes a bust, small statues, and an assortment of bones. Although the fact that girls did not learn this profession in groups ensures there are no equivalent scenes of them at work, it cannot be assumed that they missed out on this aspect of training. Bandinelli's advanced Albertian ideas about the status and education of artists were probably accepted by most artists,

Diana (Scultore) Mantovana, *Christ and the Woman Taken in Adultery*, 1575. Most women artists at this time were the daughters of artists, and Diana Scultore was no exception. Trained by her father, the engraver Giovanni Battista Mantovano, Vasari said that her engraving 'was a thing to marvel at.' It was thought that the cleanliness and small scale of engraving made it particularly suitable for women.

Lavinia Fontana,
Self-portrait, 1579. The artist
makes a claim to artistic
seriousness through the desk,
statues and scholarly atmosphere.

even the most provincial ones, by the early sixteenth century,
and daughters of artists would have been able to copy the casts,
busts, statuettes and skeletons that were part of the studio furniture.
In 1554, Lavinia Fontana painted a portrait of herself surrounded
by small nude figures and casts of body parts, a totally new departure
in the area of female self-portraiture. It was a brilliant way round
the impropriety of showing herself in the presence of a living nude
figure, and a clear statement of her determination to measure herself
against the men.

Apart from having access to a family workshop, a woman could
develop her artistic talent if she happened to be born into a wealthy
noble family and received private lessons as part of her education.
The concept of the cultivated lady formulated in the early sixteenth
century included the ability to draw and paint: 'I want this lady to be
knowledgeable about literature and painting, to know how to dance
and play games, adding a discreet modesty and the ability to give a
good impression of herself to the other principles that have been
taught the courtier,' explained *The Courtier*.[9] The wife of Count
Clemente Pietra 'occupied herself with drawing and painting, as she
still does, after having been taught by Alessandro Allori, the pupil of
Bronzino, as may be seen from many pictures and portraits executed
by her hand, which are worthy to be praised by all.'[10] Her inclusion in

Vasari's chronicle suggests she was a professional, but her rank and the lack of surviving work suggests she was a well born amateur taught by a respected artist, a familiar type in art history's cast of characters. Vasari's refusal to distinguish between amateurs and professionals was perhaps intended to suggest that art was a suitably refined profession for women. Or perhaps he merely wanted to boost the numbers of his survey of a field that was so much smaller than the men's.

Although most amateurs learned from men – Titian taught Irene di Spilimbergo, dead at eighteen but praised so highly that her name lives on – some learned from the women artists who held positions at court. Sofonisba Anguissola, as her lady-in-waiting, taught Queen Isabella of Spain, third wife of Philip II: 'The queen, who shows much ingenuity, has begun to paint, and Sofonisba, who is a great favourite of hers, says that she draws in a naturalistic way in a fashion in which it appears that she knows well the person whom she is painting.'[11]

Some women learned to paint in the convent. A romantic view has developed that convents were like boarding schools where sympathetic females passed on their skills to younger women. This view arose from the fact that convents were not only homes for earnest girls with vocations: daughters were placed in convents to save on their living expenses (although dowries were often demanded), and widows and the unmarried also found homes there. While in theory a convent provided a way for a woman to develop artistically, without offending propriety or involving the family in apprenticeship fees, they did not all offer the nurturing female environment of recent myth. Few convents encouraged education, let alone artistic pursuits, though the Dominican order provided the exceptions: four women were sent from the convent of S. Domenico in Pisa, to establish miniature painting in a convent in Lucca.[12] And the convent of Sta Caterina di Siena in Florence was encouraged at its foundation to dedicate itself to the arts as a way to attract donations.[13] Its abbess after 1568, the painter-nun Plautilla Nelli, was said to have trained four women, two of whom were nuns. Not all the instructors were women. Some lines in a letter of around 1400, in what has been described as the earliest documentation of Italian women artists, show that Giovanni Dominici taught miniature painting to the Venetian nuns in his charge.[14]

The daughters of artists, like Antonia Uccello, and well born women would have learned to paint before they entered the convent. In the fifteenth century, Caterina dei Vigri was the abbess of the Poor Clares at the convent of Corpus Domini, Bologna, a Franciscan order that stressed neither education nor creative activities. As a girl, she was lady-in-waiting to Niccolò d'Este's daughter Margherita, only entering the Corpus Christi convent in Ferrara in 1427, when she was about fourteen, after Margherita's marriage. Accounts show her work was more a matter of religious fervour than talent, which suggests that she had no more than a child's minimal art education:

She wrote her breviary, moistened with spirituality even in its decoration, more with tears than pleasure, as anyone who still lives can attest, and often it was necessary to take it away from in front of her, because she would have ruined it with the abundant tears she shed from her piteous eyes; and always in all things, working, writing, reading or spinning or in whatever exercise, Divine Office or prayer, her mind was turned to God, and this could be seen well in her every attitude.[15]

Elena Anguissola took the skill she had learned from the painter Bernardino Campi into the convent with her in 1551, though it is not known if she continued to paint.

Conflicting speculation about the training of Plautilla Nelli sums up the likely routes to training for a nun. Vasari implies that she was self-taught: 'She, beginning little by little, to draw and to imitate in colours pictures and paintings by excellent masters, has executed some works with such diligence, that she has caused the craftsmen to marvel.'[16] Today's historians suggest that, as the daughter of aristocratic parents, Plautilla Nelli was most probably taught to paint before entering the convent. A third theory is that she was trained by a painter from the brother monastery of St Mark, a former assistant of Fra Bartolommeo, who, like his master, drew from plaster figures instead of live models, a suitably decorous teaching method for a nun. She also had access to the hundreds of drawings by Fra Bartolommeo that were kept in the convent.[17] The evidence, as so often where women artists are concerned, is full of confused and scattered examples from which one is nervous to deduce grand patterns.

Because women artists were such a rarity and because their careers could not be guaranteed to progress along conventional lines, those around them would try and publicize their work. Amilcare Anguissola brought his young daughter's talent to Michelangelo's attention in an astute bid to involve an influential member of the art world in her cause. On 7 May 1557, he wrote to the greatest living artist in Rome, where Sofonisba was working:

Therefore I am asking you, as in the past you were kind enough by your gracious courtesy, to talk to her and encourage my daughter, once again in the future to share your divine thoughts with her. I promise you, when she knows the honourable favour you are bestowing on her, she will direct her mind with great devotion in such a way that I would hope for the best results. We could not receive that with more honour and happiness. This would be all the more if you would be kind enough to send her a sketch so that she can paint it in oil, obliging her to send it back duly finished by her own hand. If you would do this, to compensate my obligation to you, I would dedicate my daughter, Sofonisba, the dearest thing that I have in this world, as your servant.[18]

(right) Sofonisba Anguissola, *Deposition*, c. 1550s.
(below) Bernardino Campi, *Deposition*, c. 1550. One learning method in the artist's workshop was to copy the master's work. In the 1540s, the two eldest Anguissola sisters were sent to Bernardino Campi to learn to paint. The figures of Christ and the Madonna in Campi's *Deposition* were copied by Sofonisba – one of the ways in which she learned to draw the male nude body.

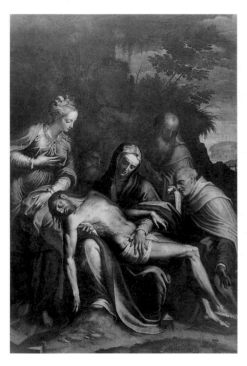

That he did indeed help her is revealed by a thank-you letter of twelve months later in which he assures Michelangelo that 'among the many obligations I have to God, that such a great and talented gentleman – beyond any other man – such as you, was kind enough to examine, judge and praise the paintings done by my daughter, Sofonisba.'[19] Examples of overseeing and encouragement by a master often appear in accounts of women artists' training. They also feature in the lives of male artists, but one never feels, as one often does with women, that it is the only kind of help on offer.

Although women managed to learn to paint professionally, assumptions about female frailty, potential and intellectual capacity ensured that their training was rarely as intensive as that of the men. One of the most damaging effects of these beliefs was that women were not allowed to draw from nude male models, the basis of history

painting. I have never found a sixteenth-century written rationale for this; it just seems to have been a given. Vasari's clear-headed comments about Plautilla Nelli reveal how women worked without the benefit of a decent training:

> The best works from her hand are those that she has copied from others, wherein she shows that she would have done marvellous things if she had enjoyed, as men do, advantages for studying, devoting herself to drawing, and copying living and natural objects. And that this is true is seen clearly from a picture of the Nativity of Christ, copied from one which Bronzino once painted for Filippo Salviati. In like manner, the truth of such an opinion is proved by this that in her works, the faces and features of women, whom she has been able to see as much as she pleased, are no little better than the heads of the men, and much nearer to the reality. In the faces of women in some of her works she has portrayed Madonna Costanza de'Doni, who has been in our time an unexampled pattern of beauty and dignity; painting her so well that is impossible to expect more from a woman, who for the reasons mentioned above, has had no great practice in her art.[20]

Here from the pen of a sixteenth-century male artist is the total acceptance that women did not, 'as men do', draw from life.

All the same one wonders how unfamiliar the women were with the nude, particularly the daughters of painters who could have had some sort of access to the models used by their fathers. Copying their teachers' work was another way they could familiarize themselves with the nude male body. Sofonisba Anguissola's version of *The Deposition of Christ* by her teacher Bernardino Campi in the 1550s, may not be backed by anatomical knowledge (although one has no idea what was included in her course of study), but it does raise questions about the content of her training.

Once a male artist had learned his trade, he could set up his own studio. Custom and convention presented barriers against women doing this. None of the stories about sixteenth-century woman artists exhibit the freewheeling quality of the lives of their male counterparts, who were able to travel, brawl, sell their talents, exhibit eccentricity, work up ladders and in public – all freedoms which came from being the norm in a male profession.

The legal position of women was akin to that of minors, first in the care of their fathers, then of their husbands. This meant that it was simpler for them to set up a studio in the parental or marital home – easiest of all if the parent or husband was a painter. This male control helps make sense of the tale of the artist Marietta Robusti, Tintoretto's daughter, as told by Carlo Ridolfi a century after her death. Tintoretto adored her, and, so the story goes, dressed her as a boy and kept her near him in the studio where she worked as his assistant. His control

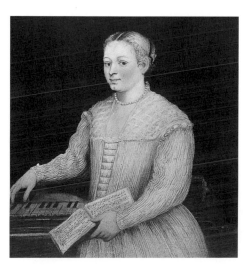

Marietta Robusti (attributed), *Self-portrait, c.* 1580. The daughter of the Venetian artist Tintoretto chooses to present herself as an accomplished musician.

extended to refusing to allow her to accept positions at the courts of the Emperor Maximilian and Philip II of Spain and encouraging her to marry a local suitor. This story, so odd to us and with no equivalent in male biographies, can only be understood and accepted as an example of fatherly control over a painter-daughter's destiny.

Not all men wielded Tintoretto-type control. Though neither of Sofonisba Anguissola's husbands were artists, she painted through both her marriages, doubtless because her reputation, made before her first marriage in her late thirties, was sufficiently impressive to add to her husband's glory. Marriage to an artist could be an enabling move. Lavinia Fontana's painter-husband who, in a reversal of the usual situation, is barely known today, was her professional partner.

PATRONAGE

Working for a royal court was particularly comfortable for a female artist because of its automatic conferral of gentility and status. Women must have drawn great confidence from the fact that enticing a woman to work at court was a coup akin to the acquisition of a rare object for the royal collection. Henry VIII of England employed the female miniaturist Levina Teerlinc. Trained by her father Simon Bening, she entered royal service in 1546, earning £40 a year and great status: she was referred to as a gentlewoman and her husband was made a Gentleman Pensioner. The courts of various members of the Spanish royal family were receptive to women artists. Catharina van Hemessen and her husband Christian de Morien, an organist of Antwerp Cathedral, were carried off to Spain in 1556 by Queen Mary of Hungary, the aunt of Philip II of Spain, after she abdicated as ruler of the Netherlands. Such an artistic double act could only have added lustre to the court. In 1559, in the same decade as Philip II's invitation to Tintoretto's daughter, Sofonisba Anguissola was invited to his wife Queen Isabella's court. In 1589, Lavinia Fontana was commissioned to paint a Holy Family for the Escorial, the Spanish palace outside Madrid.

Court positions involved more than painting, and Sofonisba Anguissola was known as *dama*, lady-in-waiting, to Isabella of Spain. Male court painters had titles like *valet de chambre*, and were responsible for a broad range of activities, all connected to design in some way. Sofonisba Anguissola's post involved her in choosing fabrics and designing dresses for the queen, which suggests that, as much as she was considered an artist in the queen's employ, she was also seen as a well born, multi-talented royal companion. In a self-portrait of her first years at the Spanish court, she painted herself at the clavichord, the image of an aristocratic young woman skilled in the courtly arts.

A court post may have been glamorous, but it was also demanding, as is revealed by Sofonisba Anguissola's reply to her former teacher Bernardino Campi's request for a painting of the king:

About the portrait of the King that you requested, I cannot help you as I would like, because I do not have any portrait of His Majesty. At the present time I am busy doing a portrait of Her Serene Highness, the King's sister, for the Pope. Just a few days ago, I sent him the portrait of our Serene Highness the Queen. Therefore, my dearest teacher, Signore Bernardino, you see how busy I am painting. The Queen wants a great part of my time in order for me to paint her portrait, and she does not have enough patience for me to paint (others), so that she is not deprived of my working for her.[21]

She had to ask permission to work for clients outside the court, even those as grand as the Pope: 'Holy Father, I have learned from your Nuncio that you desire a portrait of my royal mistress by my hand. I consider it a singular favour to be allowed to serve your Holiness, and I asked Her Majesty's permission, which was readily granted, seeing the paternal affection which your Holiness displays to her.'[22]

Although a fog obscures the details of how women worked as independent artists in the sixteenth century, the fact is that they did. In the 1550s, in her twenties and unmarried, Sofonisba Anguissola travelled to Milan where among other projects she painted the Duke of Alba's portrait. Was she accompanied by a member of her family? Did she draw the duke and take the sketches back to a painting room in her lodgings? Did he come to her? Did a servant or an assistant carry her equipment if she painted him in his home?

There is no information on who helped the women painters in their workshops. It is hard to imagine a woman artist of position and refinement – and there is no reason to suspect them of being anything but that – employing male assistants. It is unlikely a young woman would wish to do the work, though facts still waiting to be found may tell a different story. Presumably, like the men, women artists took students to boost their income and trained assistants to help them in the workshop, but there is not much information on this subject. With the exception of Francesco Piola, a young artist whom Sofonisba Anguissola was said to have helped when living in Genoa with her second husband, most references to students in this period are members of the artist's families. Lavinia Fontana who worked first with her father and then with her husband may have used the communal workshop assistants to stretch canvases, mix colours and transfer her drawings to the wood or canvas. Artists in convent workshops, particularly painters of large-scale works, would be helped by the sisters. Training a daughter (Lavinia Fontana) or sisters (Sofonisba Anguissola) could create assistants, though there is no evidence that any of Sofonisba's sisters worked with her after she started to travel in her twenties.

Women produced few of the large-scale history or religious subject paintings for which models were needed before the century's end.

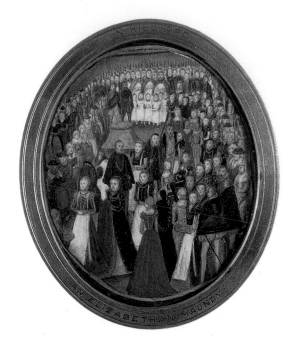

A court position offered a safe harbour and secure income for women artists.

(below) Sofonisba Anguissola, *Portrait of the Queen of Spain, Isabella of Valois*, c. 1565. As lady-in-waiting to Philip II's third wife, the artist was in Madrid 1559–73. The young queen kept her busy with demands for painting lessons and portraits, and choosing fabrics for and designing the queen's clothes.

(below left) Sofonisba Anguissola, *Portrait of Prince Carlos of Austria*, c. 1560. This is a portrait of Philip II of Spain's young son.

(opposite) Catharina van Hemessen, *Portrait of a Man*, c. 1550. This fine gentleman posed for the artist in Antwerp or Brussels, before she and her musician husband were taken to the Spanish court in 1556 by Philip II's aunt.

(above) Levina Teerlinc, *An Elizabethan Maundy*, c. 1565 (previously attributed to Nicholas Hilliard). Levina Teerlinc was the daughter of the Flemish miniaturist, Simon Bening. Marriage brought her to England where she was employed by four successive English monarchs: Henry VIII, Edward VII, Mary I and Elizabeth I. The miniature shows the traditional royal distribution of Maundy money to the poor, just before Easter.

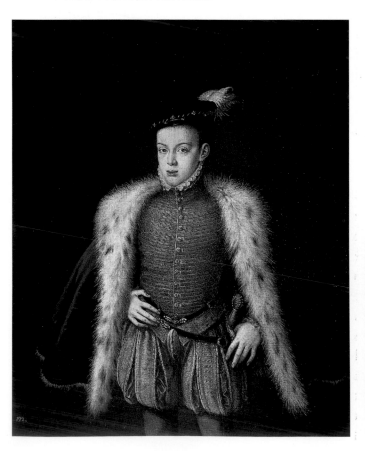

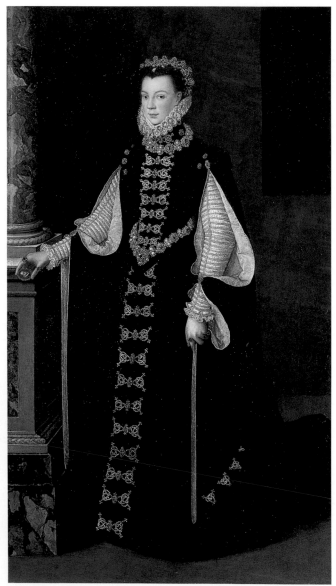

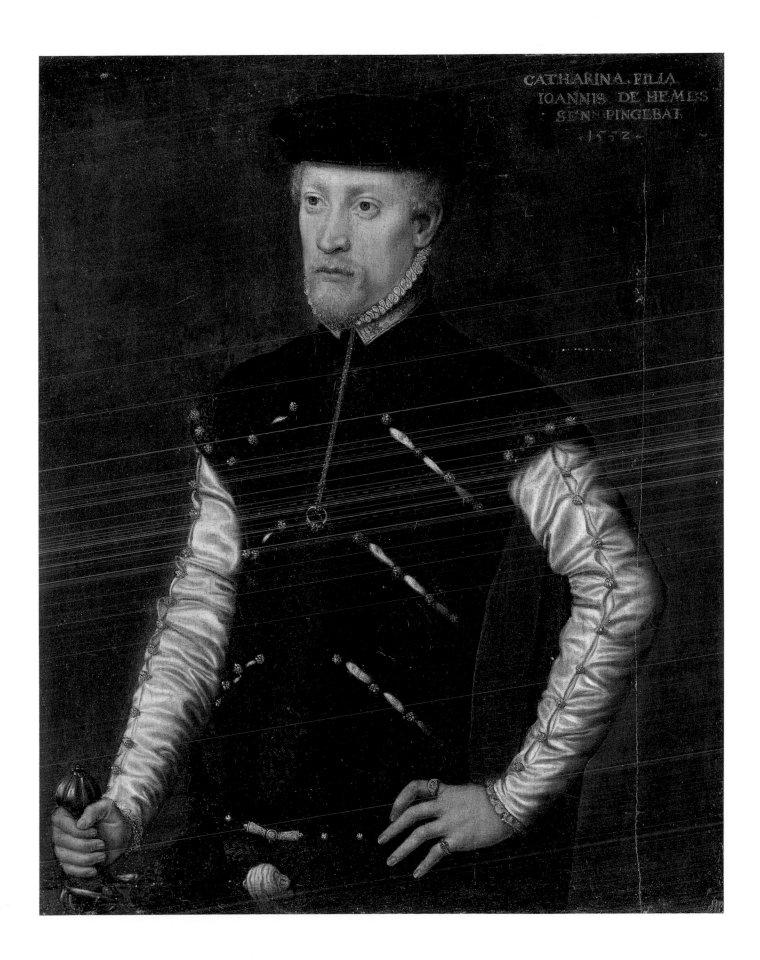

But because women were operating in a climate where the ability to draw the human body was a necessary and admired skill, it seems unlikely that women artists did not use models, however formulaic and derivative their work. Even small-scale religious works needed a knowledge of the figure, and models were used in portrait painting to save sitters tedious posing hours while their clothes were painted. A kind of sensible speculation has been substituted for the absence of information about women artists' use of models in the sixteenth century, though the suggestion that they used their knowledge of their own bodies to enable them to paint the figure is surely taking coyness too far: if they had got as far as practising professionally, they surely would not have stopped at employing models. Actual evidence for this, however, has to wait for the seventeenth century.

ARTISTIC FIELDS

Operating from a family workshop or at a court saved women from the unfeminine behaviour of going out and selling their work and themselves as artists. When temperament or social conventions worked against them advancing themselves, men acted as intermediaries. Male artists also used intermediaries as a way to find work, but women artists could not do without them. Vasari shows Properzia de' Rossi working through men to achieve her ambitions. He reports that she petitioned to sculpt figures for S. Petronio in Bologna 'by means of her husband' and that she did a marble portrait bust of Conte Guido Pepoli in the hope of influencing his son to employ her on the façade. Both ploys worked.[23]

Inside the studio, the women practised all kinds of art, though with emphasis on some more than others. The dirt, dust, and strength required to do the work made sculpture a rare choice for women. Not even Vasari could throw much light on the sculptor Properzia de' Rossi, except to say that she was beautiful and cultivated. She is not thought to have been a sculptor's daughter (or perhaps he was not well known), which makes her choice of profession even more extraordinary for this period. He is more informative about her work, which included carving everything from peach stones to figures in relief.

The specialized practice of fresco was done on site and involved ladders, scaffolding, danger from falls, speed and the specialized technical knowledge of painting a daily section of a large design into wet plaster. A simpler method involving painting on to dry wall had its own attendant dangers, and still demanded the physical daring which made it off-limits to women. The vast areas involved in fresco necessitated assistants and apprentices as well as self-confidence. Its relative neglect by women throws into relief the fact that until the end of the century women found it simpler (which has nothing to do with their wishes, dreams or ambitions) to concentrate on the kind of art that could be accomplished by one set of hands. Fresco painting

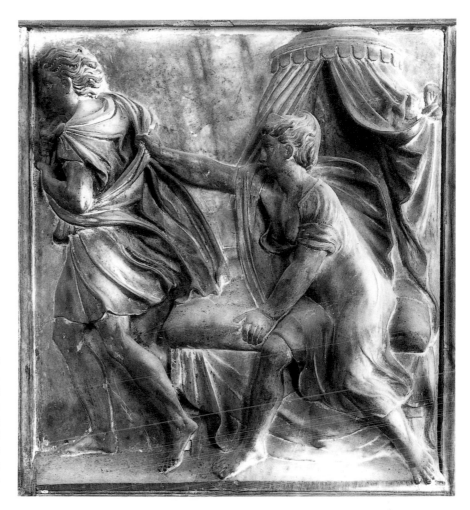

Properzia de' Rossi, *Joseph and Potiphar's Wife*, c. 1520. The artist, one of the rarest creatures of the age, a female sculptor, turns stone, the hardest of materials, into a flurry of activity. Even the bed curtains echo Joseph's clothes as he flees the frame in a *tour de force* of agitated movement.

seems only to have been practised by women artists in convents, moved to decorate their surroundings through necessity or religious fervour. Caterina dei Vigri's fifteenth-century biographer described how 'Gladly, in the books and in many places of the monastery of Ferrara she painted the Divine Word in swaddling clothes'.[24] Plautilla Nelli painted a *Last Supper* for the refectory of her convent which is now stored in Sta Maria Novella in Florence.

When it came to choosing a field in which to practise, the women's range of choices was different from that of the men. Naturally they chose to do what they would do best, and what they would do best was what they had been best trained for – the portraiture that did not involve them in drawing from the nude. What would earn them amazed praise were the large-scale altarpieces that only men were thought to be capable of producing, and far outside the range of women's tiny hands, and as the century drew on one or two women attempted these. Their search for subject matter was conducted with a similar common sense. In an age of propriety, they chose subjects of female suitability from within the available range, portraits of women or panels of the Virgin and Child.

Whatever their ambitions, and the women who achieved professional status in a chivalrously amazed but patronizing male art

world clearly had them, inadequate training and prejudice equipped them poorly for competition in the prestigious areas of Renaissance art. The kind of work they produced suggests they had a shrewd knowledge of the insults they would attract if they expanded beyond their capabilities or beyond the place allowed them. This throws up an important point: although women wanted to be judged by the standards of their day, they were aware that their work would be scrutinized for weakness. They therefore limited their practice to genres in which it was possible to be trained for success rather than risk ridicule for attempting genres for which they were poorly equipped. Women who stuck to portraits were not lacking ambition so much as accepting the realities of the art world. Women could hardly remain unaware of the widely held conviction that they lacked the imagination and intellectual power to deal with the ideas needed for history and narrative painting. That is the reason that portraiture accounts for most of the work by women artists in the sixteenth century. This practice accorded with their limited training, for without the practice of drawing from the nude, their figures would always be criticized as untrue to life. And as portraiture was often – though not always – small scale, it dispensed with the need for scaffolding, ladders and huge studio spaces.

The tendency of most sixteenth-century women artists to specialize is as much an index of their realism as their timidity. However, research is beginning to reveal that their work is not as one-note as once thought. More religious works by Sofonisba Anguissola than have survived are mentioned in documents, showing that it is wrong to see her solely as a portrait painter. Lavinia Fontana's work broadened out from portraiture into religious and classical subject matter as she developed. By the end of the century, women were definitely becoming more adventurous. Fede Galizia produced portraits, religious subjects and, something new – still life.

A surprising number of men sat to women, a fact of some fascination to their contemporaries who never miss a chance to mention the fact. Perhaps the writers saw it as a refined and artistic type of titillation, a reversal of the usual sexual roles, in which the

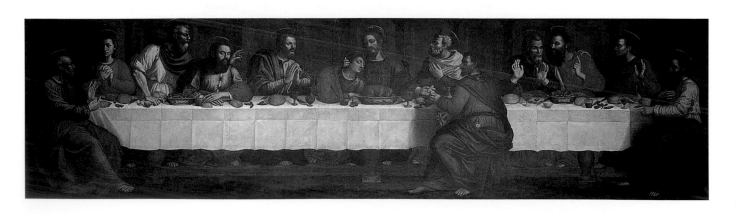

Lucia Anguissola, *Portrait of Pietro Maria, Doctor of Cremona*, c. 1560. In the second edition of his *Lives of the Artists*, Vasari wrote: 'Lucia left at her death fame no less than that of Sofonisba...as may be seen at Cremona from a portrait that she executed of Signor Pietro Maria, an eminent physician' (8.47).

normally passive woman takes the active role, while the normally active male offers himself as a feast for her eyes. The gentlemen of Cremona seem to have been particularly susceptible to women painters: Soprani said of Sofonisba Anguissola that many Cremonese gentlemen wished to have her do their portraits.[25] Vasari described Europa Anguissola who while still a child 'executed many portraits of gentlemen at Cremona, which are altogether beautiful and natural.'[26] In the 1570s, Lavinia Fontana painted several portraits of scholars and clerics which were much admired by her contemporaries. While a frisson was attached to women painting men, it was seen as natural for them to paint women, their female talent for copying (as it was expressed at the time) earning them particular praise for their realistic depiction of elaborate clothes and jewels.

Miniatures were an important format in the sixteenth century, a portable form of portraiture which could be carried or worn as jewelry, and there is a healthy list of female practitioners – Vasari lists seven, mainly from the Netherlands, including the daughter of Simon Bening (Levina Teerlinc). The small-scale and portrait subject matter made it a suitably feminine area – though mysteriously no such attitude reduced the reputations of the male miniaturists. The English miniaturist Nicholas Hilliard described the fastidious practice and personal cleanliness necessary to the practice of his profession (as well as its superiority to lower forms of decoration), and, although it was men to whom he was talking, it was this that made it suitable for women:

> Now therefore, I wish it were so that none should meddle with limning but gentlemen alone, for that it is a kind of gentle painting, of less subjection than any other; for one may leave when he will, his colours nor his work taketh any harm by it. Moreover, it is secret: a man may use it, and scarcely be perceived of his own folk. It is sweet and cleanly to use, and it is a thing apart from all other painting or drawing and tendeth not to common men's use, either for furnishing of houses, or any patterns for tapestries, or building, or any other work whatsoever.[27]

Easel painters also produced miniatures. Lavinia Fontana's self-portrait with figures, painted for Alonso Chacon to reproduce in his projected collection of prints of notable men and women, was only six inches (fifteen centimetres) in diameter. Plautilla Nelli painted miniatures before attempting religious panels. Though it is customary to think of miniatures as limited to portraits, multi-figured scenes were also painted. A miniature crowd scene of Queen Elizabeth I performing Maundy ceremonies has been attributed to Levina Teerlinc.

The second largest category of work produced by women were small panels of the Virgin and Child for private worship. A popular subject and format, women chose it for its small size, pious

associations, ease of finding models (existing paintings as well as live women) and appropriate subject matter. Sofonisba Anguissola learned to paint religious subjects by copying Bernardino Campi's religious works, and, on the evidence of her self-portrait, painting a panel of the Virgin and Child when she was in her twenties, probably continued to do so all her life. She may have chosen to put this subject on her easel to show off her versatility as well as the piety that sat so well on the shoulders of a young woman painter. Twelve of fifteen of Barbara Longhi's surviving paintings are panels of the Virgin and Child or the Virgin and Child with Saints.

Large religious paintings are rarer, rendered 'unfeminine' for reasons both artistic – full-length figures necessitated anatomical knowledge for their successful depiction – and practical – their size and the need for assistants. They also demanded self-confidence on the part of the painter and a rare confidence on the part of the commissioner that the painter could produce what was asked of her. Sofonisba Anguissola's lost works include *Saint Catherine with a Wheel*, the *Mystic Marriage of Saint Catherine* and *Lot and His Daughters*. Their size is not known, although two of her surviving religious works measure a respectable four by three feet (a hundred and twenty by a hundred centimetres).

Lavinia Fontana, *Birth of the Virgin*, 1590. Even though this ambitious artist was attempting to rival the men with her huge altarpieces, her choice of subject matter was suitable for a woman painter.

As more women artists flourished in the last two decades of the century, they began to be involved in the production of altarpieces. From the the 1580s until her death in 1614, Lavinia Fontana was commissioned to produce altarpieces for churches, not just in her home town of Bologna, but outside as well. In 1603 she was invited to Rome by the pope to paint an altarpiece of the stoning of St Stephen. It was badly received, but, as it only survives as an engraving done before its destruction by fire in 1613, it is impossible to verify whether the work justified the black marks, or whether it was merely drawing down on its head local disapproval of an outsider artist, not just from Bologna, the Pope's home city, but also a woman. Many of her works were huge, an early example of a woman confounding expectations that female work was always small and sweet. *The Birth of the Virgin* for the Chiesa della SS Trinità in Bologna measured ten by over six feet (three by two metres).

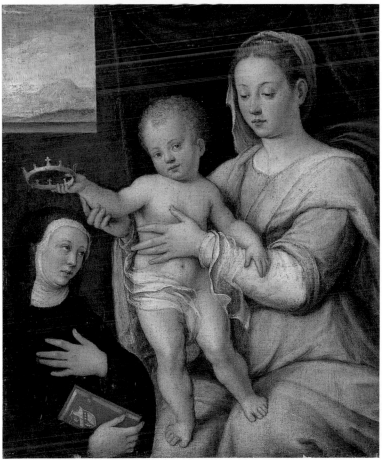

THE VIRGIN AS SUBJECT

In the sixteenth century, the major artistic categories were portraits, religious scenes and history paintings. Since women did not draw the nude male body, they tended to concentrate on portraiture and on religious subjects with a female slant, particularly stories from the life of the Virgin Mary.

(opposite) Plautilla Nelli, *Adoration of the Magi*, mid-16th century. This painter-nun did not limit herself to working for her own church and convent: she also accepted commissions, all of which appear to have been of religious subjects.

(above left) Sofonisba Anguissola, *Self-portrait Painting the Madonna and Child*, 1556. Here Sofonisba Anguissola is displaying her versatility, intimating that her talent for painting religious imagery is as great as her talent for portraiture.

(above) Sofonisba Anguissola, *Nursing Madonna*, 1598. Patrons wanted devotional works for their homes. The artist did several versions of this subject, probably for women.

(below left) Barbara Longhi, *Mary and the Child Jesus in the Act of Crowning a Saint*, c. 1590–95. Barbara Longhi lived a quiet life in Ravenna, away from Italy's major artistic centres. Trained by her father and content to keep to his style, she specialized in versions of the Madonna and Child, although she also worked on several altarpieces. She was not an innovative painter, but the serenity in this painting explains the appeal of her work.

Barbara Longhi assisted her father on his altarpieces and painted two of her own around 1595, the *Cappuccini Altarpiece* and *The Healing of St Agatha*. Some convent-based artists did secondary work on a master's altarpieces, while others like Plautilla Nelli took responsibility for painting the religious works they needed.

History painting, scenes from classical or national history or the Bible, was transmuted and scaled down into religious panels by most women artists. The exceptions were those with the training and ambition to compete with men, and the ability to find subjects with a female slant. While men were free to choose subjects centred on either gender, and could work from female as well as male models, women were forbidden to draw the nude male, and were tied to a notion of subject matter appropriate to their sex. The first woman to make a consistent attempt to produce histories was Lavinia Fontana. Her paintings of *Venus and Cupid* (1585 and 1592), and of *Minerva* (1613), are probably the first female nudes by a woman, and illustrate a Renaissance sense of propriety with their female subject matter for a female painter. The number of women artists who seized on the vogue for paintings of *Judith with the Head of Holofernes* shows their determination to find heroines to rival the ubiquitous male heroes.

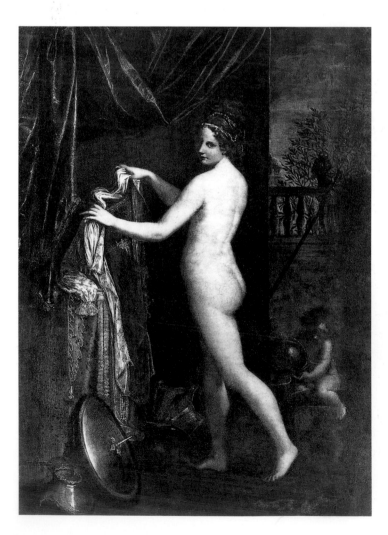

Lavinia Fontana, *Minerva Dressing Herself*, 1613. This artist is the first woman to paint the female nude, shown here in the guise of Minerva, Roman goddess of war and of crafts. This painting is designed to show the artist's mastery of textures: the metal of the helmet, breastplate and shield contrasts with the sinuous body and soft clothes.

Sofonisba Anguissola painted one, now lost, as did Lavinia Fontana, Barbara Longhi, and Fede Galizia. Clearly there was such a thing as female subject matter, not innate, of course, but dictated by circumstance and convention.

Whenever Vasari wrote about women artists, he made sure that part of his account was devoted to their charm, accomplishments and good looks. In this way, it was early made clear to women that to be successful they had to add social to artistic skills in order to meet the conventions of the age regarding women. While the biographies of sixteenth-century artists are full of colourful men who became successful artists, this is never the case with women artists for whom eccentricity or lowly origins were no help at all. As the daughter of a well known artist and the wife of an artist related to nobility, and as the rumoured possessor of a doctorate from the university of Bologna, Lavinia Fontana had impeccable credentials for painting the scholars who made up a great proportion of her work in the 1580s after her marriage and the ladies who commissioned her in the following decade. Not only was Sofonisba Anguissola well born, but her years at the Spanish court had given her a touch of royalty.

The gracious phrases of their letters show their command of the necessary elegance of letter writing, and their decisions about how to represent themselves in their self-portraits illustrate their wish to be seen as gentlewomen, holding books to signify their education and playing music to signify their talents. Women artists' presentation of themselves as refined and accomplished was a strategy to distance themselves from the craft element in their profession and a way to dispel any prejudice against the outlandishness of a professional woman artist. The music, singing and painting included in the list of accomplishments in *The Courtier* lay behind several self-portraits of women artists as elegant ladies holding music or at a musical instrument, their ability to paint either implicit – they were the authors of the image – or spelled out, as in Lavinia Fontana's self-portrait at the keyboard with an easel in the background.

When it came to getting work, the women understood the importance of publicity. The circulation of prints and drawings of their work helped spread awareness of their achievement in an age when collections were prized and pored over. They also took care to offer a reliable product. The many versions of Barbara Longhi's religious panels and Lavinia Fontana's portrait format for her female sitters with small dog and richly encrusted clothing show they were prized for their ability to deliver work done according to a recognizable and desirable formula.

Existing on the periphery of male artistic networks, women had to find ways to promote their interests. With so many channels of promotion closed to them, women exploited their rarity value. Self-portraits were used both to satisfy and to exploit the interest in themselves as that unusual being, a female painter. A number of Sofonisba Anguissola's self-portraits exist in several versions, evidence of the demand for images of the woman artist.

As powerful patrons could boost their reputation, they sent their paintings as gifts to those with influence. When a woman was well connected artistically or socially, then the greatest in Europe – princes and popes – wanted her work. Amilcare Anguissola assiduously promoted his daughter by sending her paintings to the grand and powerful. It was a kind of mutual flattery. The artist benefited, but so did the patrons: in an age of conspicuous cultural consumption,

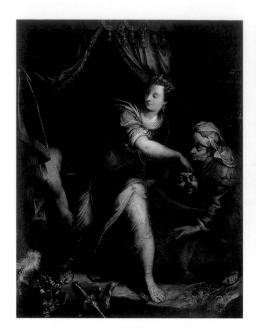

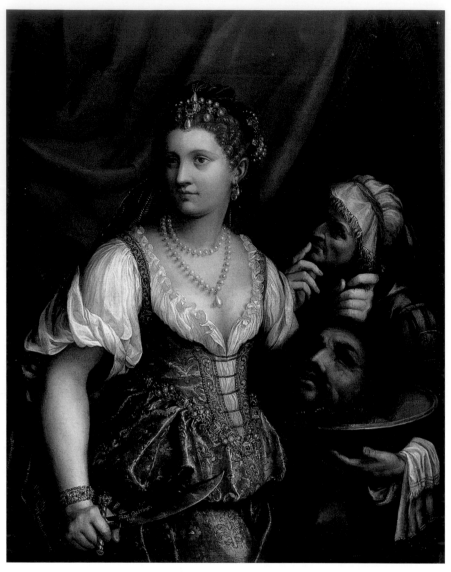

(above) Lavinia Fontana, *Judith and Holofernes*, *c*. 1590–94.
(right) Fede Galizia, *Judith with the Head of Holofernes*, 1596. The Old Testament heroine Judith – who feasted with the enemy commander and, when he was drunk, cut off his head with his own sword – was a popular subject in the period, and one that appealed to several ambitious women artists.

a work by that rarest of creatures, a woman artist, was a visible testament to the patron's discernment and originality. By remaining in Ravenna all her life, working modestly in the manner of her father's shop, producing portraits and small religious panels, Barbara Longhi did not attract the attention of kings and princes. The reason her reputation has survived the centuries is that Vasari kept his ear close to the ground, and, in his discussion of Luca de' Longhi of Ravenna he mentions that his daughter, 'still but a little girl, called Barbara, draws very well, and has begun to do some works in colour with no little grace and excellence of manner.'[28]

Exploitation of the female networks that existed, even in a world where men made taste and wielded power, could be a useful strategy. Even though in general terms the absence of independence, money and power meant that female intermediaries could rarely be as powerful as the men, there were exceptions. Among the widowed, wealthy, well born and indulged women, it is possible to glimpse a world of female enclaves and female spheres of influence. If women had money of their

own, they could commission portraits, and if well born they could bring a woman artist to the attention of the powerful man in their circle. Amilcare Anguissola sent a self-portrait by his daughter to Lucrezia d'Este, a member of the great ruling family of Mantua, relying on the sympathy that should exist between women to benefit his daughter. An example of women patrons with the power to commission arises in connection with Lavinia Fontana who has been called a 'woman's artist', a statement supported by a comment written within a half-century of her death that, 'For some time, all the ladies of the city would compete in wishing to have her close to them, treating and embracing her with extraordinary demonstrations of love and respect, considering themselves fortunate to have seen her on the street, or to have meetings in the company of the virtuous young woman; the greatest thing that they desired would be to have her paint their portraits'.[29] Sofonisba Anguissola's position at the Spanish court, where the queen – and doubtless other ladies in the court circle – shared her interest in making art offers another pattern of a female artistic community.

The history of male artists is full of links, influences, friendships, master-pupil relationships and rivalry between artists, a state of affairs that was still at an embryonic stage for women. Since women artists were so few and far between, it is unlikely that there was much sense of community between them. A rare instance of one woman artist acknowledging another is Lavinia Fontana's reply to Alonso Chacon's request for the self portrait for his gallery of engravings in which she modestly expressed how honoured she was at being included alongside Sofonisba Anguissola.[30]

REWARDS

And what of the rewards? We hear so much about their frustrations that it is useful to be reminded of their pride in themselves, which must have been one of the greatest gifts of their profession. Through their signatures, the women's voices can be heard defining themselves and offering an insight into the pride they felt as women artists. Artists take great pains to inform us of their status in their families – something rarely seen in later centuries. Lavinia Fontana's signatures reveal her successively as daughter, then wife. Far from depressing evidence that women only existed in relationship to men, these signatures are evidence of their desire to advertise their singularity. Sofonisba Anguissola signed several portraits as 'Sofonisba Anguissola, virgo', not to advertise her chastity but to show she was unmarried, a woman, a daughter and a painter – unusual in other words. Catharina van Hemessen signed a portrait of a woman as 'Catharina, daughter of Jan'. By including her artist-father's name she is signalling her pedigree and her credentials as an artist, and by stressing her unmarried state she is pointing to her unique position as a woman

Barbara Longhi, *St Catherine of Alexandria*, c. 1590. The saint is shown with her traditional attribute, the wheel she was broken upon for refusing to deny her religion. The hand gesture and look towards the spectator has given rise to another tradition: that this is a self-portrait. However, it seems unlikely that the artist would not have chosen St Barbara if that was her intention.

in a male profession. What better example of pride than Sofonisba Anguissola's signature on *The Chess Game* as 'Sofonisba Anguissola, maiden, daughter of Amilcare, painted this true likeness of her three sisters and a servant in 1555.' Fede Galizia signed a portrait of Paolo Morigia as 'Fedes Gallicia virgo pudiciss' (most modest maiden), and adding her age, eighteen, to show her pride in her youthful talent. Lavinia Fontana signed her self-portrait at the keyboard aged twenty-five as 'Lavinia maiden daughter of Prospero Fontana has represented the likeness of her face from the mirror in the year 1577.' Their willingness to advertise their chastity, youth and skill shows them happily exploiting their difference from men. The fact that a successful woman artist was a rarity and a figure of some status, must have done much to compensate for any unhelpful attitudes.

Working as an artist could also bring more tangible rewards. It was one of the few ways for a woman to earn a respectable living, in the double sense of propriety and money. Even when, due to their secondary legal status, women did not keep their earnings, the ability to earn added immeasurably to their status within the family. The first reference to the huge sums earned by a woman artist comes in a seventeenth-century report that the prices charged by Lavinia Fontana for her portraits of Bolognese ladies would equal the prices charged by Van Dyck today.[31] Retirement from court brought a pension. Sofonisba Anguissola transferred hers to her brother, and her biographer has suggested that a self-portrait she painted when she was about seventy and sent as a gift to Philip III of Spain was a thank-you for permitting this transfer. She holds a letter inscribed: 'To his greatest majesty, Philip III of Spain, with thanks.' As well as an elegant means of self-promotion, and a strategy to guarantee her work would be held in a royal collection, it was perhaps her way of paying respects to the new ruler whose father had treated her so well, employing her, furnishing her with a pension and giving her a dowry for the husband he found for her.

Gifts such as costly fabrics counted as earnings. Sofonisba Anguissola received a diamond for her portrait of Don Carlos. Vasari reproduced a letter of thanks from Pope Pius IV to Sofonisba Anguissola for her portrait of the Spanish queen and told his readers that it was accompanied by 'gifts worthy of the great talents of Sofonisba.'[32] Vasari was always interested in female earnings, reporting that Catharina van Hemessen earned a good salary in the service of the queen of Hungary; that Properzia de' Rossi was badly paid for her S. Petronio sculptures; and that Sofonisba Anguissola had a handsome salary and much honour from her service to the queen of Spain.[33]

Fame as well as fortune hung enticingly over the head of women artists. The male artist became a figure of glamour in the period as Alberti's arguments for raising the status of the artist from craftsman

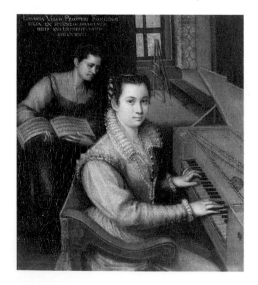

Lavinia Fontana, *Self-portrait with Clavichord and Servant*, 1577. This self-portrait, which must have been intended to compete with Sofonisba Anguissola's self-portrait of 1561, displays the artist's pride in her skills in both music and painting. The inscription tells us that she represented the likeness of her face from the mirror in the year 1577.

Anthony Van Dyck visited the aged Sofonisba Anguissola in 1624, recording the visit with a sketch. His impressions of her at ninety-six were that she had a good memory and a quick spirit.

to learned humanist took concrete shape in the form of state rewards to artists. The much repeated classical tale of Alexander the Great bending to pick up the brushes of his painter Apelles had its contemporary version in the golden chains of office bestowed by kings on artists. Although women received no gold chains, they were offered other marks of respect and came in for their share of honours. Their work was collected by princes and popes, they were mentioned in contemporary histories and honoured by academies.

The academies of St Luke, the patron saint of painters, which began to be founded in several cities to replace the earlier guilds, bestowed a professional seal of approval on their members, and offered a space where male artists and intellectuals could discuss the philosophy of art and refine their taste. In 1603 Lavinia Fontana was invited to join the academy of St Luke in Rome when she set up a studio there in 1603, and in 1611, when she was in her seventies, a medal was struck in her honour with the artist on one side and a depiction of the female personification of Painting on the other. Several women artists were celebrated in poems and songs, and in 1575 Barbara Longhi was mentioned in a lecture: 'You should know that in Ravenna, there is a young girl, 18 years old, the daughter of the most excellent painter Luca Longhi, who is just as remarkable in this art, especially the painting of portraits, which she captures with only a single glance. Even her father marvels at her, for she paints better than those who practise this art in a mediocre fashion.'[34] After their death came the eulogies. This was the eulogy for Irene de Spilimbergo, dead at eighteen:

> A weeping Titian said, 'Then you with your artist's hand
> Would have expressed faces in a more learned way than the ancient Apelles.'
> Then Death said, 'It is right that heaven be decorated with your painting.
> You, Titian, are enough for the world.[35]

Sofonisba Anguissola lived on into extreme old age, her longevity adding to her fame as an artist. In 1624, when she was over ninety, Van Dyck paid a visit to this artistic phenomenon, recording his reaction in his sketchbook around a drawing which he later worked up into two paintings. 'Portrait of Signora Sofonisba Anguissola, painter, done from life at Palermo on July 12 1624, when she was 96 years old, still with a good memory, quick spirit and kind. Although her eyesight was weakened through age, it was a great pleasure for her to have pictures placed in front of her, and while she then placed her nose very close to the painting with a lot of effort, she managed to recognize some of it. She enjoyed that very much.' He concluded: 'When I drew her portrait, she gave me several hints: not to get too close, too high or too low so the shadows in her wrinkles would not show so much.'[36] It is the earliest example of a woman painter giving advice to a male painter.

1600–1750
The celebrated line of women artists

*'I will show Your Most Illustrious Lordship
what a woman can do.'*

ARTEMISIA GENTILESCHI

After 1600, the number of women artists
increased, although the work of many
of those mentioned in contemporary
writings has not survived. The idea of
the woman artist began to gain general
acceptance, and the women themselves
became more ambitious, as can be seen
in the widening range of subject matter
they attempted. At the funeral of Elisabeth-
Sophie Chéron in 1712, a list of famous women
artists, from the Anguissola sisters onwards,
was recited in the eulogy. It proves that by
the start of the eighteenth century, the notion
of a line of women artists, with a history
of at least a hundred years, had penetrated
the art world and could be summoned
up when necessary. They may have been few
in number compared to the men, but these
role models had made their mark
and stood as beacons for those
who followed them.

CAST OF CHARACTERS

Some of the artists discussed in this chapter who give
a picture of the art world at this time.

MARY BEALE was born in England in
1633. She was probably taught by her
clergyman father, who was an amateur
artist, and then by artists in her circle
whose influence can be traced in her
work. She married Charles Beale in 1652
and had two sons. After her husband lost
his government post, he managed the
portrait studio she set up in their London
home. She painted the portraits of
aristocrats, clergy and gentry of her own
circle. She died in 1699.

ROSALBA CARRIERA was born in Venice
in 1675 to a clerk and a lacemaker.
Information on her artistic education
is hazy, but led her from snuffbox
decoration through miniature painting
to pastel portraiture. Unmarried, she
was assisted by her sister until Giovanna's
death in 1637. Her skill at the relatively
new medium of pastel was early
recognized: important patrons included
Maximilian of Bavaria, Frederick IV
of Denmark and the Prince Elector of
Saxony, later Augustus III of Poland.
She became a member of the Academy
of St Luke in Rome in 1705 and of the
French Royal Academy in 1720. Her
sight weakened after 1746, and she died
in Venice in 1757.

ELISABETH-SOPHIE CHÉRON was born
in Paris in 1648, and taught by her father,
a miniature painter, then by Charles Le
Brun. Her work included portraits,
history and religious paintings, pastels
and engravings. She was also famous as a
musician and poet. She saw her marriage
in 1692 as an intellectual partnership and
kept her own name. She became a
member of the French Royal Academy in
1672 and of the Accademia dei Ricovrati,
Padua, in 1699. She died in Paris in 1711.

(previous pages) Giovanna Garzoni, *Still
Life*, painted for Ferdinand II de' Medici
between *c*.1650 and 1662 (detail).
(this page, left to right) Mary Beale,
*Self-portrait Holding Portraits of Her
Sons*, *c.* 1665 (detail). Rosalba Carriera,
Self-portrait, *c.* 1746 (detail). Pierre
Mignard, *Elisabeth-Sophie Chéron as a
Shepherdess*, late 17th century (detail).
Artemisia Gentileschi, *Self-portrait*,
c. 1630–40 (detail).

ARTEMISIA GENTILESCHI, born in Rome
in 1593, was trained in her father's
studio. In 1611 the painter Tassi was sued
for her rape and was imprisoned for eight
months. She married the painter Stiattesi
in 1612, and lived in Florence until 1620,
bearing four children, separating *c.* 1626.
Her portraits, allegories and paintings
of heroines attracted Spanish royalty,
Roman nobles and the Medici as patrons.
She worked in Naples, Genoa, Venice
and London, and in 1616 became the
first woman member of the Florence
Academy of Design. She died 1652/3.

GIULIA LAMA was born in Venice in 1681. Little biographical information survives. Her early training was probably with her artist-father. Three surviving Venetian altarpieces reveal an accomplished and confident style: *Virgin and Child with Saints*, 1722, Sta Maria Formosa; *Crucifixion*, S. Vidal; *Assumption of the Virgin*, parish church of Malmocco. She died in 1747.

(left to right) Giulia Lama, *Crucifixion*, c. 1730 (detail). Judith Leyster, *Self-portrait*, c. 1633 (detail). Rachel Ruysch, *Still Life*, early 18th century (detail). Elisabetta Sirani, *Self-portrait*, mid-17th century (detail).

JUDITH LEYSTER was born in Holland in 1609 into a non-artist family with interests in brewing. She perhaps trained with Frans Pietersz. de Grebber and was certainly influenced by Frans Hals. Her speciality was genre paintings of domestic intimacy. She ran her own workshop and was a member of the Haarlem Guild of St Luke (1633) before her marriage to the painter Jan Miense Molenaer in 1636. A mother of five, she may have worked in partnership with her husband after their move to Amsterdam on their marriage. She died in 1660.

RACHEL RUYSCH was born in 1664 into an intellectual family. Her father was a scientist. Her studies with the flower painter Willem van Aelst from the age of fifteen prepared her for her career as a flower and fruit painter. She married portrait painter Juriaen Pool in 1693, and had ten children. In 1701 she and her husband became members of The Hague painters' guild. She was court painter to the Elector Palatine, Johann Wilhelm, in Düsseldorf, 1708–16. Her contemporaries celebrated her in books and portraits. She died in 1750 in Amsterdam.

ELISABETTA SIRANI was born in Bologna in 1638. At the instigation of Carlo Malvasia, who wrote an account of her after her death, she was trained as a painter of portraits, histories and religious works, probably by her father, Giovanni Andrea Sirani. She took female students, produced around 200 works in her short life and had many famous patrons. Her sisters Anna Maria and Barbara were also painters. A mythology has developed around her beauty and early death in 1665.

Aspiring women artists were helped by the spread of more enlightened ideas about the role of women. Although these varied from family to family and from country to country, there is, nonetheless, a drift towards an acceptance that women could be allowed to take up a brush and paint, particularly in the Netherlands, where women took on various roles outside the home, and in some of the Italian states where art had an important place in social life. Environment continued to play a part, and one has to assume that Bologna's self-consciousness about its role as a cradle of women artists encouraged the acceptance of the idea that women could work in this profession. While artists' daughters and wealthy amateurs remained the most likely candidates for learning to make art, there was now an increased possibility of women from other backgrounds entering the profession, such as Judith Leyster, a Haarlem brewer's daughter. Nonetheless, it remained the case that the incidence of women artists owed more to the possession of an artist-father or a cultivated background than to anything else. The number of amateurs increased and one or two, like the intellectual prodigy Anna Maria Schurman, entered art history. The trend

(top) Judith Leyster, *Self-portrait*, *c*. 1633.
(above) Pieter van der Werff, *Venus*, 1715.
(right) Gabriel Metsu, *Girl Drawing*, late 1650s. Evidence of the growing number of female artists is their appearance in self-portraits and as subject matter in paintings by male artists.

continued, begun by Vasari, of mentioning amateurs in the same breath as professionals and heaping the praises high.

One piece of evidence that proves how the idea of the woman artist was beginning to seem almost normal, was the increase in paintings showing contemporary women as artists. Some came from the hands of the women themselves, as they continued to advertise their prowess through self-portraits of increasing imagination and complexity. Some came from the men who followed in Van Dyck's footsteps and did portraits of these female painting phenomena. But newest of all was the development in the Netherlands of a genre of subject pictures of women working as artists. Some are straightforward, while others have a sub-text which is not about women artists at all. Pieter van der Werff's image of a girl comparing a drawing of Venus with the original cast is a lubricious fantasy uniting a young girl, a young man and an allusion to sexuality. By contrast, Metsu's painting of a young lady drawing is a model of decorum. Fashionably dressed in gleaming gown and fur-trimmed jacket, she is perhaps one of the amateurs the Netherlands produced at this time. But portrait or imagined\ incident, the value of these images lies in the addition of a woman drawing to the range of credible female activities.

Women were still regarded at best as different from men and at worst as inferior to them. A hint of the problems that these attitudes caused women artists can be picked up from Artemisia Gentileschi's letters to her patrons. 'You think me pitiful, because a woman's name raises doubts until her work is seen.' 'I will show Your Most Illustrious Lordship what a woman can do.' 'You will find the spirit of Caesar in this soul of a woman.'[1]

TRAINING AS AN ARTIST

There were several developments in the field of art education. Apprenticeship remained important, but as the century went on, academic teaching was developing the curriculum that would take hold all over Europe. Its components included copying classical casts, studying anatomy and drawing from nude models, all intended as training for the highest class of art. At the same time, a number of less formal academies opened which offered painters the chance to draw from life, often by candlelight after the day's work was over. In the early eighteenth century, the English silver-engraver William Hogarth, through dogged ambition and attendance at an evening life-drawing academy, managed to shed his first career and achieve his goal of becoming a painter. Even though they could not attend the academies, the new flexibility of entry into the profession was psychologically helpful to women who had rarely been able to take the conventional routes. Rosalba Carriera's unorthodox progress from designing lace patterns to painting snuffboxes to becoming a leading pastel portraitist makes her Hogarth's female counterpart.

Judith Leyster, *Lute Player*, after Frans Hals, 1625. The artist may have copied this work by Hals as part of her training, or perhaps it was a commissioned copy.

Despite these changes, the family workshop remained the most common training ground. Young women were trained if they showed any talent at all, for extra hands were always useful. Fathers taught daughters, brothers taught sisters and uncles taught nieces, and the growing number of women artists meant that mothers taught their daughters in a budding version of female artistic dynasties. Like Lavinia Fontana before her, Artemisia Gentileschi taught at least one of her daughters to paint, informing a patron that she is sending a youthful work by her daughter: 'As she is a young woman, please don't make fun of her.'[2] Like Sofonisba Anguissola before her, Elisabetta Sirani taught her sisters Anna Maria and Barbara.

Apart from daughters learning from their parents, apprenticeship was still not a method used by aspiring women artists. An exception is Judith Leyster. On the evidence that she joined the Haarlem Guild in 1633 – the first woman to do so – it is possible that she served something akin to a male apprenticeship, since the Guild demanded that its members should have studied for three years and been apprenticed for at least one. Leyster has been associated with two Haarlem artists, Frans Hals and Frans Pietersz. de Grebber and perhaps she was trained by one or both of them. In 1625, aged sixteen, she copied Hals's *Lute Player*. In 1628, a poem about de Grebber referred to the artist's daughter Maria ('The father and the son and also the daughter I have to praise. Who ever saw a painting made by the hand of a daughter?') as well as to another young woman who may have been the nineteen-year-old Leyster ('Here is somebody else painting with good and bold sense').[3] It is possible that in their search for an artist to train their daughter, the Leysters looked with favour on de Grebber, as his artist-daughter, seven years older than theirs, would have been a suitable companion.

In Italy the convent retained its role as a forcing ground for talented women by providing them with opportunities for painting altarpieces, fresco and assorted devotional works. The women whose reputations have survived, thanks to the guide books and historians of their day, were wealthy, educated or from artists' families, and learned their skills before entering the convent. Suor Maria Eufrasia delle Croce came from an aristocratic background and was the sister of an art collector. Suor Maria de Dominici was trained by Mattia Preti and studied sculpture in Rome. Lucrina Fetti had both artistic and aristocratic roots: she was the sister of the artist Domenico Fetti whose link with the Mantuan court obtained her a convent dowry from the Duke of Mantua. Presumably they chose and trained their assistants from among the pupils and convent inmates, not all of whom were devoted exclusively to religious duties.

A great disadvantage to women was their exclusion from academic education of any kind – one could certainly not imagine them in a candlelit life-drawing academy. Since the second half of the sixteenth

century, male artists had gathered to discuss theory, to draw from casts of admired sculptures and from the nude model, and to learn anatomy and perspective. Barred from attending academies, women not only missed out on all this, but also escaped the constructive criticism so necessary to improvement. To make up for the gaps in their education, women who had their eyes on figure painting may have consulted the anatomy books that became available in the seventeenth century, although, without access to a library or money for costly books, they would have needed a wealthy or intellectual intermediary to accomplish this.

Giulia Lama appears to be the first woman to have gone anywhere near the academic training offered by such institutions. Talented and educated (she learned mathematics as a girl), she was the daughter of an artist in the small Venetian artistic community and a friend of the artist Piazzetta. It is thought that she may have attended the Scuola di Antonio Molinari in Venice, alongside Piazzetta, which makes her a candidate for the title of first woman to attend an art academy. The large-scale religious works she went on to produce imply a grounding in the perspective and life drawing which was taught in such schools.

Many women learned to paint through the fatherly attentions of a male artist in their circle. The English artist Mary Beale was associated with three male artists, although there is no evidence that she had anything approaching a conventional pupil-teacher relationship with any of them. Her father John Cradock, an amateur painter, knew Robert Walker, chief painter to the Parliamentarians during the Interregnum. Walker painted Mary Beale and her husband in the 1650s, and an assumption has been made on stylistic grounds that he gave her some instruction. The gentleman poet and miniaturist Thomas Flatman was a close friend of the Beales from the 1660s, and taught their son Charles to paint miniatures. In his letters to Charles, he refers to Mary Beale as his Valentine and scholar, so it is possible that he also gave her some instruction. Her final mentor was Sir Peter Lely, painter to the king. Lely was famously secretive about his methods, and in the 1670s the Beales commissioned two portraits from him in order to watch him at work, Charles Beale commenting that they were surprised by his way of working which had much changed. It shows the lengths Mary Beale had to take to keep abreast of artistic developments. In 1672, Lely admired her copy of Van Dyck's *Endymion Porter and Family*. In 1677, he told Charles Beale that she was much improved, and that he was impressed by her use of casts of her own hands and arms. He lent her a portrait to copy 'in little', a favour that occurred in one of her most successful years: she had 83 commissions in 1677.[4]

While education for most women meant the reading, writing and sewing and basic arithmetic designed to equip them for marriage and motherhood, well born women had the chance to discover a talent for

Giulia Lama, *Crucifixion, c.* 1730. This artist's ability and ambition is revealed in the altarpiece for the church of S. Vitale in her home town of Venice. Her competent depiction of foreshortened figures has given rise to suggestions that she may have attended an academy in Venice.

STILL LIFE

Still life became a genre in its own right in the seventeenth century, and several women, particularly from the Netherlands, practised it with great success. For the woman artist, still life was akin to portraiture in that rigorous training in figure drawing and knowledge of anatomy, both taboo for women artists, were not required. Precision, mastery of perspective and three-dimensional illusion, plus the ability to balance tone, light and colour, were necessary skills.

(opposite) Rachel Ruysch, *Still Life*, early 18th century. The well born Rachel Ruysch was trained by the flower painter Willem van Aelst and made a highly successful international career as a flower painter.

(top left) Maria van Oosterwijck, *Still Life*, 1668. This artist was able to command high prices for her works which were collected by the rich and royal.

(above) Giovanna Garzoni, *Still Life*, c. 1650–62. A painter of portraits and religious works, Garzoni was exposed to the realism of the northern schools while in the service of the Duchess of Savoy, and later to scientific illustrations of the natural world.

(left) Clara Peeters, *Still Life with Flowers and Goblets*, 1612. Little is known about this artist who concentrated on still life throughout a very successful career. Her speciality was her technique in painting lustres, surfaces and textures. The artist painted her tiny self-portrait reflected in the oval convex surfaces of the vessel on the right.

art through drawing lessons. Several of the upper-class amateurs showed how seriously they took their talent by asking to be judged by a wider audience than family and friends. In England Anne Killigrew, daughter of a courtier at the court of Charles II, left a portrait of Prince James. In the Netherlands, the multi-talented young intellectual Anna Maria Schurman has left at least one self-portrait and was painted by other artists. On any scale of brilliance, these amateurs would not figure; their relevance is as examples of the growing visibility of women artists.

Although their talents were public, these women remained amateurs because they took no money. But a few crossed the line into professionalism. Mary Beale painted portraits of her circle in the 1650s

Luisa Roldán, *St Michael and the Devil*, 1692. Luisa Roldán was the most famous female sculptor of the seventeenth century. As the daughter of a sculptor, her talent was early recognized and encouraged, and marriage to a sculptor ensured the continuation of a supportive environment for her work. Professional security came from her employment by the Spanish royal family.

and 1660s, and then in 1670, a little before her fortieth birthday, set herself up professionally with a painting room in her London house, responsible for the major portion of her family's income. The Dutch artist Rachel Ruysch was another of these women from moneyed, aristocratic or educated backgrounds who took painting lessons as part of a charm and accomplishment offensive, and then used them as a ladder into the professional world. Her artistic and intellectual parents, who, like Anne Killigrew's, moved in court circles, sent her to the leading flower painter, Willem van Aelst. Having absorbed his teaching, she went on to become one of the most important flower painters of the age. Willem van Aelst, said to have proposed marriage to the flower painter Maria van Oosterwijck, is an example of that recurring phenomenon, the male painter who takes female students through sympathy to their ambitions or desire to boost his income.

Male artists expanded their training by going from one master to another and from patron to patron, each new teacher and location offering the chance to see new styles and works of art. Though the constrictions of women's lives, even professionals like these, ensured that they could not travel without chaperones, women began to share in this manner of developing range and style when they accepted patrons' invitations to carry out commissions or travelled to take up court positions. When the Italian Giovanna Garzoni worked in Turin in the 1630s for the Duchess of Savoy, her eyes were opened by the court's collection of Netherlandish, Northern Italian and English portraiture, and the influences fed into her art.

CHOICE OF GENRES

When it came to choosing an area in which to work, some things remained the same as the previous century. Portraiture was still the favoured subject, for all the reasons already met with.

Religious imagery carried on in Catholic countries, practised in its most conventional form by the convent painters and in a more daring form by those women who wanted to make a reputation in the art world. Sculpture attracted as few women as ever. The female sculpture star of the century is the Spanish artist Luisa Roldán, a member of a sculpting dynasty who went from sculptor-father to sculptor-husband, and produced large works in wood and smaller works in terracotta. Women artists were still not employed on major decorative commissions like fresco or decorations for the integrated interiors of the period. The painted ceilings and wall panels designed to fit the internal architecture of grand homes involved assistants and scaffolding, and were either not attractive to women artists or, more likely, not offered. The claim that Orazio Gentileschi, ill and in charge of the decorations at Greenwich Palace, was helped by his daughter, Artemisia, on this project for Henrietta Maria, the French wife of the English king Charles I, has recently been disputed.[5]

Changes in the wider world of art led to the range of subject matter increasing for women in this period. In the seventeenth century, motifs that had previously played a minor role in paintings, such as a vase of flowers in a portrait, a bowl of fruit in a banquet scene, a vignette of activity in the corner of a scene from the Bible, a landscape vista in the background, break out of their parent paintings to become subjects in their own right. The widening range of work from the hands of women artists shows them using this development to spread their artistic wings. It is a measure of their increasing confidence and ambition that several try their hand at two or three genres in the course of their careers. For example, Elisabeth-Sophie Chéron, taught first by her miniaturist father then by Charles Le Brun, the leading history painter of the seventeenth century, produced portraits, histories and religious subjects.

The new genre of flower painting attracted several female artists. It appealed to women for the same reasons as portraiture in that anatomical knowledge was irrelevant, the subject matter easily available and the works themselves a manageable size. Furthermore, the association of women and flowers was as acceptable to the public as women and the Virgin Mary. Women all over Europe painted flowers, though it is usually presented as a northern phenomenon. Several women from the low countries were among the stars of the genre, including Maria van Oosterwijck, Rachel Ruysch and the botanical illustrator Maria Sybilla Merian. The majority of the handful of women admitted into French Royal Academy in its first hundred years were flower painters. Their success proves that, when they were properly trained in a genre, they were capable of painting as well as the men.

Still life gathered fewer followers, perhaps because an understanding of perspective was necessary, a skill that women could not come by without access to a good teacher. Nevertheless, several female artists took to it. Fede Galizia, one of the earliest practitioners of still life in Italy, was an influence on Giovanna Garzoni whose best known surviving works are twenty still lifes of fruit and vegetables for Ferdinand II de' Medici. The arrangements of fruit, flowers and elaborate vessels by the Flemish artist Clara Peeters were collected by the rich and royal of Europe.

Since the Dutch had developed the new genre of domestic interiors, it was not surprising that a painter from the Netherlands was the first woman to produce work in this style. Research into Judith Leyster's work has shown how the artist introduced a female point of view into her quiet genre paintings.

The number of women artists attempting history paintings increased in the seventeenth century, the heroic age of history painting. Since daughters tended to continue with their father's speciality, the luckiest were those whose ambition coincided with their training. It is

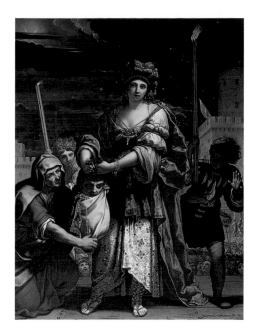

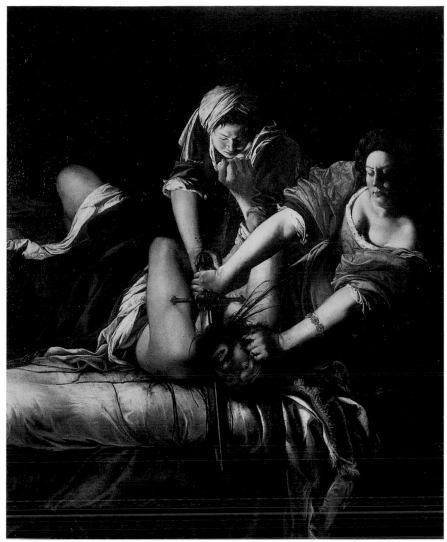

(above) Elisabetta Sirani, *Judith and Holofernes*, mid-17th century. (right) Artemisia Gentileschi, *Judith Slaying Holofernes*, c. 1620. The subject of Judith retained its fascination for female artists, although their treatment varies dramatically. Elisabetta Sirani's ensemble has an operatic air about it and Judith looks as if she could break into an aria. Artemisia Gentileschi has painted a bloodier business.

no coincidence that the history painters Artemisia Gentileschi and Elisabetta Sirani were the daughters of history painters, their training encouraging them to see this genre as within their reach. Orazio Gentileschi's production of large-scale subject paintings gave his daughter tuition in this most respected branch of art, and one which she went on to exploit to the full.

Most women searched for heroines, and some of their choices were very bold. Artemisia Gentileschi produced large paintings starring heroines from the Bible or the classics. And when the young Elisabetta Sirani produced her paintings of Madonnas and the repentant Magdalene it is not hard to imagine the allure these subjects added to their young and beautiful creator. The Biblical story of Judith who cut off the head of Holofernes retained its appeal for women subject painters. Elisabetta Sirani and Giulia Lama each did at least one version, and Artemisia Gentileschi at least three.

As women produced more ambitious works, they had to hire models, women for sure, and perhaps men. Artemisia Gentileschi is the

first female voice to be heard on the subject. In 1649 she was working on a large painting with eight figures, two dogs, a landscape and a seascape, at a time when she was marrying off her second daughter and was, she said, bankrupt. She asked the patron for money:

> The expenses for hiring nude women (models) are high. Believe me, Signor don Antonio, the expenses are intolerable, because out of the fifty women who undress themselves, there is scarcely one good one. And in this painting I cannot use just one model because there are eight figures and one must paint various kinds of beauty. When I find good ones, they fleece me, and at other times, one must suffer their pettiness with the patience of Job.[6]

Male nudity, was still not attempted by most women, who had no desire to display their lack of life-drawing experience and were aware of the prurient interest such subject matter would arouse. When the naked male model was sculpted or painted, it was usually in the guise of Christ. Giulia Lama executed some stunning religious commissions

which displayed her ability to paint the male nude. A number of her drawings of male and female nudes exist, possibly studies for her paintings. Perhaps she copied them from someone else, but the air of immediacy that rises from their confident lines suggests that she was drawing from life. They appear to be the earliest surviving drawings of male nudes by a woman artist.

One glaring absence among the genres taken up by women was in landscape. Although it was taken to glorious heights in this period by Claude, Poussin, Rubens and Ruysdael, not one woman practised it. It seems to have been an area as unapproachable as male nudity. One can think of several reasons why this was so: the impossibility of a woman drawing alone in nature; the difficulty of learning the necessary science of perspective, which had to be mastered not just in linear but also in colour terms; the large scale of the best works; and the lack of exposure to contemporary developments. Several women, however, worked landscape backgrounds into their paintings. In a letter to a patron, Artemisia Gentileschi refers to establishing the vanishing point of perspective in a landscape and in the process having to redo two figures: 'The *Andromeda* contains a most beautiful landscape and a most splendid seascape.'[7]

TO MARRY OR NOT TO MARRY?

When they set themselves up in business, women often chose a man of the family to ensure the smooth running of the studio. Artemisia Gentileschi beseeched Cassiano dal Pozzo in Rome to return her brother to her within four days, 'since I need him badly because he manages all my business'.[8] Mary Beale's husband managed her career. He kept the accounts, organized the flow of clients, bought the materials and helped her by experimenting with the drying times of various mixtures of oil and pigment – the research and development arm of the family business – leaving her free to get on with the painting that was the basis of the family income.

Marriage and children were not necessarily a hindrance to a career, and husbands were not automatically repressive. The fact that Rachel Ruysch produced her much prized flower paintings throughout her marriage to the portrait painter Juriaen Pool and the resulting ten children suggests that her husband put no obstacles in her way – tantamount to support and encouragement in a period when it was deeply unconventional for well born women to work.

As always with women, however, there is no norm. The case of Judith Leyster, shows that marriage to an artist was not an automatic guarantee of freedom to work. Most of her known work was done between 1629 and 1635, when she was in her twenties, single and running her own workshop. Only one dated work exists after her marriage to an artist, a watercolour tulip done around the time of her daughter's birth, when, her biographer suggests, maternal began to triumph over painterly demands. Of course she may have continued working after marriage, contributing works to the family studio under her husband's name.

The importance of a husband in helping or hindering a wife's career throws light on the striking number of artists who remained unmarried, Giovanna Garzoni, Elisabetta Sirani, Rosalba Carriera, Giulia Lama and Maria van Oosterwijck among them. Artemisia Gentileschi operated as a single woman after separating from her husband when she was in her early thirties. Could professional success have given them a taste for independence they had no wish to lose? Or was it merely that no one asked them?

Women could fight for themselves if they had to. Though the conventions of the day made such behaviour rare, the occasional self-confident fight for rights is a reminder of the strength and single-mindedness required to succeed in their profession. It must have taken a great deal of righteous anger or self-confidence for the young Judith Leyster to complain to the Haarlem guild that Frans Hals, older than she was, well established and a far more important painter, had taken over one of her apprentices. Artemisia Gentileschi broadcast her ability to dazzle clients with her variations on a subject, writing that clients 'come to a woman with this kind of talent'.[9]

(**opposite**) Giulia Lama, *Male Nude*, and *Standing Male Nude*, *c.* 1730. These drawings question the claim that women never had access to the nude male model. Are they copies of a male artist's work? Or preparatory drawings for commissioned works?

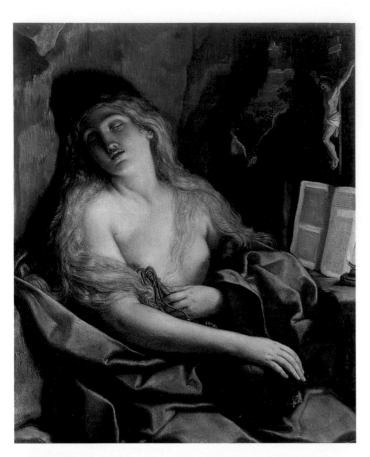

THE NUDE IN WOMEN'S ART

It was still rare for women painters to portray the nude figure, but there were a few, usually the daughters of painters, who must have been trained in life drawing and anatomy.

(**above left**) Elisabetta Sirani, *The Penitent Mary Magdalene*, 1663. In her short life, this artist painted more than two hundred works, most of them of female subjects.

(**below**) Giulia Lama, *Judith and Holofernes*, c. 1730. An unusual treatment of the subject in that the artist has concentrated on the handsome body of Holofernes. The painting was no doubt based on life drawings of the type seen on page 64, and in its anatomical realism and skill in foreshortening offers a clear challenge to those who thought such subjects impossible and unsuitable for women.

(**opposite**) Artemisia Gentileschi, *The Penitent Magdalene in a Landscape*, c. 1617–20. Less erotic than Elisabetta Sirani's image of the subject, this is a monumental Magdalene.

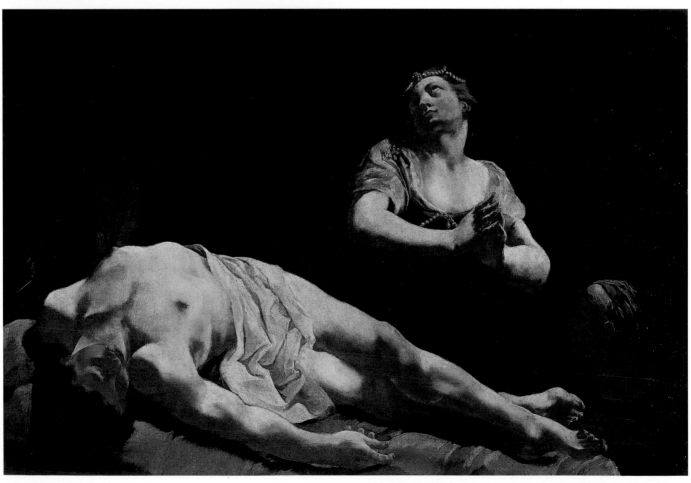

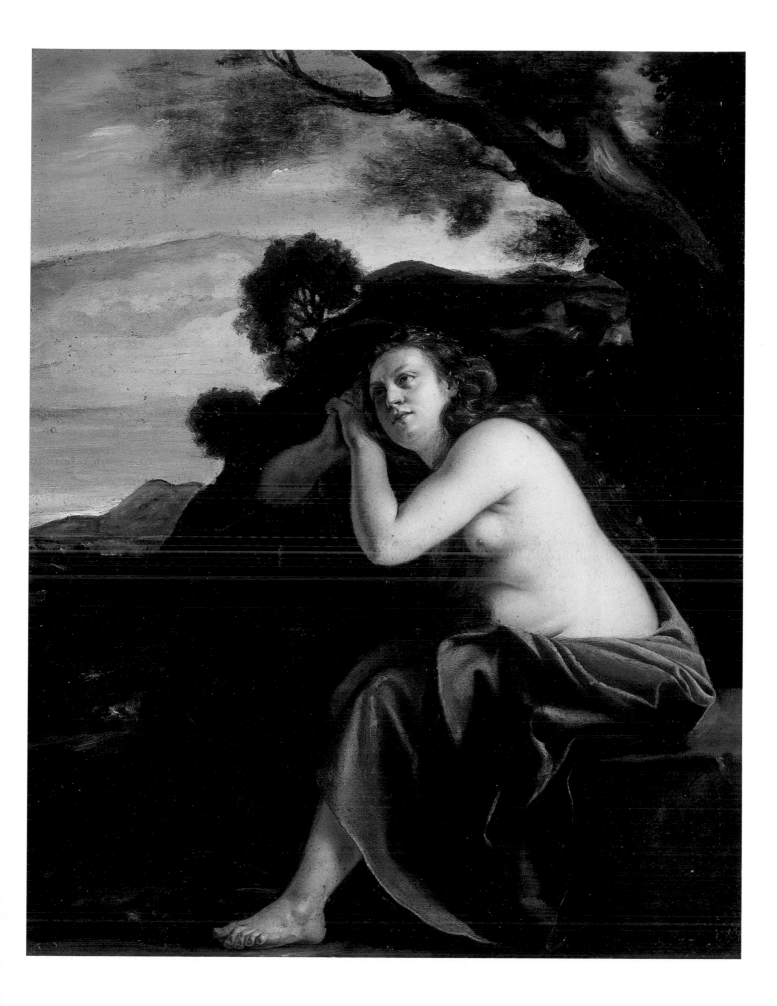

Artemisia Gentileschi's sense of herself was so strong that she had no compunction in flouting a patron's wishes:

> As for my doing a drawing and sending it, I have made a solemn vow never to send my drawings because people have cheated me. In particular, just today I found myself [in the situation] that having done a drawing of souls in purgatory for the Bishop of St Gata, he, in order to spend less, commissioned another painter to do the painting using my work. If I were a man, I can't imagine it would have turned out this way, because when the concept [*inventione*] has been realized and defined with lights and darks, and established by means of planes, the rest is a trifle.'[10]

Gertrude Pietersz, *Flowers, c.* 1718. As the idea of a professional woman artist became more familiar, women artists took female assistants. Maria van Oosterwijck unusually trained her maid Geertje Pietersz in flower painting, the glory of Dutch and Flemish art at this period, and a genre in which several women specialized.

Her words show a woman aware of the prejudice she faced but her attitude reveals a woman with the confidence to fight for herself. Of course, fighting did not have to involve confrontation. Most women used intermediaries, female frailty and charm to achieve their aims. After separating from her husband, even the strong Artemisia Gentileschi adopted the conventional tone and formula of a defenceless woman, pleasing to Cassiano del Pozzo, 'I have no other protector but Your Lordship, to whom I have always entrusted my interests, I turn to you and ask that you make every effort to help me in this matter.'[11]

Assistants were necessary to an artist in the days before paint came packed in tubes, and finding them was always more of a problem for women who had a much smaller pool to draw on than men. Most young men would not have wanted to work for a woman and few young women would have been allowed to. The easiest source of supply was through the workshop pattern of training family members to prepare their materials for them. Mary Beale's sons helped paint the clothes of her sitters, leaving her free to do as many faces as she could, the most important part of a portrait. Rosalba Carriera instructed her sister to assist her, acknowledging her importance to her career in a self-portrait. Elisabeth-Sophie Chéron taught her

Sarah Hoadley, *Portrait of the Rev. Benjamin Hoadley*, c. 1726–34. Sarah Hoadley was taught by the London-based portrait painter Mary Beale.

nieces Jeanne and Ursule de la Croix to engrave her work. The signature of Luisa Roldán's brother-in-law Tomás de los Arcos, on the left foot of her sculpture of St Michael, reveals him as the polychromer. More unusually, Maria van Oosterwijck taught her maid Geertje Pieters to assist her. I have no doubt at all that the problem of getting and keeping assistants was as important as their limited training in explaining the number of women who painted the miniatures and small copies that did not involve them in that most unfeminine practice, making demands on other people.

Family was not the only source. Women artists began to follow the men, firstly by taking students from outside the family and secondly by taking apprentices. It is not always easy to distinguish between the two. Elisabetta Sirani welcomed women of all ages into her studio, amateurs as well as aspiring artists like Ginevra Cantofoli who went on to make a reputation of her own. It is unlikely that the two hundred works Sirani produced in her twenty-six years were all from her own hand. Her students would have learned by making copies of her work, and the most talented would have produced work that could leave the studio as a Sirani workshop product.

For the most part, the artists took pupils of their own sex. However, there are exceptions, such as Judith Leyster, all of whose known students are male. The evidence for this comes from the Haarlem Guild hearing at which she complained that one Willem Woutersz left her after only a few days to study with Frans Hals. During the hearing, at which Leyster asked for eight gilders from Woutersz's mother (the Guild decided that she receive four, Hals was to be fined three and Willem could choose any master save Hals), Davidt de Burry and Henrick Jacobsz were named as her students.

Mary Beale took both male and female assistants. As they grew older, Mary Beale replaced the sons she had trained to assist her with several apprentices and students who helped her in the studio. In 1681 she had two pupils in her studio, one of them a Mr More, the other Keaty Trioche, who may be the subject of an unfinished profile portrait of a young woman. A decade later, Mary Beale had Sarah Hoadley in her workshop, another example of a female assistant who went on to set up her own painting practice.

Rosalba Carriera's diary for the year she spent in Paris in 1720 to 1721, sheds light on the ambiance of the studio of a fashionable portrait painter. One of the earliest practitioners in the new medium of pastel, her portraits brought her fame all over Europe. Her requirements as a worker in pastel were simpler than those for an oil painter and, although she gives no details, she presumably worked in some kind of painting room in her Parisian host's house. Her account is factual and economical, yet still a picture of a busy professional life manages to emerge. Through her spare sentences, one gets a sense of the French upper classes moving around en masse, like flocks of birds.

Mary Beale, *Portrait of a Young Girl, c.* 1679–81. In 1681, the artist was teaching two young people, Mr More and Keaty Trioche. Charles Beale wrote in his studio book that, when work was slack, his wife would paint herself and her assistants 'upon account of Study & Improvement'. It is likely that this painting is of Keaty Trioche.

'I saw the first president who came with his brother and some friends to keep his daughter company while I did her portrait.'[12]

Since cleanliness and proper dress were so important to a lady, professional painter or not, and since these women had to deal with clients, and since as occupiers of a professional space that was normally the preserve of men they were objects of interest, one cannot help wondering what they wore for work. One imagines that special clothes were kept for painting, but just about the only evidence for this is Charles Beale's reference in one of his studio diaries for the payment for a pair of sleeves for his Dear Heart, as he called his wife. Sleeves were a way of varying daily dress – perhaps these were painting sleeves. Images of women artists at work supply no clue, as they dress in their best for their appearance in paint. There is not an apron in sight in the artists' self-portraits or in the portraits made of them by others.

Women continued working in convents and as court artists. Placements at court were as much to their benefit in terms of status as ever, a wonderful solution to the problem of reconciling work and gentility. For a woman, working in the service of a noble, sure of one's patrons and of one's keep, was a risk-free way of operating. Rachel Ruysch spent several years at the court of the Elector Palatine, invited

there with her portrait-painter husband, Juriaen Pool, a seventeenth-century version of the van Hemessen/Morien double act of the mid-sixteenth century. Giovanna Garzoni structured her professional life around a series of appointments. She worked in the service of the Spanish Viceroy in Naples, the Duke of Alcala in 1630; in the service of Cristina of France, Duchess of Savoy in Turin from 1632 to 1637; and for the Grand Duke Ferdinand II de' Medici and his wife. The post wrapped an unmarried woman like Garzoni in a cloak of propriety and glamour borrowed from her royal employers.

Not all court appointments were as golden as these. In 1692, when she was forty, Luisa Roldán was appointed sculptor to the Spanish king Charles II at a time when the country was economically weak, and her letters reveal her begging for money. In 1697 she wrote to the queen: 'For more than six years she has had the good fortune to be at your royal feet executing different figures for the pleasure and devout purposes of Your Majesty, and considering that she is poor and in great need she beseeches Your Majesty to be kind enough to give her

(below) Rosalba Carriera: *Portrait of Jean-Antoine Watteau*, 1721; *Prince Friedrich Christian of Saxony*, 1739; *Spring*, c. 1727. The artist was one of the most famous practitioners working in the new pastels. Her informal portrait of Watteau, a fellow artist, required a different approach from that used for the young son of the Elector of Saxony, for whom she did over a hundred and fifty pastels, and who honoured the artist with a gallery devoted to her works.

clothing or a gratuity or whatever Your Majesty likes.' Later that year, she writes that 'because she is poor and has two children she is suffering great want, for on many days she lacks enough to buy what is necessary for daily sustenance and for this reason she is obliged to implore Your Majesty to be kind enough to give her an allotment of goods in order that her want may be a little relieved.'[13]

It was not enough to have a workshop and call oneself an artist. One had to stay in business. For those outside court or convent environment where finding a market was not a problem, the search for customers was of the utmost importance. The best way to do this was to offer a recognizable, reliable and desirable product. It was the same problem for an artist like Mary Beale who stuck to a limited circle of patrons as it was for an artist like Artemisia Gentileschi who ambitiously competed against the greatest artists of the day for the attention of the greatest patrons. Whether circles were grand or modest, they represented security for the artist who would be passed around them on recommendation. Mary Beale painted the portraits of the clergymen and intellectuals of her own circle, plain men, women and children who appreciated the sober but respectful way in which she presented them.

These women were running businesses, and, as in all businesses, cash flow was a potential problem. Artemisia Gentileschi's letters give a note of the desperation involved in bridging the gap between the expenses involved in working and the ultimate payment. She refers several times to her financial situation, begging patrons for quick payment due to the costs involved in marrying off her daughter: 'I need work very badly and I assure your most illustrious lordship that I am bankrupt.'[14] As always with artists, earnings could be erratic. Even Mary Beale, who offered a reliable product to a particular segment of society, found her income fluctuating from year to year as her husband's account books show. In her most successful year she made over £400. She had to work hard for it, fulfilling a huge society wedding commission of more than thirty paintings, some of which were copies to be given to the couple's relatives. The whole family was involved: Charles Beale recorded the payments to the Beales's two sons for doing the underpainting of the fabrics in three of them. Charles Beale kept meticulous accounts of the studio income and outgoings, noting payment for frames, pigments, a roll of sacking for use as inexpensive canvas. He even recorded when times were bad and they had to resort to borrowing money from a cousin:

Mary Beale, *Catherine Thynne, Lady Lowther*, 1676–77. One of over thirty paintings commissioned to commemorate the marriage of Catherine Thynne and Sir John Lowther, it helped make this the artist's most financially successful year with earnings of £416.

Our Gracious Good God was pleased to afford us this most seasonable supply, when we were in such great and pressing need, we had but only 2s.6d. left us in the house against Easter for wch signall mercy his most holy Name be praised who thus graciously rememebred us his poore creatures in our low condicion.[15]

However well organized the studio, work rarely came in an obligingly even stream. Mary Beale's husband recorded in one of his small black books that when commissions fell off she would fill in the slack periods by painting herself, her assistants, her children and anyone else who was around for 'study and improvement'. During her Paris year, Rosalba Carriera was rushed off her feet. The brevity of her diary entries cannot hide the stresses of being a fashionable portrait painter. There were pressures to fulfil commissions quickly and to try and please the patrons. 31 December 1720: 'I turned down, for fear of not having the time to do them, the portrait of a beautiful woman and of two others, husband and wife. It was settled with Mme de Parabère that I would do her portrait on the 2nd and with Mme Lauriller that I would begin hers on the 4th.' 22 February 1721: 'The duchess come at the normal time with a huge entourage. She was very impatient to have her daughter's portrait.' She was so much in demand that she had to turn sitters away. 28 February 1721: 'The duchess came with her daughter Mlle de Clermont and many other lords and ladies. The whole company crucified me to do a portrait of the Prince of Conti's sister and that of a very beautiful lady, for which I was paid an excessive price in advance.'[16]

Advertising one's talent was always necessary and artists continued to send gifts of their work to those with power and influence. Artemisia Gentileschi sent a present of a painting to Duke Francesco d'Este in Rome 'because I have served all the major rulers of Europe who appreciate my work' and because 'it provides the evidence of my fame.'[17] After the death of Charles II of Spain, Luisa Roldán presented his successor Philip V with two terracottas, 'Two jewels of sculpture by her own hand', in an attempt to induce him to offer her a court position.[18]

REPUTATIONS AND RECOGNITION

Women always had to take care that their behaviour was as good as their work. As intruders in a male world, women were at the mercy of slander and gossip. The privacy that surrounded the world of the artist, with its nude models and women closeted for hours on end with the men whose portraits they were painting, encouraged speculation. A contemporary reported of Giulia Lama: 'The poor girl is persecuted by the painters, but her virtue triumphs over her enemies.'[19] The word virtue suggests the content of the persecutions. It also suggests she took pains to prove the 'persecutions' untrue.

Elisabeth-Sophie Chéron, *Self-portrait*, 1672. The artist presented two paintings on her introduction to the French Royal Academy in 1672, and this self-portrait was one of them. She was only the fourth woman to be received into the Academy. Although here she holds a drawing, in other self-portraits she alludes to her skills in music and poetry.

A criticism that women had to deal with for the first time was of not being the author of their own work. Elisabetta Sirani painted in public in order to prove that she, and not her artist father, was the author of her paintings. Her death at the age of twenty-six was always said to be due to poison, though recent thought points to stomach ulcers as the culprit, no doubt irritated by the stress of non-stop work and the responsibilities of being her family's sole support.

So much has been written about the limitations of being a woman artist that it is necessary to suggest that their gender may at times have worked to their advantage. Elisabetta Sirani's beauty as well as her talent made her a star, and the rich and royal came to Bologna to watch her work. But even an artist like Rosalba Carriera, who was forty-five at the time of her Paris success, benefited from being a woman, her sex adding an attraction to her novelty as a practitioner of the fashionable new genre of working in pastel: she was a double curiosity. The writings of this pious lady betray no signs of vanity, and I do not think for a minute that she deliberately exploited her femininity. The diary reveals a hard-working woman who was level-headed about her success, and a family-minded woman who went out and about in Paris to the opera and social gatherings in the subdued and proper company of her mother and her sister. The fact that she was a woman as well as an artist added to her appeal, but took no effort on her part.

Promoting one's work could be a difficult area for women, as it contended with expectations of femininity that forbade anything approaching boastfulness. It was always simpler to find someone else to blow their trumpet for them. Women were happy to collude in their celebration as prodigies. Elisabetta Sirani was promoted by her father, as Sofonisba Anguissola had been before her.

One way that they could show themselves as prodigies was through their self-portraits – as a legitimate response to satisfy the curiosity that their situation aroused, these offered a way to show their pride in themselves. Elisabeth-Sophie Chéron made sure her self-portraits illustrated the full range of her talents, showing herself as a poet and a musician as well as a painter, an evolution of the previous century's admiration for the cultivated gentlewoman.

A brand new air of self-confidence rises off self-portraits which manage to suggest the self-respect earned from being women artists in a male art world. Mary Beale pictured herself with the sons she trained to prepare her canvases in a manner which clearly shows herself as the one in charge. Artemisia Gentileschi presented herself as the female personification of painting, La Pittura, hardly the imaginative leap of a modest person. It has been said repeatedly, but it is worth repeating, that her uniting of two strands of female artist imagery, the allegorical personification of painting as a woman and the self-portrait of the artist at work, was most original.

Several women artists earned enough to support their families, either full time, like Mary Beale after her husband lost his post at the patent office, or for a period, like the sixteen-year-old Elisabeth-Sophie Chéron after her father fled from Paris in 1664 for religious reasons. Maria van Oosterwijck made a string of sales to royalty, who were impressed by her still life and flower pieces. Gifts continued as part of payment. After Maria van Oosterwijck sold a still life to Emperor Leopold of Austria, she was further recompensed with portraits of the Emperor and his wife in diamond-encrusted frames.

Academies replaced the guilds as indicators of their members' professionalism. Run by men for men, they occasionally invited women to be members. Although women were forbidden to vote or attend policy meetings, making their election more of an honour conferred than evidence that women were gaining a forum for their views and experiences, this still cannot tarnish the importance of such recognition. Once Catherine Duchemin was accepted into the French Royal Academy in 1663, membership existed as a goal for other women artists, becoming part of the structure that acknowledged their professional success. Whatever the reality of a group of men allowing a handful of women over a century into their ranks, to the accompaniment of debates as to whether their numbers should be limited, for those invited it was a boost to their reputation and an elevation to their status. They may have been patronized, which was annoying and insulting, they may have been flattered, which was often a recipe for encouraging the recipient to rest on her laurels, but no one could deny that these women had achieved a success in art world terms.

Artemisia Gentileschi, *Self-portrait as La Pittura, c.* 1630–40. The decision to paint herself as the personification of painting, with her hair disarrayed by the frenzy of creation, is not the product of conventional feminine modesty.

Several women artists made strong reputations in the period. Elisabetta Sirani achieved legendary status after her death at twenty-six. She was helped in this by the publication in 1678 of Conte Carlo Cesare Malvasia's *Lives of the Bolognese Painters* which devoted several pages to her, and in which he called her, in an untranslateable phrase, a heroic female painter, a woman artist of epic stature. Malvasia had encouraged her in life by insisting her father develop his daughter's talent, and he continued to do so after her death. The Elector of Saxony owned more than one hundred and fifty pastels by Rosalba Carriera, and gave over a gallery at his court in Dresden to their display. Rosalba Carierra's wide European success inspired many

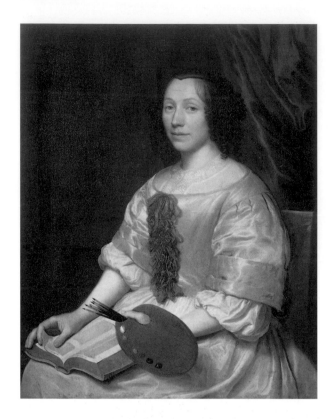

Wallerant Vaillant, *Portrait of Maria van Oosterwijck*, before 1677. Portraits of women artists increased with their numbers and reputation. In this image of a celebrated artist patronized by royalty, her piety, shown by her demure pose and the open Bible on her lap, is accorded equal status with her talent, signified by the brushes and palette.

women, amateurs as well as professionals, to try their hand at pastels, and sentenced several generations of women to the title of the English/Danish/German Rosalba if they produced anything half-way tolerable. Though works by women were never used as examples of good painting practice in the theoretical treatises of the day, their names were recorded in the biographical surveys which followed in Vasari's footsteps.

Recognition in their own day came from a number of sources. They were fêted as court artists and collected by the rich and powerful. In 1630 Artemisia Gentileschi moved to Naples, where one of her patrons, the Duke of Alcala, was Viceroy. Her stay probably coincided with the visit there of Giovanna Garzoni in 1630, who was also working for the Viceroy, an intriguing coincidence which suggests that there may have been patrons who collected works by women artists. The collections of the rich and royal were only open to a limited circle, but public art exhibitions as we know them, in galleries open to the public for the purpose of viewing and assessing, slowly started up in this period. An important advantage of academy membership was the opportunities it brought for exhibition. The female members of the French Royal Academy of Art, including Elisabeth-Sophie Chéron and Rosalba Carriera, had a public platform in the exhibitions that it held from 1699.

The last chapter ended with Van Dyck's visit to the old and ailing Sofonisba Anguissola and the portraits he made after this visit. In the seventeenth century, paintings of women artists by their male counterparts become more common. Piety, to prove the virtue of a woman operating in a male world, or glamour, to show her femininity, are common patterns used by male artists to picture their female counterparts before the twentieth century. Maria van Oosterwijck was painted by Wallerant Vaillant in 1671, an artist who made a speciality of genre paintings of artists at work. With her palette in one hand and Bible in the other she is the very image of a pious female artist, an accurate interpretation of both her personal character and the religious character of her still life paintings. By contrast, Michiel van Musscher's spectacular baroque fantasy of an enthroned artist, said to be Rachel Ruysch, surrounded by allusions to her profession, including a bust of the goddess Minerva, offers an image of worldly success. A comparison to Minerva, goddess of the arts, was considered a particularly apt compliment to women painters, and was frequently used in the poems that were a common way of celebrating the fame of women artists.

Comparisons between the artist's view of herself and portraits of her by another hand can be fascinating. Giulia Lama's unvarnished

acceptance of herself as plain contrasts with her colleague Piazzetta's sensual image of her. Did he truly see her this way (perhaps there is truth in their rumoured love affair) or was he merely applying the flattering gloss required for a portrait of a woman?

The grand funeral is a recurring theme in Western artistic mythology, and knowledge of this ultimate accolade was always there to spur on the ambitious. One of the features of the funeral orations for male artists was the placing of the dead artist in a line of the famous who had preceded him. Eulogies at women artists' funerals inserted them into a parallel female line. At her funeral in 1712, Elisabeth-Sophie Chéron was situated in the company of Lavinia Fontana, Anna and Minerva Anguissola (thereby supporting the belief of today's historians that Sofonisba Anguissola's absence from art history was due to a misreading of her position as a lady-in-waiting at the Spanish court), Fede Galizia, and the two Boulogne sisters, Geneviève and Madeleine, who had been received into the French Academy in 1669. A history of women artists was developing.

Michiel van Musscher, *Portrait of an Artist in Her Studio*, c. 1692. A flower painter, thought to be Rachel Ruysch, is presented enthroned in triumph in contrast with the sober depiction of Maria van Oosterwijck opposite.

1750–1850
Objects of fascination

*'Women reigned supreme then:
the Revolution dethroned them.'*

ELISABETH VIGÉE-LEBRUN

This quotation from the memoirs of the successful French portrait painter Elisabeth Vigée-Lebrun refers to the glittering days of this young artist who in her early twenties became painter to Queen Marie Antoinette and one of the four female members of the French Royal Academy. But it also tells a general truth about the second half of the eighteenth century with which many artistic women in France, and to a lesser degree all over Europe, would not disagree. The celebration of women who united culture and charm in a gracious exterior worked to women's advantage. Their numbers increased with the century, and in several places and at various times a female artistic culture was in place, with female artists taking female students and benefiting from a female circle of patrons.

By the nineteenth century, there were many women working in the world of art. Some were famous, but the majority, trying to turn their artistic skill into a career as etchers, copyists and teachers, are unknown today.

CAST OF CHARACTERS

Some of the artists whose words and experiences reveal what it was like to work as a woman artist in this period.

MARIE-ANNE COLLOT was born in Paris in 1748 and trained by Jean-Baptiste Lemoyne, and then, aged fifteen, by the sculptor Etienne-Maurice Falconet, achieving an early Salon success with her portrait busts. Aged eighteen, in 1766 she accompanied Falconet as his assistant to the court of Catherine the Great of Russia, staying there until 1778 and working on busts, medals and Falconet's equestrian monument to Peter the Great. She married Falconet's son in 1778 (one daughter), but he was abusive, and she left him in 1779 to work with her father-in-law at The Hague. She stopped sculpting in 1783 to nurse her father-in-law, who died in 1791, the same year as her husband. In 1791 she retired to an estate in Lorraine. A member of the St Petersburg Academy, she died in 1821.

MARIA COSWAY (née Hadfield) was born in 1760 to an innkeeper in Florence. She took painting lessons from 1773 to 1778. After visiting Rome and Naples 1778–79, she moved to London with her family. She married the artist Richard Cosway in 1781, and had one daughter who died in 1790. She had a close friendship with Thomas Jefferson in Paris in 1787. She exhibited portraits and history pictures at the Royal Academy in London 1781–90, then a smaller surge of works, mainly engravings, around 1800. Emotional turmoil and religious feelings led her to travel, and she had a second career as an educator in Italy where she founded two schools for girls. She returned to England to nurse her husband from 1817 to 1821. She was made an honorary member of the Florence Academy of Design in 1778. She died in Lodi in 1838.

ANNE FORBES was born in Scotland in 1745. Supported by £600 from a group of backers, she studied in Rome for three years, advised by Scottish painters there, and copying prints and paintings. After a year in London, enduring ill health and inadequate earnings, she worked in Edinburgh for the rest of her life, remaining single. In 1772 she exhibited at the Royal Academy, and in 1788 became portraitist to the Society of Antiquaries of Scotland. She died in 1834.

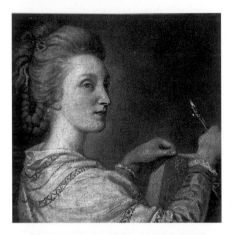

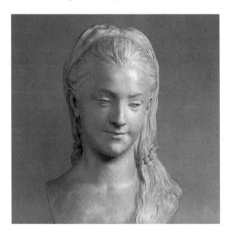

(previous pages) Marie Gabrielle Capet, *Studio Interior,* 1808 (detail). This homage to her teacher Adélaïde Labille-Guiard shows Capet preparing the palette; Labille-Guiard's husband M. Vincent standing; Vincent's teacher, M. Vien, as sitter.
(this page, left to right) Marie-Anne Collot, *Bust of Mary Cathcart,* 1768. Maria Cosway, *Self-portrait with Arms Folded,* 1787 (detail). David Allan, *Portrait of Anne Forbes,* 1781 (detail). Nathaniel Dance, *Portrait of Angelica Kauffman,* 1764 (detail).

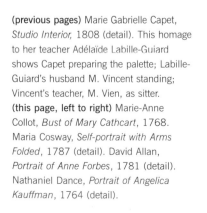

ANGELICA KAUFFMAN was born in 1741 in Switzerland. She was escorted by her painter-father to Italian artistic centres 1763–65, and went to London in 1766 where, after an unfortunate marriage, 1767–68, she stayed for fourteen successful years, painting in the new neoclassical style. She moved to Rome on marrying the painter Antonio Zucchi in 1781. Member of the academies of Bologna, Florence and Rome, she was a founder member of the London Royal Academy. Two of her works were carried in her Roman funeral procession in 1807.

ANNA DOROTHEA LISIEWSKA-
THERBUSCH was born in 1721 in Berlin.
She and her sister, Anna Rosina, were
taught by their father. She married an
innkeeper in 1742 (d. 1772), had three
children, resumed painting in 1760. She
worked at the courts of Stuttgart (1761)
and Mannheim (1763), and in Paris
(1765–67). Frederick II of Prussia and the
Tsar of Russia were patrons in the '70s.
A member of the French and the Vienna
academies, she died in Berlin in 1782.

CONSTANCE MAYER was born in 1755
in Paris to a customs official. She studied
with Greuze and Suvée, and briefly in
1801 with David. In 1802 she became
the pupil of Pierre-Paul Prud'hon with
whom she collaborated professionally;
after his wife's mental collapse in 1803
she also ran his home. At the Salon she
showed miniatures, portraits of women
and children, domestic genre paintings
and allegorical subjects. Her achievement
was acknowledged in 1816 with lodgings
in the Louvre. She killed herself in 1821
when Prud'hon refused to marry her.

KATHARINE READ was born in 1723,
the daughter of a Scottish merchant.
She studied pastel painting with Quentin
de la Tour in Paris after 1745, and was
in Rome 1751–53. She set up a studio in
London in 1753 where for twenty years
she painted portraits, mostly in pastel
but sometimes in oils, of female
aristocrats, royals and children. She
was made honorary member of the
Incorporated Society in 1769. She died
on board ship in 1778 returning from a
visit to her brother in India to find work
for herself and a husband for her niece.

ELISABETH VIGÉE-LEBRUN was born
in Paris in 1755. She was trained first by
her father, then by other mentors. She
married an art dealer in 1776 (one
daughter), divorcing him in 1794. After
early success as the favoured portraitist
of Marie Antoinette, she left Paris on the
eve of the 1789 Revolution, and toured
the courts of Europe as a portraitist.
She resettled in France in 1809. Her
many honours included membership
of the academies of Paris, Rome, Parma,
Bologna, St Petersburg, Berlin, Geneva
and Rouen. She died in 1842.

Paul Sandby, *A Lady Painting*, c. 1770. The female amateur artist came into her own in the eighteenth century, contributing much to the pairing of women and art. The watercolourist Paul Sandby had several women students and here he shows one of them at work in an enchanting image of accomplished femininity.

There was no lack of role models for a woman who wanted to be an artist. When in 1783 Elisabeth Vigée-Lebrun and Adélaïde Labille-Guiard were accepted into the French Royal Academy, bringing the total of female academicians to four, young women everywhere could feel such rewards could be theirs. They knew nothing of the men's machinations to keep them out or to limit their numbers: all they could see was that women were capable of the highest in the field of art. 'I do not despair yet before I die that I may bear a comparison with Rosalba or, rather, La Tour, who, I must own, is my model among all the portrait painters I have yet seen,' wrote Katharine Read from Rome.[1] As the number and fame of women artists increased, the idea of a career in art presented itself as an attainable reality. Evidence of this is the fact that the pool from which the artists came was no longer dominated by artist families. In France Adélaïde Labille-Guiard's father was a haberdasher, Gabrielle Capet's father a domestic servant.

The most telling proof that art had become a career for women was the encouragement that parents gave their daughters to take up art to make their living. Marie Benoist and her sister were sent by their father to study with Elisabeth Vigée-Lebrun in the hope that the skills she taught them would compensate for the dowries he could not give them. In England, Gainsborough wrote of his two daughters: 'I'm upon a scheme of learning them both to paint landscape.' Not to an amateur level 'to be partly admired and partly laugh'd at at every Tea Table; but in case of an accident that they may do something for bread.'[2]

The amateur artist came into her own in this period, and contributed much to the pairing of women and art. As objects of interest and leaders of taste, the aristocrats who practised drawing as an accomplishment did much to make a social commonplace of the idea of women making art. A genteel hand with the pencil was akin to skill at embroidery, and less hard on one's family and friends than singing or playing an instrument. The Duchess of Devonshire assured her mother that her dislike of Lady Elizabeth Foster was groundless:

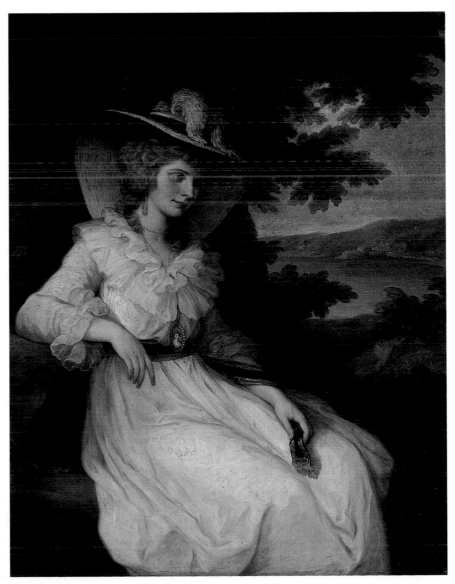

Angelica Kauffman, *Lady Elizabeth Foster*, 1786. This artist had a secure circle of patrons among well born British ladies, and was able to mix with them socially because of her fame and talent. Lady Elizabeth Foster was a well regarded watercolourist.

'she is the quietest little thing and will sit and draw in a corner of the room, or be sent out of the room, or do whatever you please.'[3] Her mother's forebodings were proved correct: the feared rival would become the second Duchess of Devonshire. As the idea of drawing as an aristocratic accomplishment filtered down through society, the visibility of women artists increased, and well bred heroines who sketched and worked in watercolours began to appear in fiction. 'It is evident, in spite of his frequent attention to her while she draws, that in fact he knows nothing of the matter,' said Marianne dismissively of her sister Elinor's suitor in Jane Austen's *Sense and Sensibility* (1811).[4]

The world of the amateur artist echoed that of her professional sisters, and a small industry developed to service her needs. Young girls learned to draw and paint from tutors and from the new how-to-paint manuals; adults learned from artists, often after they watched them paint the portraits of family members. The amateurs hung their work on the walls of their houses, showed it to their friends and kept up-to-date with current artistic theories. They could even exhibit their work, although of course their amateur status was made clear – that is, that they did not paint for money. Some amateurs received artistic honours: after spending five months painting in Rome, Lady Lucan was made an honorary member of the Academy of St Luke.

Samuel F.B. Morse, *Gallery of the Louvre*, 1833. It was part of an artist's education to learn to paint by copying the great art works of the past, and women as well as men availed themselves of the opportunity to do this in the Louvre in Paris.

The amount of visual evidence for the existence of women artists increased dramatically. Illustrations were made of them copying paintings in art galleries, and their teachers recorded their female students at work in watercolours and drawings. The woman artist became so familiar a sight that male artists mined it for its charm. The French artist Boilly, always alert to new trends for his paintings of contemporary life, produced several oils of women artists at work, some serious, some with racy overtones. Amateurs were also illustrated. Ladies were shown studying the art in private collections, and a lady with a portfolio by her side became a standard portrait format for the depiction of an accomplished upper-class woman. It did women artists no harm that the neoclassical movement of the late eighteenth century led to a rash of representations of Design personified as a woman, or that the origin-of-art myth showing a woman tracing her departing lover's profile on the wall was a subject chosen by several followers of the neoclassical movement, such as Joseph Wright of Derby.

The way in

As always, the women who had the easiest access to education were those born into the learning structure offered by artists' families. In these families, where female talent was accepted and nurtured, a woman's skill was sure to be put to use. A striking number of gender-blind dynasties of painters can be found in the period. In the German Mengs family, daughters and sisters, nieces and wives all practised art. In the United States, Anna and Sarah Miriam Peale, daughters of the painter James Peale and nieces of the painter Charles Willson Peale, carried on the family tradition of miniatures, still-life and portraits.

But there were plenty of other women who wanted to enter the profession who were not from artists' families. The demand for training from women with little or no connection to the world of art forced the development of teaching patterns other than that of the family studio. In France, where the female stars of the 1780s inspired so many women to paint, a market grew up in selling skills to women. Artists who took women students included Greuze, Regnault, Vien, whose wife, Marie-Thérèse Reboul, was made an *académicienne* in 1754, and David whose students included Mme Benoist and, briefly, Constance Mayer. In the first decades of the nineteenth century Alexandre Abel de Pujol chose his second wife, Adrienne Grandpierre-Deverzey, from his class of female students, and Cogniet set up teaching studios for men and women in 1830 with his sister in charge of the female one.

Elisabeth Vigée-Lebrun was taught by a succession of male artists from an early age. 'Having made my first communion at the age of eleven, I left the convent for good. Davesne the oil painter invited me to his studio so that I might learn to make up a palette.'[5]

WOMEN'S CLASSES

In the opening decades of the nineteenth century there were hundreds of women artists at work in France, exhibiting at the Salon, teaching, copying and etching. A whole industry grew up to meet their needs.

(below) Adrienne Grandpierre-Deverzey, *Interior of Pujol's Studio, c.* 1822. This picture of the class for women given by Alexandre Abel de Pujol was painted by his wife, who had been a student there. A decorous assembly of women surround their relaxed and seated master, amid the familiar studio collection of busts and casts and works of art. The stove, a typical element in French paintings of the studio, was there to keep the nude model warm when posing for the life class. Women painting the nude was not, however, an acceptable activity to be shown at this time.

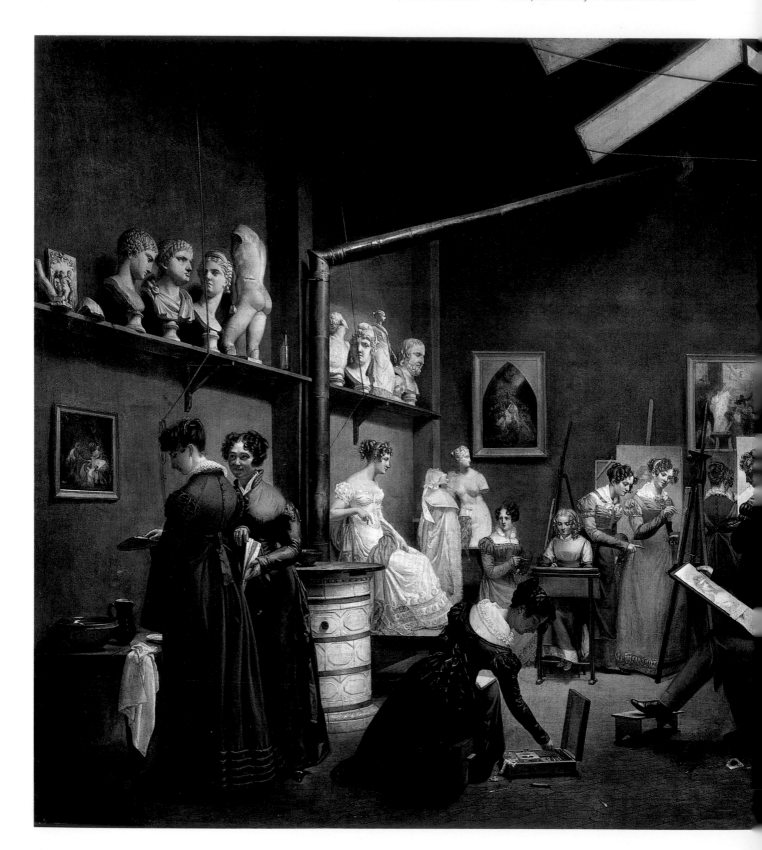

THE MALE NUDE

The male artist drawing and painting the male nude was the central holy mystery of art. Some women were able to draw from the female nude and a few may have copied the male nude, but convention forbade either process to be depicted.

(top) Léon Matthieu Cochereau, *Interior of David's Studio*, 1814. Jacques-Louis David's male class is shown here. He also taught such women artists as Marie Benoist and Constance Mayer, but had to emphasize: 'They are completely separated from the studio where my male students work.'

(below) François-Marius Granet, *Léontine Painting in Granet's Studio in the Louvre*, after 1826 when Granet became a curator at the Louvre. The contrast between male and female styles of art training (or perhaps what it was permissible to show) could not be greater.

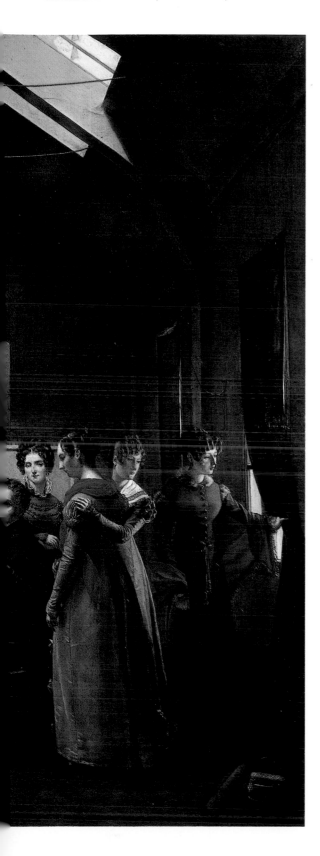

A little later, aged fourteen, she and Mlle Boquet often went to draw at the house of the painter Briard:

> He lent us his drawings and classical sculptures to copy. He had a residence at the Louvre, and in order to be able to spend more time drawing there, we would each bring a basket containing some light midday fare…. My aptitude for painting was remarkable and my progress so rapid that I became a topic of conversation in high places; all this led to my making the agreeable acquaintance of Joseph Vernet. This famous artist encouraged me and gave me some excellent advice: 'My child,' he said, 'do not follow any school of painting. Look only to the old Italian and Flemish masters; but above all, draw as much as you can from nature, nature is the greatest teacher of all…. Study her carefully and you will avoid falling into mannerisms.' I have always followed this advice, for I have never really had a teacher as such.[6]

This last sentence could be echoed by many women whose instruction was never as organized as that of the men.

Young women of the period had a better chance of being taught by women than ever before. In a parallel practice to the men, many women took students, a development celebrated in a number of paintings at the end of the century depicting women artists with their pupils. In Florence, Maria Cosway, then known as Maria Hadfield, the precocious young daughter of an English hostel-keeper who catered for northerners touring Italy, at the age of eight was sent to take lessons from Violante Cerroti, a female member of the Florence Academy. But it was in France, with its relatively large number of high-profile women artists, that this phenomenon had its fullest expression. Around 1779, after separating from her first husband, Adélaïde Labille-Guiard opened her studio to women, doubtless to increase her income but also out of her belief in training girls for art. She included two of her pupils in the life-size self-portrait she exhibited at the 1785 Salon. Pauline Auzou, a constant Salon exhibitor from 1793 to 1830, ran a studio for women artists for over twenty years from the start of the nineteenth century. Even Elisabeth Vigée-Lebrun took pupils in the 1780s, although she hated teaching, claiming that she was forced to do it by her husband:

> I was overwhelmed with commissions from every quarter and although Le Brun took it upon himself to appropriate my earnings, this did not prevent him from insisting that I take pupils in order to increase our income even further. I consented to this demand without really taking the time to consider the consequences and soon the house was full of young ladies learning how to paint eyes, noses and faces. I was constantly correcting their efforts and was thus distracted from my own work which I found very irritating indeed.[7]

Having a successful woman artist as a teacher made the idea of becoming a painter a normal aspiration, and fuelled the ambition of their students.

All this activity meant that large numbers of women were entering places which had formerly been the preserve of men. Not everyone approved of these developments. In 1785, in the name of morality, (though it was just as likely to have stemmed from male fears that the rise in the number of women arts would destabilize the art world as they knew it), women art students were banned from the Louvre, where members of the Royal Academy had free lodgings. In 1787, while building a new studio, Elisabeth Vigée-Lebrun sent her students there to work under David's tutelage. When the authorities cautioned him, David argued for the impeccable conduct of his studio and of the women students:

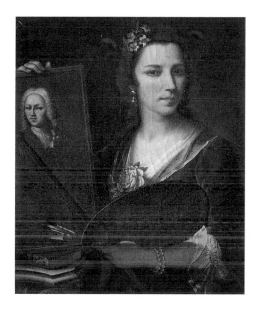

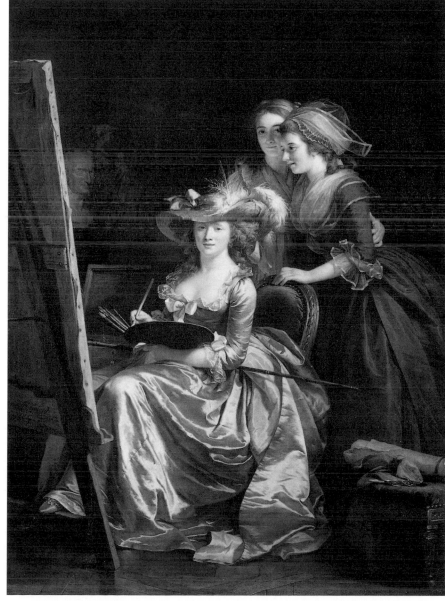

(above) Violante Cerroti, *Self-portrait*, 1735.
(right) Adélaïde Labille-Guiard, *Self-portrait with Two Pupils*, 1785. Many women painters took female students in the second half of the eighteenth century. Violante Cerroti was a member of the Florence Academy and the first teacher of Maria Hadfield (later Cosway). In Labille-Guiard's life-size image, the glamorous artist depicts herself at work on a huge canvas, while her pupils, Mlle Marie Gabrielle Capet and Mlle Carreaux de Rosemond, look on as she paints.

They are completely separated from the studio where my male students work and have absolutely no communication with them. Their morals are beyond reproach, and I am convinced that whatever the slander, it cannot touch the justice their conduct deserves – I myself have too much self-respect to keep them for an instant if their conduct were otherwise.[8]

These warnings from on high were enough to make some painters close their women's studios. Such examples of discrimination are usually offered as proof of the poor treatment women received at the hands of men, but, as always, the women continued to train right through the setbacks. Many of the discussions and changes connected to the national art institutions in the years before and during the French Revolution were probably more frightening for the men, who risked the loss of their state-endorsed stairway to success, than they were for women who learned early in their careers to adapt to changing circumstances.

Marie Ellenrieder, *Kneeling Girl with Overflowing Flower Basket*, 1841. This artist was the first woman to take classes at the Munich Academy, 1813–16. A respected painter of religious works and portraits, depression brought her career to an end.

Caroline Bardua, *Flora, or the Wreath Maker*, c. 1843. In 1805, on Goethe's recommendation, this artist was allowed to study at the Weimar Drawing School. She had a successful career as a portrait painter in Berlin, supporting her sister, financing her brother's education and founding a literary and artistic club for women which ran from 1843 to 1848.

At the start of the French Revolution, the education and work of women became a topic of debate. Adélaïde Labille-Guiard's proposal for a female school of art met with resistance, showing that, while it was fine for female art education to take place informally or privately, attempts to institutionalize it were not acceptable to the authorities. Though most suggestions exploded like fireworks into nothing, Mme Campan's school for fashionable young women, opened at St Germain-en-Laye in 1794, was based on the conviction that the arts could help girls earn their own living. The girls spent two hours a day on pencil drawing, life drawing and relief drawing, and once a week they painted from landscape. Jean-Baptiste Isabey was a teacher there and gained an entrée into the court of Napoleon through his student, Hortense de Beauharnais, the Empress Josephine's daughter from her first marriage.

The diaries of the English artist Joseph Farington for the years round 1800 point to a layer of women artists working away at a lower level than the stars whose names have survived. His account of everyday life in the art world reveals a substructure of working

women who made a living engraving, copying and teaching. These
women got their artistic education at the schools set up to teach
design. One of the first was the Society of Arts set up in London
to encourage and improve British manufactures. Prizes were offered
for good work and women were allowed to enter some of the drawing
competitions. Even though the aim was the practical one of improving
young people's design skills and not helping them become fine artists
(an altogether more elevated area of study), many women armed
with one of the Society's prizes set out to make careers as
watercolourists, copyists, engravers or teachers. In the first half
of the nineteenth century, a number of design-orientated female
schools of art taught skills that could be applied to design, crafts or
motherhood, and here again graduates tried their ill-trained hands at
watercolours, etching and miniatures as mid-century approached.

From the end of the eighteenth century, small academies that were
no more than a room, an instructor, and casts and drawings to copy
began to pop up in a number of cities. Few and far between, they
tended to be used by the less ambitious kind of woman hoping to gain
credentials for teaching. Furthermore, they did nothing to argue
against the general belief that women should not and could not reach
a male artistic standard. In Edinburgh, at the end of the eighteenth
century, the landscape artist Alexander Nasmyth opened a drawing
academy for amateurs and set his daughters up to teach in it. The
course of study involved sketching trips to beauty spots and copying
the work of others. Although all the Misses Nasmyth who taught there
were artists in their own right, none of them was famous: they were
typical of the hundreds of women in the period who made a living
from meeting the need created by the culture of accomplishment.

In 1824 Henryka Beyer became the director of Poland's first art
school for women, the Salon for Drawing and Painting Flowers.
As with the schools of design, it is likely that a professional path
was in some minds: a student with talent and limited means might
try and turn her skill into an income.

Early in the nineteenth century a little flurry of activity involving
male academies enabled a handful of women to get a taste of the kind
of teaching that aspiring male artists took for granted. In Germany
several women in Goethe's circle took classes at various academies.
In 1805, Caroline Bardua studied at the Weimar Drawing School on
Goethe's recommendation. The first woman to be trained at the
Munich Academy was Marie Ellenrieder who studied there from 1813
to 1816. In 1817, Louise Seidler became the first German woman to
receive a scholarship to study at the Munich Academy and followed
this with a scholarship to study in Rome. Their education was only
partial, and they were older than the male students, earning their place
in education through a helping hand, not as the natural birthright
of talent spotted at an early age. In Sweden in the 1840s, Amalia

Lindegren was one of several women who studied in the antique school of the Royal Academy of Fine Arts in Stockholm.

Except for the odd prohibition, like the British Royal Academy's rule forbidding unmarried men under twenty to draw the female nude, men experienced nothing like the taboo women still faced against drawing the male nude model. In 1752, the Abbé Grant wrote to Katherine Read's brother: 'Was it not for the restrictions her sex obliges her to be under, I dare safely say she would shine wonderfully in history painting, too, but as it is impossible for her to attend public academies or even design or draw from nature, she is determined to confine herself to portraits.'[9] However, although it was understood that the refusal to let women draw from the nude prevented them fulfilling their promise, no move was made to change the situation. When the question of increasing the number of female academicians came up in France in 1791, it was argued that 'this number is adequate to honour talent: women can never be useful to the progress of the arts, since the modesty of their sex prevents them from studying nude figures in the school established by Your Majesty.'[10]

Despite this, the more determined artists found ways to study the nude. One solution was to copy the drawings made by men, and I suspect many women learned to draw the nude this way. Drawings exist by Pauline Auzou of naked female and male models. It is often hard to tell whether a nude drawing is original or a copy of someone else's work, but one thing is certain: if they did do nude drawings, it would have been in private or female-only classes. The claim that was frequently heard that men and women worked together in life-drawing classes could not possibly have been true, and the fact that no evidence exists for this suggests it was one more example of the excited curiosity surrounding the lives of women artists. In academic training, life classes were bolstered by anatomy lectures conducted with the aid of a figure whose skin had been removed to reveal sinews, muscles and bones, varnished to stay that way forever. Women desirous of learning this 'unfeminine' science had to consult anatomy books or take private lessons, as did the English sculptor Anne Damer who, fortified with the confidence of class and money, studied anatomy with the celebrated anatomy teacher and surgeon, Dr William Cumberland Cruikshank.

The father's role in training daughters has meant that the input of mothers has been overlooked, but daughters had much to thank them for. Because their decision to become artists was still so unusual, women needed more support than men in pursuing their profession, and mothers could help in several ways. It was believed that young artists could learn a great deal from studying the work of great artists. Young women needed chaperones and Elisabeth Vigée-Lebrun turned to her mother when she needed someone to escort her to the private collections of Paris when they were opened to the public. 'As soon as

I entered these great galleries, I behaved just like a bee, gathering knowledge and ideas that I might apply to my own art. I would copy paintings by Rubens, portraits by Rembrandt and Van Dyck as well as several paintings of young girls by Greuze, all of which I hoped would strengthen my own skill.'[11]

Although it was Rolinda Sharples's artist father who instructed her, it was her mother who offered the rationale for following a career. Mrs Sharples had taken up art professionally in order to boost the family income.

> The continual fluctuation of the funds and other property in which our money had been invested the uncertainty in mechanical pursuits in which Mr S delighted – all had an influence in deciding me, soon after our arrival in Philadelphia where Congress then assembled, to make my drawing which had been learnt and practised as an ornamental art for amusement, available to a useful purpose.[12]

By passing on her experiences, she hoped to guarantee a prosperous life to her daughter.

> I had frequently thought that every well educated female, particularly those who had only small fortunes, should at least have the power, (even if they did not exercise it) by the cultivation of some available talent, of obtaining the conveniences and some of the elegancies of life and be enabled always to reserve that respectable position in society to which they had been accustomed. Many circumstances had led to the formation of this opinion, not only the French Revolution, which occasioned the entire loss of fortune to the great number of ladies and gentlemen who sought refuge in this and other countries. The reverse of fortune had been frequently observed in married and single ladies, a few the loss of their whole income, others of a part, obliging them to observe the strictest economy. In mercantile and various other concerns, men of abilities once affluent had become poor, others by thoughtlessness and extravagance.[13]

Her views were clearly useful to her daughter, who remained unmarried and made a living as a painter in the west of England until her death at thirty-six.

A fashionable and intelligent mother with her own circle of female friends could offer support of a different sort. Anne Damer was described as having 'the advantage of meeting the members of the brilliant circle that surrounded her mother, including Angelica Kauffman. Such company excited the artistic instincts that she inherited from her mother, who did everything in her power to help her to develop them.[14] When the writer Fanny Burney was a young woman, her mother took her to Katherine Read's studio, which was a well-known meeting place. 'Thursday mama took us with her to

Miss Reid, the celebrated paintress, to meet Mrs Brooke, the celebrated authoress of *Lady Julia Mandeville*. Miss Reid is shrewd and clever, where she has any opportunity given her to make it known; but she is so very deaf, that it is a fatigue to attempt [conversation with] her.'[15] Exposed so early to a circle of successful women, it is no wonder that Fanny Burney saw no hindrance to her dreams of becoming a novelist.

Because their training was less structured than that of men, aspiring young women artists needed a great deal of self-discipline. The immense single-mindedness needed to keep on studying outside the official training structures should be recognized when women artists are under the microscope. Unable to rely on the paths to instruction, women had to be self-starters, willing to work at home and alone. When Vigée-Lebrun was in her early teens and studying with Briard, she said that:

I also drew from nature, continuing the work at home by lamplight, usually with Mlle Boquet with whom I was friendly at the time. I would

Rolinda Sharples, *Cloakroom of the Clifton Assembly Rooms*, 1817–18. Her father taught her to paint and her mother offered her proof that a woman could work as an artist. She worked as a painter in Bristol, south-west England, making a local reputation as a reporter of provincial scenes, and a national one through exhibiting at London's Royal Academy.

go to her house in the evenings, in the rue St-Denis opposite rue Truanderie, where her father owned a bric-à-brac shop. The route was a fairly lengthy one since we lived in the rue de Cléry opposite the Hôtel de Lubert, but my mother always made sure I was chaperoned.[16]

Self-motivation was necessary at every stage of a woman's life. Anna Dorothea Lisiewska-Therbusch stopped painting after her marriage and the birth of her children. When she decided to take up her career again in 1760, she began to brush up her skills alone before emerging into the public eye.

Young artists still in the middle of their education understood that it was never too soon to expose their work. In France before the Revolution, ambitious artists could exhibit at the Young Persons' Exhibition which was held one day each year in the Place Dauphine. Here young men and women brought their work and, in the case of the women, themselves, to the attention of the public. The exhibition had something of a spectator sport about it, particularly so in 1786 when several striking paintings by young women were on show:

> The exhibition of the paintings in the Place Dauphine... has offered nothing so remarkable as the sight of half a dozen balconies loaded with young women, some endowed with their natural charms, others with all the embellishments they could contrive; these were all young ladies whose portraits were exhibited, making it really easy to compare and judge their resemblance. This new type of coquettishness has drawn many art lovers more interested in looking at the originals than the copies.[17]

David Allan, *Portrait of Anne Forbes*, 1781. Like his sitter, David Allan's stay in Rome was financed by a group of Scottish backers. He was one of Anne Forbes's Scottish advisers during her years in the city, 1768–71. Her backers hoped that their protégée would follow Katharine Read by crowning study in Rome with success in London. This portrait was painted when both artist and sitter had returned to Edinburgh.

FOREIGN TRAVEL IN THE SERVICE OF ART

To complete his artistic education, the ambitious male artist would travel to the Low Countries (to see Rubens and Rembrandt) and to Italy (to see classical and High Renaissance works). A few determined women followed this path, though with a difference. Unlike men, who merely needed money (essential) and letters of introduction (useful), women also needed a cloak of respectability. Before marriage this was supplied by their family; after marriage, by their husbands. One cannot think of a young male artist who went off to study in Italy accompanied by his mother, and was escorted there and back by his brother, but that is exactly what happened to the young Scot, Anne Forbes. Sometimes a young female artist travelled at the invitation of an aristocratic woman who liked the presence of an artistic and attractive young girl in her entourage. Angelica Kauffman was invited to London by Bridget, Lady Wentworth, wife of the British Resident in Venice.

Anne Forbes, *Lady Anne Stewart*, c. 1820s. After studying in Italy, ill health and lack of patrons decided Anne Forbes to leave London after a year and return to Edinburgh in 1773. She remained unmarried and worked as a portrait painter for the rest of her long life (she died in 1834).

An exception was Katharine Read who went to Rome alone after studying in Paris. Her relative maturity – she was twenty-seven – explains this; she also had introductions to the most respectable and was escorted in Rome by the Scottish cleric, Abbé Grant.

In Italy, the women were the objects of all eyes. In their letters, the men assessed the women's form: the Scottish artist Gavin Hamilton was sure that after a year in Rome Anne Forbes would 'make a considerable figure in her own country'.[18] Gossip of a mildly salacious nature abounded. Anne Forbes's mother was distressed by groundless rumours that her daughter was about to become engaged. Angelica Kauffman was the subject of constant gossip when she was a young unmarried girl in Rome in 1764, and when the beautiful Maria Hadfield (later Cosway) appeared there two decades later, she was described as Kauffman's successor and also watched with interest. Not a shred of scandal was ever proved; it was more a product of men's imagination than of reality. Women dealt with these occupational hazards as best they could. Some, like Maria Cosway and Angelica Kauffman, glowed in the midst of the attention and

turned it to their advantage. For Anne Forbes, who was often ill, it was a martyrdom to be endured for the future glory of a British career.

One gets a strong sense of what today would be called career management in this period. There was always the problem with girls of how far to indulge them in their dream of becoming an artist. The amount spent on a daughter had to be judiciously gauged: a sufficient investment was necessary to develop her talent but overspending was money lost to the family if she married. If she was lucky, she might attract the attention of backers. It is known that a number of talented young men were enabled to train through the interest of a wealthy party, but not so well recognized that women were also the recipients of such help. At some point after 1805, the Earl of Radnor allowed the adolescent Margaret Carpenter to copy paintings in his collection at Longford Castle, and gave her financial help to move to London in order to study and set herself up in business. His generosity was rewarded: his protégée, who is one of those women artists who has been mislaid by history, had a successful career as a portrait painter with over a thousand portraits to her name by the time of her death in 1872.

A group of Edinburgh supporters gave Anne Forbes £200 per annum to study in Italy for three years with a view to supporting her family as a portrait painter after her brother resigned his commission in the army. No doubt the success of her fellow Scot Katharine Read, who had been in Rome a decade earlier, helped make this seem a sensible course of action. Mr Chalmers and his friends in Scotland were doing no less than speculating on Anne Forbes's future success when they staked her to an Italian course of study, and they worked within a plan. She was to study in Italy, make lots of contacts, exploit those contacts when she set up in London and make her fortune as that most unusual creature, a woman portrait painter. A letter to Mr Chalmers from Mrs Forbes during the year the family spent in London reveals the thinking that lay behind the decision to back her daughter, as well as the fact that her progress was not proving to be as straightforward as had been envisaged:

> It is certain that had I imagined she was to grovel here for years and to creep into business by slow degrees I never would have stirr'd from home, but here we came buoy'd up with the imagination that she was to be received with open arms and patronized by people of the first rank and fortune, and really from appearances both abroad and at home, we all were apt to think that nobody could set out with a fairer prospect, but how it has succeeded you may be sensible, as every picture she has done your own self has been the procurer of, and which she might have done with more pleasure and profit in Edinburgh the short and the long dear sir is this, that without a run of English business such as could enable her to employ a drapery painter she can in no way live here.[19]

Rome and Naples were the centre of the art world at the time, and spending time there could pay huge dividends in terms of contacts as well as broadening the mind artistically. For the young women artists of the last third of the eighteenth century, Italy was a special place. It was where the aristocratic young men who had come from the north to complete their education and sow their wild oats, made contact with the taste-makers, intellectuals and artists who had come from all over Europe to worship at the source of culture and the shrine of art. From the artists' point of view, the aristocrats on the Grand Tour were all potential clients, and the artists and intellectuals were representatives of the community to which they wished to belong.

The women artists who converged on Rome were as anxious as the men to sharpen their skills, view the finest art the world could offer, and mix with the aristocrats and intellectuals who would form their patronage base when they returned to their respective countries. When Katherine Read wrote to her brother that she felt that a year

(top) Anna Dorothea Lisiewska-Therbusch, *Self-portrait*, c. 1780. This Polish artist, court painter to the Elector Palatine, also received commissions from the King of Prussia and the Tsar of Russia.
(above) Anne Vallayer-Coster, *Sea Plume*, 1769. This still-life artist became a member of the French Academy in 1770 and painter to Queen Marie Antoinette in 1780.
(right) Elisabeth Vigée-Lebrun, *Marie Antoinette and Her Children*, 1787. On the eve of the Revolution, nervous over her royal connections, the artist left France to paint the portraits of the rich, royal and intellectual of Europe.

in Rome would fit her for work in London, she was not just referring to honing her skills as an artist: the contacts made with the intellectual, artistic and aristocratic inhabitants of these Grand Tour destinations could open doors when she returned to England. The women were well aware of the advantages of their time in Italy and the shrewd among them knew how to exploit them. When the young Angelica Kauffman reached Rome in 1763, a prodigy, attractive, and protected by her father, one of the first things she did was to paint the portrait of the influential neoclassical theorist Winckelman, an immensely sensible career move. It was a strategy she was to repeat when, soon after arriving in England in 1766, she painted the portrait of Sir Joshua Reynolds. A clever woman could begin her professional career in Italy. It was common for artists to take on commissions while they were there to finish their training. Katharine Read wrote from Rome that she was painting a profile portrait of a beautiful woman: 'As this is for L. Charlemond, I shall get money for it.' [20]

Women moved around more freely than before, criss-crossing Europe in the search for training and work. As artistic reputations, styles and information spread from one country to another, the resulting internationalism of the art world meant that many artists travelled to where the work was. Though chaperones in the shape of servants and family were necessary when women moved from place to place, some women managed to act with an element of independence. On the eve of the Revolution, frightened for her life owing to her position as favourite painter to Queen Marie Antoinette, Elisabeth Vigée-Lebrun gathered up her daughter and the governess, and took a coach out of Paris on the first step of her travels round the courts of Europe.

Courts, and in particular the numerous German courts, continued to play an important role in the careers of women artists by offering them status and safety. Anna Dorothea Lisiewska-Therbusch was invited to the Stuttgart court in 1761 and was appointed court painter at Mannheim in 1763. In 1765 she went to try her fortune in France. The hostile gossip and attacks on her work she met in her three years there as described by Diderot in his Salon commentaries, suggests that life at court with appreciative patrons was far more comfortable than painting for the open market. Changes in the nature of court patronage made it a more flexible arrangement for the artist. Though both Elisabeth Vigée-Lebrun and Anne Vallayer-Coster were painters to Queen Marie Antoinette, they did not live at court and were not limited to painting for the court. Despite this loosening of protocol around court artists, court positions could be seen as too restricting and also with events in France in mind, politically unwise. In the 1780s, the successful, married and respected Angelica Kauffman refused a request to become a painter at the court of Naples, though she continued to move in royal circles.

Women tried their hands at practically everything. Portraiture was still the favoured area for all the familiar reasons plus the inspirational new one that Rosalba Carriera, one of the most famous portraitist of the first half of the century was not only a woman, but a woman who used the fashionable new medium of pastel. Pastel was far simpler for a woman to use as it took up less space and made far less mess than oils, and Rosalba Carriera inspired many followers, amateurs as well as professionals. Some portrait painters became famous for their innovations: when Winterhalter chose his pose for the Empress Eugénie holding her son on her knee in 1857, one of the paintings he had in mind was Elisabeth Vigée-Lebrun's portrait of *Marie-Antoinette and her Children* of 1787 which he knew from the royal collection.

THE ARTISTS' OWN TESTIMONY

The survival from this period of letters, diaries and memoirs means that what previously had to be deduced from career patterns, paintings or biographical information can now be learned from the artists themselves. Where previously one was a detective, one now becomes a reporter. For example, the painter herself can explain how she achieved her effects. A successful portraitist, like a society photographer today, was able to make her subjects look wonderful. Elisabeth Vigée-Lebrun's ability to produce powerful yet flattering images of women, was the key to her success:

> I tried as far as I was able to give the women I painted the exact expression and attitude of their physiognomy; those whose features were less than imposing, I painted dreaming, or in a languid, nonchalant pose. In the end they must have been pleased with the result, for I had difficulty in keeping up with the demand for my work and the list of potential customers grew longer and longer. In short, I was the fashion.[21]

As art became an increasingly fashionable affair, artists had to keep abreast of the trends if they wanted to stay in business. Anne Forbes's sister explained current taste in a letter to Scotland: 'The taste of the present times here is confounding portrait and history painting together which is a thing peculiar to Britain, amongst all the paintings we saw both in France and Italy they were both properly distinct but here the misses are not pleased without they be flying in the air, or sitting on a cloud or feeding Jupiter's eagle.'[22] When Elisabeth Vigée-Lebrun arrived in Rome in 1789 she transformed a sixteen-year-old English sitter into a goddess on a cloud who offers an eagle a drink from a goblet. The artist was terrified lest the bird attack her as she painted. She had borrowed it from Cardinal Bernis who kept it outdoors, and it became bad-tempered from being confined in her studio.

The large number of women producing history paintings was a mark of their ambition to operate in the highest branch of art. Several history paintings by women involving nude or partially clad females were exhibited at the Salon. When in 1767 the Salon rejected Anna Dorothea Lisiewska-Therbusch's painting *Jupiter and Antiope* on the grounds of impropriety, Diderot reported that she was so distressed that 'she cried out, she pulled her hair, she rolled on the ground, she grasped a knife, uncertain whether to use it on herself or her painting.' Diderot, who investigated the rejection on her behalf, felt the fault lay with the looks of the models: 'It's quite something to have put together such a nude female, it is quite something to have painted flesh: I know more than one person, proud of his talent, who could not do as much.' Unfortunately, he says the model with her spindly legs and deformed toes was a servant girl and Jupiter was a labourer with a flat face.[23] Many of the women's paintings had heroines and depicted episodes illustrating female examples of loyalty, love and sacrifice. Maria Cosway exhibited *The Death of Miss Gardiner* at the Royal Academy in 1789, in which the nobly dying Miss Gardiner, young and all in

Maria Cosway, *The Death of Miss Gardiner*, 1789. Maria Cosway is an intriguing figure, above all for the tragic death of her daughter and her reputed affair with Thomas Jefferson while he was US Ambassador in Paris. This tender painting of female piety and grace is one of the more than thirty paintings she exhibited at the Royal Academy until discouraged, she said, by her husband from continuing, and also perhaps by her daughter's birth in 1790.

Angelica Kauffman, *Design*, 1778–80. This monumental personification of Design drawing a male torso was one of four allegorical images of art that the artist was asked to paint for the ceiling of the Royal Academy's new home at Somerset House in London. The request for this particular set of subjects was no doubt viewed as a special compliment to this neoclassical painter, founder-member of the Academy and friend of the great Sir Joshua Reynolds.

white, expresses the desire to join her mother in heaven. A less dramatic alternative to histories and allegories was genre painting of daily life, and women were quick to see the possibilities of this as an area suitable to their talents and to critical perceptions of their work.

By the early nineteenth century, women were beginning to paint landscapes. Although there is no proof, it seems possible that women's increasing comfort with landscape had as much to do with the way that art had taught the fashionable how to view the natural landscape as with female ambition to rival the male achievements in the genre. By the end of the century, appreciation of landscape was one of the signs of a cultivated person. Catherine Morland, the young and enchantingly ignorant heroine of Jane Austen's novel *Northanger Abbey*, is faced with her lack of knowledge of the proper standards in the company of the knowledgeable Tilneys:

> They were viewing the country with the eyes of persons accustomed to drawing, and decided on its capability of being formed into pictures, with all the eagerness of real taste. Here Catherine was quite lost. She knew nothing of drawing – nothing of taste…. It seemed as if a good view were no longer to be taken from the top of a high hill, and that a clear blue sky was no longer a proof of a fine day. [24]

One of the bridges between landscape paintings and the appreciation of real landscape was a fashionable toy for the artistically inclined.

This was the Claude glass, a viewing device named after the great seventeenth-century French landscape artist, that organized the messy details of the landscape into picturesque lights and darks. Henry Tilney explained the new way of viewing the landscape to Catherine Morland: 'He talked of foregrounds, distances, and second distances – side-screens and perspectives – lights and shades.'[25] It seems quite possible that many women artists came to landscape through its taming in this way.

As women stretched their wings, they began to be involved in producing the painted panels that adorned the rooms of the interiors of the period. During her London years, Angelica Kauffman produced several designs for William Kent's interior schemes for his wealthy clients and, in what was doubtless meant as a compliment to her sex, she was asked to produce personifications of art – all female –for the ceiling of the Royal Academy of which she was a founding member. Mary Moser painted flower pieces on to canvas to be set into the walls of the Queen's palace at Frogmore. Anna Dorothea Lisiewska-Therbusch painted a number of decorative works for over-doors and the hall of mirrors while at the court of Duke Karl Eugen von Württemberg in Stuttgart.

As the number of painters increased, so did the sculptors. Just as most painters produced portraits, most sculptors concentrated on the portrait busts which were the more manageable end of the sculpture spectrum. However, as always, there were women who wished to compete with the men on their own ground. Sculpture was a far from risk-free activity and Anne Damer fell from the scaffold surrounding her eight-foot statue of George III. She wrote to Mary Berry:

Sarah Miriam Peale, *Catherine Embury Mankin*, c. 1820. A member of an American artistic dynasty, this artist did several portraits of women and children against a landscape background.

I did not hurt myself in the least essentially, I do assure you, but the other day I got a fall from my scaffold, rather from a part of it, which contributed to this fall and gave me a shake. My mother and Dumby came in very soon afterwards; I continued my work and did not even mention my fall. I could not help being diverted with a sort of comedy, though alas! too fatal an emblem of my life. Dumby's whole conversation was, 'Lord! What a charming scaffold! What a delightful scaffold! So clever; was there ever anything so clever, so well contrived?' And Lady A – 'Look at her figure, what a good figure; well, I do admire her figure, and how well she does look.' During this conversation I grew in pain and actually faint, so as to be obliged to go upstairs which I could accomplish and get a good glass of hartshorn and water, which my faithful Mary gave me, observing that I looked very ill and that she saw there was something the matter the moment I called her. This recovered me, and so ends my story.[26]

A lot more information is available on how artists conducted their business. In 1766, the young Angelica Kauffman described to her father

the way things were done in England: 'I have four rooms; one in white in which I paint, the other where I set up my finished paintings as is here the custom [so that] the people [can] come into the house to sit – to visit me – or to see my works.'[27] In London, studio visits were part of the social round. Fanny Burney recorded a morning visiting artists' studios, first Sir Joshua Reynolds, then Katharine Read whose pastels 'seem really to nearly reach perfection; their not standing appears to me the only inferiority they have to oil-colours; while they are new, nothing can be so soft, so delicate, so becoming.'[28]

Painting was not an easy career. On a physical level it took stamina. The good health that was necessary to the long hours worked by an artist was not to be taken for granted in women, whose lives, apart from horse-riding and walking, were conventionally less active than those of men. During her year in London Anne Forbes was constantly unwell. Childhood weakness had been exacerbated by her stay in Italy where she suffered from heat and headaches. Her mother dreamed of goat's whey and summer in the Highlands for her daughter and worried that London life would 'make an end of her.' In an account of Anne's painting activities, she writes:

Sofia Sukhovo-Kobylina, *Self-portrait, c.* 1847. The Russian artist shows herself at work on a large circular landscape painting. Women came slowly to landscape which at first figured only as a background to other subjects and then as small watercolours which amateurs had popularized. The work on the easel was probably suggested by other artists' paintings or worked up from a sketch on the spot.

All this to a man painter would have been little, or even to the famous Miss Angelica who added to her great facility has such a constitution that she is able to work from 5 in the morning till sunset in summer and during the whole daylight in winter, whereas Anne can not rise till eight or fall to work till ten, nor will she attempt it for any consideration, sleep being her only support as well as luxury.[29]

The Forbes family letters were written with the purpose of convincing Anne Forbes's Scottish backers that London was an unsuccessful experiment and that she would have more success if she worked in Edinburgh, but the details speak clearly about the realities of portrait painting in eighteenth-century London and by extension other northern cities. The short hours of daylight and the weak quality of winter light was a constant problem for northern painters. Mrs Forbes describes the dark foggy winter days in a letter of January 1773.

HISTORY PAINTINGS

As women artists grew increasingly ambitious, more of them attempted history paintings. Most continued the convention of painting heroines. Many of their works carried an erotic charge, an effect inevitably increased by the link between female artist and female nude.

(right) Constance Mayer, *The Dream of Happiness*, 1819 (detail).

(below) Angelica Kauffman, *Hector Taking Leave of Andromache*, 1769. Her classical subjects, though focusing on women, often, and unusually, include male figures.

(opposite top) Constance Mayer, *The Sleep of Venus and Cupid*, 1806. This painting was based on drawings by the artist's partner Pierre-Paul Prud'hon which gave rise to a criticism that her work was a copy of his.

(opposite below) Elisabeth Vigée-Lebrun, *Peace Leading Abundance*, 1780, an allegory subtly complimenting the French monarchy.

William Kent, *Lady Burlington at Work*, c. 1740. Lady Burlington was an accomplished amateur who unusually worked in oils (thought unsuitable for ladies because of the mess and smell) as well as watercolour. Shown here working on her double portrait of herself and her daughter, the outlines of an apron can just be made out.

Mr Berry has sat twice, and came today to have given a third but the day was so dark and the picture so wet that nothing could be done. Since Monday that he sat, Annie has not been able to paint a stroke by reason of darkness visible, I really never saw the like in our country the fogs have been so thick for many days past that in the streets people could not see above 3 or so yards around them and many poor folks have been run over and kill'd with carts and coaches.[30]

Painting was uncertain work. Mrs Forbes described the unsettling situation of wondering whether visitors to the studio would commission a painting. 'A coronet coach came the other day with 5 ladys, to look at the pictures they said they knew none of them and that there was not half enough pictures some of them had been here before as they asked in particular to see Miss Forbes's sister's picture with a guitar.' Waiting for someone to commission a work could be as humiliating as waiting to be asked to dance. 'Mrs. Pelham has at last favoured us with a call in, But no more, she is sitting to Sir Joshua, Miss Angelica and Dance.'[31]

One of the problems of portraiture was that the job was not finished when the painter had taken a likeness. Long hours then had to be spent on painting the sitter's clothes. Painting was a business like any other, and, if costed properly, a drapery painter could be employed for the purpose. Anne Forbes could not afford one and at one stage during her year in London she had thirteen heads completed awaiting the drapery:

The case is this to paint a drapery I must have it put whatever it is, gentleman's coat or lady's gown, upon a wooden figure which is set in the place where the person sat and is put in the same attitude they were in which figure must not be moved nor one fold of the drapery altered till the whole is finished which is always the work of several days indeed I may say weeks when it is a half length picture. The necessity then of working at draperys at this season was that I had little chance of any sitters I might get my figure set without running in danger of being disturbed.[32]

The Forbes letters reveal how important it was to have a well-managed studio, particularly when the main business was painting portraits. An efficient studio involved organizing the sitters, finishing work on time, delivering it and maintaining a cash flow. The letters make a sorry contrast with the experience of Mary Beale a hundred years earlier. Charles Beale's organizational role in keeping track of the progress of work, listing sitters and keeping records, and his practical role of buying materials and experimenting with paints and canvases to discover an ever shorter drying time, made the Beale studio a model of efficiency compared with the Forbes studio. Anne Forbes wrote to her sponsor Mr Chalmers on 17 November 1772

that 'so far from making what you calculated I could do, that I have just made £246, and on cashing up accounts of our outgoings of which there is no exact register, we have spent within a trifle of £500 and living at the same time the life of hermits.'[33]

All the successful painters were good managers. Elisabeth Vigée-Lebrun's success was not just a matter of presenting the sitters at their best. The *Advice on Painting Practice* she wrote for her niece reveals her to have been formidably professional. Before she dealt with posing the model and choosing the correct colours and lights and shadows she advised:

> You should always be ready half an hour before the model arrives.
> This helps to gather your thoughts and is essential for several reasons:
> 1 You should never keep anyone waiting.
> 2 The palette must be prepared.
> 3 People or business should not interfere with your concentration.[34]

Anne Damer, *Mary Berry*, c. 1800. Anne Damer was a wealthy and childless widow when she took up sculpture. Always serious about her profession, her amateur status was signalled by the title Honorary Exhibitor at the Royal Academy. The portrait bust is of her close friend, the woman of letters, Mary Berry.

Painting was messy work, not the image women wanted to project. In 1747, the amateur Lady Dorothy Burlington was drawn by William Kent at work on her self-portrait with her daughter. Close scrutiny suggests that she may be wearing an apron. Though a few male artists in this period began to show themselves in their workclothes in their self-portraits, women were reluctant to be painted or paint themselves in a manner which contravened eighteenth-century standards of femininity. It was risky for a woman artist to transgress conventional codes of dress. Fanny Burney described Katherine Read as 'a very clever woman and in her profession has certainly very great merit; but her turn of mind is naturally melancholy, she is absent, full of care, and has a countenance the most haggard and wretched I ever saw; added to which she dresses in a style the most strange and queer that can be conceived and which is worst of all, is always very dirty.'[35] Elisabeth Vigée-Lebrun, who took her appearance very seriously, went in for a kind of studied simplicity, all in white with a twist of muslin round her hair as she described it in her *Mémoires*. It may be that she is wearing her working turban in her Ickworth self-portrait although it is hard to be sure since she looks pretty enough to attend a party. She wears a similar turban in the self-portrait done for the St Petersburg Academy two decades later.

The first murmurs about cross-dressing are heard in this period. The gossipy Farington reported in 1798 that 'The singularities of Mrs Damer are remarkable – She wears a man's hat, and shoes, and a jacket also like a mans – this she walks about the fields with a hooking stick.'[36] It may be that working as a sculptor she found some elements of male dress more comfortable than traditional female clothing, or it may have been an expression of something more personal: at the time Mrs Damer was involved in a close friendship with Mary Berry. It is

(**above**) Elisabeth Vigée-Lebrun, *Self-portrait*, 1800. The artist, aged forty-five, is wearing the twist of muslin around her head that she had favoured since her twenties. Marie-Guillemine Benoist, *Pauline Bonaparte, Princess Borghese*, 1808. The artist suggests the femininity of her sitter, Napoleon's favourite sister, by posing her in a particularly large chair. Marie Benoist enjoyed two decades of success before being forced to stop when her husband was appointed to a high position in Louis XVIII's administration.

also possible that Farington's comment is an expression of the feeling that begins to be voiced in the period that any creative woman in an area thought of as male must have something masculine about her.

Marriage did not automatically prevent women working: the picture was more complex than that. A number of women painted for years until their husband's position made it impossible for them to continue. Marie Benoist had been exhibiting for two successful decades at the Salon when her husband was offered a government post of some status, a situation which forbade any further practice on her part. Though she could not ignore the diktat, she made her resentment clear: 'Do not be angry if at first my heart bled in making this decision – a decision demanded by a social prejudice to which one must submit after all. But so much study, effort, a life of hard work, and after

the long trials, the success, and to see them almost an object of humiliation – I could not bear that idea.'[37] Maria Cosway exhibited over thirty portraits and history paintings at the Royal Academy from her marriage to the artist Richard Cosway in 1781 to the birth of her daughter in 1790: 'Mr Cosway's wish was I should occupy myself as hitherto done in the Arts & so I did. The first pictures I exhibited made my reputation.' However, he seems to have lost enthusiasm for his wife's talent after a while: 'had Mr C. permitted me to paint professionally, I should have made a better painter but left to myself by degrees, instead of improving, I lost what I had brought from Italy of my early studies.'[38] It is possible that the conflict between Richard Cosway's original approval and his later unwillingness to let her paint professionally stems from his desire to have no taint of trade attached to her talent. From 1785 he was principal painter to the Prince of Wales and felt perhaps that it lowered his wife's status, and hence his, if she were to paint for money. Richard Cosway was well aware of his

Marguerite Gérard, *Bad News*, exhibited at the Salon of 1804. This artist made a reputation for meticulously finished anecdotal paintings of sensibility. Trained by her brother-in-law, the artist Fragonard, she worked in professional partnership with him until his death in 1806, then by herself with much success until she died in 1837.

Marie-Anne Collot: *Monsieur Falconet*, 1773; *Diderot*, before 1776. The bust of the sculptor who trained the artist and whom she assisted at the court of Catherine the Great, like the sculpture of the great critic Diderot, displays Collot's talent for suggesting in stone the mobility of her sitter's facial expression.

wife's charms. He did several self-portraits with her by his side, and the couple entertained constantly at gatherings at which Maria Cosway sang and played the harp. He had no quarrel with her displays of musical talent, which suggests that he wanted her to be an ornament along the lines of a talented amateur. On the other hand, he permitted her to work for money after she left him for long periods from the end of the century. From 1801 to 1803 she was involved in an ambitious project to reproduce the Old Masters of the Louvre as etchings. In the event, only eight plates were published and the project fizzled out.

A phenomenon of the period is the artistic non-marriage in which women worked in professional partnership with male artists. Constance Mayer had a professional and private relationship with Pierre-Paul Prud'hon. After the death of her mother, the fourteen-year-old Marguerite Gérard came to live in Paris with her sister and brother-in-law, the painter Fragonard. He taught her to paint and she worked with him for the whole of her professional life, collaborating with him but also producing many works of her own.

In 1763 when she was fifteen, Marie-Anne Collot entered the studio of the sculptor Etienne-Maurice Falconet, and when she was eighteen and a sculptor in her own right she accompanied him to the Russian court of Catherine the Great, staying there for twelve years. While in St Petersburg, she assisted Falconet on the head of his equestrian statue of Peter the Great, made models after the statue and worked independently on medals and portrait busts for members of the court. Her status is intriguing. Falconet's correspondence refers to his poor eyesight, and shows that he regarded Marie-Anne Collot as his right-hand woman. The only hint he gives of her personality is one

of charming compliance. At one point he refused a request to take on a pupil, explaining that he had become accustomed to the liberty of not teaching: 'A young man who knows nothing would be a torment, even were he sweet as a girl,' he told the empress.[39] Falconet was the mediator between the empress and his assistant. 'As she does medals so well, would she make me some more, for example Peter the Great and his daughter Elisabeth? I have a profile portrait of her by Caravaque that I've always thought one of his best.... I ask your advice on this and you will tell me what you think without worrying her by asking her to do too many things at once.'[40] Falconet agreed on her behalf. Even when she was in her twenties, Falconet tended to represent his assistant to the empress as a charming girl. Empress Catherine wrote, 'I think that Mlle Collot is very cross with me because the nightingale I promised her hasn't arrived.' In reply, Falconet painted a winning picture of his assistant's 'crossness': 'I do think Mlle Collot is cross with Your Majesty: for after working at her marble, she leaves it and excitedly says "the Empress is giving me a nightingale." I avow that this form of sulking looks most agreeable and I see with great pleasure that she looks set to make a head with a fine resemblance.'[41]

REPUTATIONS AND REWARDS

As women's art became more visible, the voices of the critics got louder. As a result of a number of developments – the growth of journalism, the spread of art as a topic of general interest, the fear that women might invade their profession – a new kind of criticism developed that was based solely on the maker's sex. When her work was weak it was typically female. When strong it had a masculine touch. Critics claimed that women artists had no intellectual capacity, displayed weak drawing skills, were temperamentally and technically unsuited to certain subjects. Over and over again, a successful artist is suspected of either having been helped by a man or of copying his work. No one escaped the attacks. Around the time of her entry into the Academy Elisabeth Vigée-Lebrun was frequently accused of not having painted her own works. The women in artistic partnerships were irresistible targets for the critics. In 1806, Constance Mayer was commissioned to paint *The Sleep of Venus and Cupid Disturbed by Zephyrs* for the Empress Josephine. The painting was based on Prud'hon's sketches giving rise to a criticism which would become all too familiar in the years to come:

> A student of Prud'hon, she has benefited from the advice and example of this pleasant painter and has identified so closely with his principles that her painting is an exact imitation of her master's manner. But as soon as she becomes more confident and devotes herself to the study of nature rather than other works of art, she will doubtless not delay in developing an individual manner and her original style.[42]

Even when female originality was recognized, it was at the expense of other women artists: 'Mme Auzou will never be reproached – as have several other women who have been accused (perhaps unjustly) of not having made the effort to complete by themselves the works exhibited under their names – with offering a work in which there are varied and often incoherent manners that cannot escape the connoisseurs' eyes.'[43] Such attitudes made it all the sweeter when talent was finally recognized. In 1776, Marie-Anne Collot returned to Paris for a year, bringing with her examples of the work she had done in Russia. Falconet reported to the Empress Catherine: 'It is to your protection, to your encouraging generosity that she owes the praises that she vainly desired in a country where everyone believed I did her work. They have seen her model and they have believed it. Our best artists and connoisseurs have said and written the most flattering things.'[44]

As always, the women carried on through the criticism. They may have been irritated but this did not stop them looking for work and

Louis-Léopold Boilly, *Studio of a Woman Artist*, 1800. Boilly, who often painted scenes of contemporary life, was quick to spot the charm inherent in the woman artist as a subject. In the studio, with its busts, casts, paints and clutter, sits an artist whose figure is advantageously displayed, watched by her companion in a boneless pose of fascination.

seeking success. Besides, critics could be gracious as well as scathing when judging women's work. 'This type of composition suits feminine talent better than the strong, pathetic and often terrible subjects that are often too much for the strength of a trained masculine talent, but how many young women dare to attempt such subjects, nevertheless', wrote a critic about Constance Mayer's *The Sleep of Venus*.[45]

Women continued to send their paintings to the powerful. Anna Dorothea Lisiewska-Therbusch sent the *Jupiter and Antiope* rejected by the Salon to Catherine the Great, and Diderot wrote from Paris to tell Falconet about the artist: 'She has said to herself: I want to be a painter; I will do everything I must to achieve it. I will call on nature without which one knows nothing; she has bravely undressed the model; she has looked at a nude man. You can be sure those gossips of both sexes haven't kept quiet. She has let them speak and she has done well.' He ended by throwing what sounds suspiciously like a challenge to Falconet's assistant: 'What do you think of that Mlle Collot?'[46]

The women of the period knew how to exploit their sex in pursuit of honours. In 1783, the eighteen-year-old Pauline Auzou exhibited a half-nude female *Bacchante* at the Salon. Female nudity from a woman's hand traded on the tendency of spectators to become excited by the link between the painter and her subject, and women were well aware that such works shouted out for attention: Elisabeth Vigée-Lebrun, famed from youth for her ability to capture a likeness, painted an allegory as her reception piece for the French Royal Academy in an attempt to prove that she was more than a mere face painter. The subject, *Peace Leading Abundance*, hit all its targets since it managed to be titillating in its link of female nudity to female painter, as well as a gracious compliment to the beneficent rule of the French monarchy. The real excitement came with the thought that a woman might be painting naked men. There is a telling account by Diderot of Anna Dorothea Lisiewska-Therbusch's demand that he remove his clothes when she was painting his portrait, his amazement illuminating what was considered 'normal' practice for women artists:

> When the head was done, it was time to do the neck, and the top of my clothing obscured it, which vexed the artist somewhat. To banish her vexation, I went behind a curtain, undressed, and appeared before her in the garb of a model at the Academy. 'I would never have dared ask it of you,' she said, 'but I am glad you have done it, and I thank you.' I was nude, completely nude. She painted me, and we conversed with a simplicity and innocence worthy of the first centuries.[47]

An artist like Angelica Kauffman, who included male characters in classical dress in her history paintings, obviously drew from models, and from there it was not too great a leap to imagine her painting them naked. The rumours that she worked from the nude male model

outlived her death in 1807. Years later, John Thomas Smith asked an 82-year-old ex-Academy model whether she really had worked from what he called an exposed male living model. 'He assured me that he did frequently sit before Angelica Kauffman at her house on the south side of Golden Square, but that he only exposed his arms, shoulders and legs, and that her father, who was also an artist and likewise an exhibitor at the Royal Academy, was always present.'[48]

Their clever deployment of strategies to get themselves noticed was applied to all the areas in which they worked. Elisabeth Vigée-Lebrun did more than give her sitters what they wanted. She colluded with them in setting trends. Before the Revolution, she wrote, no one wore shawls, but:

> I liked to drape my models with large scarves, interlacing them around the body and through the arms, which was an attempt to imitate the beautiful style of draperies seen in the paintings of Raphael and Dominichino. Examples of this can be seen in several of the portraits I painted whilst in Russia; in particular, one of my daughter playing the guitar. Above all I detested the powdering of hair and succeeded in persuading the beautiful Duchesse de Grammont-Caderousse not to wear any when she sat for me. Her hair was as black as ebony and I parted it on the forehead, arranging it in irregular curls. After the sitting, which ended round dinner time, the Duchesse did not alter her hair at all and left directly for the theatre; being such a pretty woman, she was quite influential and her hair style gradually insinuated itself into fashionable society and eventually became universal. This reminds me of the time when I painted the Queen in 1786: I begged her not to powder her hair but to part it on the brow. 'I shall be the last to follow that fashion,' said the Queen laughing. 'I do not want people to say that I have invented it to disguise my large forehead.'[49]

The right patrons remained as important as ever. With an eye to honours, the artists produced their portraits of the royal, powerful and intellectual. With an eye on their income and perhaps their social status, they made it their business to gather a circle of female patrons. Angelica Kauffman made a niche for herself as the painter of sympathetic portraits of upper-class, artistic and intellectual women during the years she spent in England. Another way to attract attention was to be part of the latest movements in art. Angelica Kauffman entered the English art history books by bringing the latest continental ideas to London. The work she did in England introduced neoclassical history paintings to a country where it was said only portrait painters could make a living. A critical comment reveals that several of Maria Cosway's history paintings of the 1780s explored the new subject matter of terror: 'of late Barry, Romney, Fuseli, Mrs Cosway, and others, have attempted to paint deities, visions, witchcrafts, etc., but have only been in bombast and without true dignity.'[50]

Some women artists succeeded in mixing socially with their patrons. The cultured world of well born women – reading, painting, singing, writing letters – led to female friendships and alliances that could benefit a clever artist. Angelica Kauffman was in Rome at two key periods of her life: as an adolescent when she took the town by storm, and again in her forties when she settled there with her second husband, a figure of great stature who bridged the worlds of aristocracy and art. So close was her friendship with the Duchess Anna Amalia von Weimar that a door was made in the wall dividing their gardens. The status and class of the amateurs offered the professionals a most attractive artistic persona. Angelica Kauffman borrowed it for the self-portrait she presented to the Uffizi collection in 1787, the very image of accomplishment as she sits with a portfolio by her side.

Elisabeth Vigée-Lebrun capitalized on her youth, talent and position as painter to Queen Marie Antoinette with her famous musical

Johann Georg Schütz, *Anna Amalia von Weimar and Her Suite at Villa d'Este, Tivoli*, 1789. Angelica Kauffman became a star of the Roman artistic world after settling there in the early 1780s with her second husband. This pen-and-watercolour drawing commemorates a poetry-reading outside Rome. The painter is third from the left; the Duchess von Weimar, her intimate friend, fifth from the right.

evenings where aristocrats met creative artists and talk of politics was forbidden. If ever there was a time when the female addition to society was appreciated, it was the late eighteenth century, and an artist like Elisabeth Vigée-Lebrun made the most of moving in circles of elegance, money and wit. Male and female sensibilities were thought to be complementary, men's centring on intellect and action, women's on intuition and emotion. Since the role of women was to complement the men, women played an important part in the social world as taste makers and tone setters.

The tale of Katharine Read offers a Hogarthian example of the downward spiral that could affect a woman who did not meet the feminine standards of the age. At the start of her career, all presaged well. Abbé Grant wrote from London in the 1750s that 'All the fine ladies have made it much the fashion to sit to my friend Miss Read, as to take the air in the Park.'[51] By the 1770s she was going out of fashion, and the young Fanny Burney's account of finding her altering a coat on her niece, the young amateur Nelly Beatson, suggests why she had become too eccentric to be popular. She found her 'piecing a blue and white tissue with a large patch of black silk! I believe there are few *men* in the world, who would not figure more

Johann Zoffany, *The Academicians of the Royal Academy*, 1771–72. The inclusion of the two nude male models meant that the two female founding members of the British Royal Academy of Art, Mary Moser and Angelica Kauffman, could not be shown among their fellow academicians. The artist has hung pictures of them on the wall instead, subjects of art instead of makers of art.

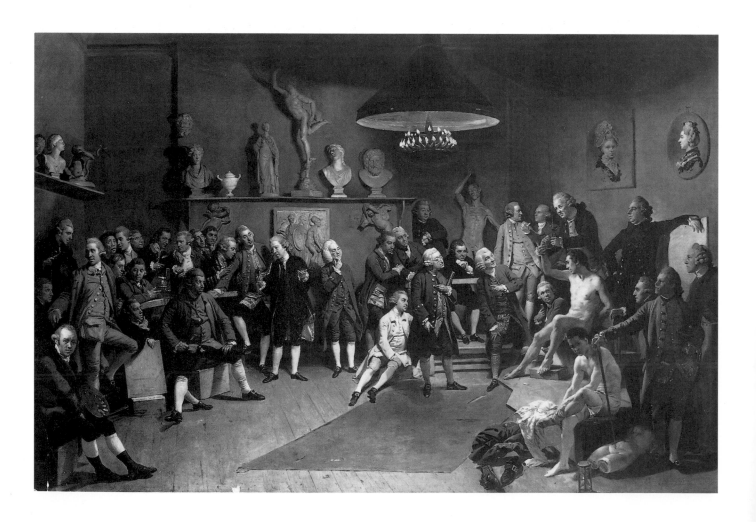

Mary Moser, *Female Nude*, late 18th century. Mary Moser is one of the mysteries of art history. Daughter of a Swiss portraitist and goldsmith, and a founding member of the British Royal Academy, she is usually referred to as a flower painter. This drawing suggests that her training was broader than might be deduced from that description.

creditably as mantua-makers. She had on a large dirty wing cap, made of muslin, and an half handkerchief tied over it as a hood...and a *shawl* that *had* been a very fine spotted one, but which was more soiled than if she had been embraced by a chimney-sweeper, was flung over her shoulders.'[52] This was written in 1775, four years before the painter set sail for India with the double goal of finding a husband for her niece and work for herself.

In order to put their work in front of the public the women sent it to the exhibitions whose development was a feature of the age. The exclusive nature of the royal academies, which by the end of the eighteenth century existed all over Europe, combined with the growing number of artists, encouraged the growth of exhibiting societies for those who had not achieved academic status. Women were quick to take advantage of these alternative exhibitions. The opening of the Salon to all, not just the academicians, after the French Revolution offered a chance to exhibit which the women seized on: a fifth of the exhibitors in 1808 were female.

Exhibitions acted as advertisements. As art became a social activity, the artists hoped to attract commissions from visitors who liked their style and subject matter – not that the strategy always worked.

When Ann came here she had in view many powerful patrons and who we suppose'd would not only shew her a way as a Artist but as a Gentlewoman, and that immediately she would have some faces to shew that were generally known, but vice versa no one has ever taken her by the hand or so much as come to see her works, all the world was at the exhibition and in the catalogue every artist's name and place of abode was mark'd so if any one had been so minded to do her service she was easy to be found.[53]

Prints were important in spreading an artist's fame, and the women made sure that their works were engraved. In England, where it became as fashionable to hang prints on the wall as to keep them in portfolios, there were more engravings after the work of Angelica Kauffman than by any other painter. 'Between 1774 and 1781...some 75 stipple engravings were published after her paintings and drawings, and nearly double that number appeared between her departure, in 1781, and 1800.'[54] Maria Cosway's paintings of the 1780s were engraved by the best printmakers of the day which added greatly to her reputation. The print made of one of Elisabeth Vigée-Lebrun's earliest self-portraits, her celebrated reworking of Rubens' *Chapeau de Paille*, was engraved: 'When this picture was exhibited at the Salon, I must say it did much to enhance my reputation. The celebrated Muller made an engraving from it; but you must feel as I do that the black shadows of an engraving take away all the particular effect of a painting such as this.'[55]

SKETCHING SEAT AND EASEL COMBINED,
ADAPTED FOR EITHER LADIES OR GENTLEMEN.
A new and very clever arrangement, and the most convenient and pleasant Apparatus ever introduced for the use of the Lady Sketcher.

THE EASEL SET FOR USE.

THE EASEL APPEARS
AS IT IN USE.

This Easel folds up in a similar manner to the German Sketching Seat, as shewn on the previous page, and occupies the same space. By a very simple contrivance the Desk is immediately attached to the Seat, and removed at the pleasure of the Sketcher. Price 30s.

Winsor & Newton catalogue, *Combination Sketching Seat and Easel*, 1849. There were so many women artists, amateurs as well as professionals, by the middle of the nineteenth century that they were targeted by advertisers. Non-smelling paints and parasols were other items sold to ladies.

The stakes were high and many women went for them. Stories of impressively high earnings surround the female stars of the age. Farington heard that Angelica Kauffman was said to have amassed a fortune of £14,000 from her fourteen years in England, and she left a fortune when she died in Rome. Elisabeth Vigée-Lebrun was supporting her widowed mother and young brother by the time she was fifteen and her womanizing and gambling art dealer husband until their divorce in 1794.

Artists actively pursued honours. Anna Dorothea Lisiewska-Therbusch was relentless in her pursuit of court positions, and when she got them she used her titles of painter to the Prussian King and later of painter to the French court as part of her self-definition. Many of the most famous women artists were made honorary members of academies, not just in their native country but in any country they happened to visit. Some of them, like Elisabeth Vigée-Lebrun amassed these honours as they travelled across Europe, adding them one by one to their collections like gold charms on a bracelet. Maria Cosway was invited to become a member of the Florence Academy when she was only eighteen. Recognition as a prodigy was about the only advantage women had over men where academies were concerned. An honour at so young an age was unlikely to come the way of a young man, and suggests that academies liked to recognize a pretty young talent and prized their power to do so. It was a sort of institutional avuncularity which rarely extended to the official election processes of the academies, as the fifty-one-year-old Margaret Carpenter discovered when her Royal Academy nomination was unsuccessful in 1844. Mary Moser and Angelica Kauffman were founder-members of the Royal Academy in Britain in 1768, a recognition so extraordinary that it deserves some thought. It seems unlikely that artistic politics were the only reason they were asked, though artistic enmities were as strong as allegiances at the time and there are some extraordinary absences from the list of founder members, Gainsborough for one. But even if this were the case, the women's selection could be defended. Angelica Kauffman was probably asked because of her friendship with the Academy's first president, Sir Joshua Reynolds, and because her role in introducing neoclassical history paintings to England accorded with his views about what constituted the finest art. Mary Moser was an artist's daughter as well as painter to the Queen and so it would have been thought politic to include her. Though such academic honours did not automatically confer the right to vote or to sit on committees, they added immeasurably to the artists' sense of their own worth and impressed those around them. Elisabeth Vigée-Lebrun recorded her academic honours on the titlepage of her memoirs when they were published in three volumes between 1832 and 1835.

Many glamorous tributes were laid at the feet of the successful. As the young and pretty painter to Queen Marie Antoinette, Elisabeth

Vigée-Lebrun was the toast of the town. After her first portrait of Marie Antoinette in 1779, which was a great success, she was taken to the theatre:

> As I had absolutely no idea of the surprise they had prepared for me,
> you can imagine my feelings when *The Art of Painting* came on to
> the stage and the actress playing the role proceeded to copy me in
> the act of painting the queen. At that very moment the entire audience,
> those in the stalls and those in the boxes, turned towards me
> and applauded heartily.[56]

In 1849, an illustration appeared in the Winsor & Newton catalogue of a combined sketching seat and easel. It was described as 'a new and very clever arrangement and the most convenient and pleasant apparatus ever introduced for the use of the lady sketcher'. There was no clearer way to prove that in today's jargon a new consumer group was being targeted. The stage was set for a transformation scene.

1850–1910
The Glory Days

*'I see only the end, the goal.
And I march straight on towards this goal.'*

MARIE BASHKIRTSEFF

These are the breakthrough years for women artists, the years when they won the right to train alongside the men. Although a woman's chance of becoming an artist still depended to a great extent on the permission and encouragement of others, the opening of art schools meant that she finally had a legitimate place in the art world. These were the glory days when everything seemed possible, as shown by the quotation above.

The chorus of opposition or derision continued, but a determined woman or one with a supportive family could for the first time finally get a training to equal the men. The expansion in their ambitions was helped by the expansion of female horizons in other areas: by the end of the century women had gained entry into universities and into some of the professions, and city streets were full of women rushing to their posts in shops or offices.

CAST OF CHARACTERS

A selection of the artists, some well known, some forgotten, whose writings and experiences reveal this era's optimism.

MARIE BASHKIRTSEFF was born in 1860 in the Ukraine and settled in Paris with her wealthy family in 1877. In the women's class at the Académie Julian she studied with Tony Robert-Fleury and Jules Bastien-Lepage and worked in a realist mode. Her journal reveals her conflict between the expectations of her wealthy family and her ambition, and is an invaluable social document. She died of tuberculosis in 1884 at the age of twenty-four, and the following year the Union des Femmes Peintres et Sculpteurs exhibited over two hundred of the pastels, sculptures and oils produced in her short but intense creative life.

ELIZABETH BUTLER (née Thompson) was born in 1846 into an educated family. Her sister Alice Meynell was a writer and poet. She was educated privately and at the Female School of Art in South Kensington. She made her name with *The Roll Call*, a battle scene, painted three years before her marriage to an army officer in 1877. In 1879, she was proposed for election to the Royal Academy, although not elected. She continued to paint military scenes through six children and her husband's foreign postings. By the end of the century her art was considered old-fashioned. Her autobiography is evidence of her pride in her career. She died in 1933.

MARY CASSATT, daughter of an American banker, was born in 1844, studied at the Pennsylvania Academy of Fine Arts (1860–64), and then in Europe. She never married, and when she settled in Paris, she was joined by her sister and parents. Degas invited her to exhibit with the Impressionists in 1877, and her future was set. She was an important influence on American collectors of avant-garde French art. She was awarded the Legion of Honour in 1904. She died in 1926.

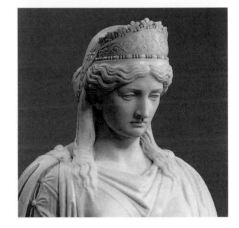

(previous pages) Eva Gonzalès, *Box at the Théâtre des Italiens*, c. 1874 (detail).
(this page, left to right) Marie Bashkirtseff, *Self-portrait with Jabot and Palette*, c. 1880 (detail). Elizabeth Butler, *Self-portrait*, 1869 (detail). Edgar Degas, *Mary Cassatt*, c. 1880–84 (detail). Harriet Hosmer, *Zenobia in Chains*, 1859 (detail).

HARRIET HOSMER, a physician's daughter, was born in Massachusetts in 1830. After learning sculpture privately and anatomy at Missouri Medical College in 1850, she studied with John Gibson in Rome in 1852. After 1854 she received financial support from Wayman Crow, father of her friend and biographer Cornelia Crow Carr. From 1863 she employed up to twenty-four assistants for her marble figures. She became a member of the Rome Academy in 1858. She returned to the USA in 1900, and died there in 1908.

LOUISE JOPLING was born in 1843. In 1867, a mother of three, she took lessons at Chaplin's women's class in Paris where her husband's career took the family. She began painting professionally in 1871 when she separated from her husband. In 1874 she married the watercolourist Joseph Jopling. In 1887 she opened an art school for women. In 1891 she published *Hints to Amateurs*, and in 1925 an autobiography, *Twenty Years of My Life*. She died in 1933.

PAULA MODERSOHN-BECKER was born in 1876 in Dresden, and trained as a teacher (a safety net) as well as an artist. She visited the German artists' colony of Worpswede in the late 1890s. A visit to Paris before her marriage to Worpswede painter Otto Modersohn in 1901, and three visits afterwards, set her on the path to her monumental and simplified portraits of peasants and still life. She sold little. She died three weeks after the birth of her child in 1907.

BERTHE MORISOT was born in Paris in 1841 into a cultivated family. Her father was a civil servant. She was supported by her family, and particularly by her mother, through training and travel to broaden her artistic mind, culminating in the mid-1860s with friendship with the avant-garde Edouard Manet. She exhibited at the first Impressionist exhibition in 1874, the year she married Manet's brother, and remained loyal to this style, exhibiting with the Impressionists each year save 1878 when her daughter was born. She died in 1895.

MAY ALCOTT NIERIKER, born in 1840, was immortalized as Amy in Louisa May Alcott's *Little Women* (1868). The success of her sister's novel enabled May, a student of William Morris Hunt in Boston, to take three study trips to London, Paris and Rome. In 1877, she had a still life accepted for the Salon. In 1878 she married a Swiss, Ernest Nicriker, settling in the Paris suburb of Meudon. *Studying Art Abroad and How to Do It Cheaply* (1879) was her guide for American women art students. In 1879 she died soon after bearing a daughter.

One character of the female art world lost her usefulness in this period: the female amateur artist. It was not that their numbers decreased. Far from it, when every schoolgirl learned to draw and amateur exhibiting societies were started in several cities. It was just that, as training for women improved, the amateur lost her importance in helping to familiarize society with the idea of women making art.

Two new developments replaced her in expanding women's opportunities as they entered the art world in increasing numbers: Bohemianism and feminism. The wave of feminism which crashed on to the shores of several countries in mid-century left notions of independence and equality in its wake. You did not have to be a paid-up feminist to clamour for access to the male art schools, go off with a friend to study art abroad or join a female exhibiting society. And you did not have to be a Bohemian to benefit from the daringly relaxed attitudes that were its legacy to the art world. Bohemia's entertainingly lawless face dates from Henri Murger's *Tales of Bohemian Life* of 1837 and its romantic one from Puccini's luscious opera, *La Bohème*, of 1887. Women had a place there, and not just as sexual companions to the men. French society's acceptance of Bohemian rules and values, so different from the bourgeois norm, helped create a space for the women artists who flocked to Paris in the century's last two decades.

The idea of the woman artist no longer seemed unusual. Images of women artists were everywhere. The women, particularly in the century's last two decades, painted each other, themselves, their art classes, their apartments and their studios. Male painters found them just as fascinating, producing dozens of portraits of women artists at work. Sometimes one wonders if reducing them to the status of subject matter was their way of dealing with the new female competition. The stereotypes certainly were. The incompetent female artist, the new woman, determinedly marching through the art school corridors, the Bohemian with paint on her nose and dishevelled hair were all beloved of writers and illustrators. The new mass-circulation magazines were hungry for stories, and the woman artist was one of those stories, illustrated at first with drawings and later with photographs reproduced by the new process of photogravure. These went a long way towards presenting art not just as a suitable profession for women but an attainable one as well. They gave ammunition to would-be women artists and encouraged their elders and betters to see a training for art as safe and suitable.

In a nod to the female invasion of the art world, histories of women artists were published in several countries, and these offered a validation for their modern daughters' choice of career. With the posthumous publication of the *Journal* of Marie Bashkirtseff in French in 1887, in English in 1890 and in German in 1891, women could read a contemporary first-person account of the pains and pleasure of

'Lady Students at the National Gallery', *Illustrated London News*, 1889. The last two decades of the century witnessed an explosive increase of women art students in the major art centres. The new mass-circulation illustrated magazines were quick to spot the potential for a story.

becoming an artist in Paris between 1877 and 1884. In 1898, Paula Modersohn-Becker told her journal: 'I am now reading the diary of Marie Bashkirtseff. It is very interesting. I am completely carried away when I read it. Such an incredible observer of her own life. And me? I have squandered my first twenty years. Or is it possible that they form the quiet foundation on which my next twenty years are to be built?'[1]

The young women understood that they were operating in a man's world and responded in different ways. Some denied the existence of male hostility. Anna Mary Howitt, recalling her student days in the Munich in the 1850s, wrote that, unlike many women who blamed men for their setbacks in the art world, she had experienced nothing but assistance from them.

'The Female School of Art', *Illustrated London News*, 1868. Founded to teach design in 1842, it followed the developing desire of women to train as artists and by this time was a well known London school for middle-class women.

And here the writer would add a few words as a living protest against a very common but thoughtless calumny, namely that it is man who thwarts every effort of woman to rise to eminence in the life of art…. Invariably and repeatedly, when a hand has been required to put aside the sharp stones and thorns which peculiarly beset a woman upon the path of Art, strong, manly hands have been stretched forth with noble generosity to remove them; and manly voices have uttered words of teaching, of encouragement, and of prophecy of happy achievement.[2]

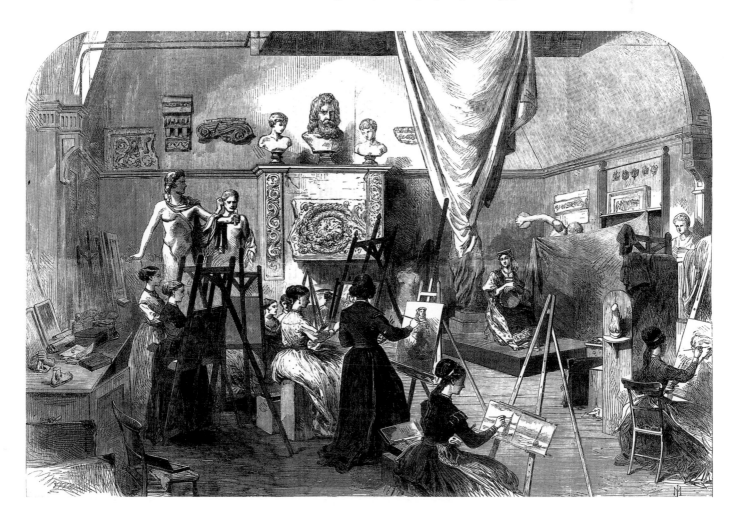

Others felt they would be taken more seriously by refusing to conform to conventional feminine behaviour. Elizabeth Butler wrote in a letter to a friend: 'I was never ill, or rather, I never allowed myself to be ill, or to have headaches and migraines to which so many girls in those days yielded obeisance.'[3]

Despite the problems, the great development of the period is that hundreds of confident women saw no reason why they should not produce the finest and most ambitious work of art. Their self-portraits shine with seriousness and single-mindedness. Women do paintings of themselves holding huge palettes, a sign of their ambition. They paint themselves with spectacles on their nose, in aprons and untidy hair, all signs of their lack of conventional female vanity. They paint themselves with a nude female model to illustrate the importance of life-drawing to their art. This optimism was never to be repeated, for at this stage there were no troubling case histories to show that despite their access to training, women still faced circumstances and situations that the men did not have to deal with.

Elizabeth Butler, *The Roll Call*, 1874. This huge scene of soldiers after a battle in the Crimean War made the young artist's reputation. Police had to control the crowds who tried to get a glimpse of it in the Royal Academy. Queen Victoria commanded that it be taken to Buckingham Palace, and bought it from the Manchester industrialist who had commissioned it.

The important story of this period is the proliferation of educational opportunities for women. Although it is traditional to focus on the opening of national academies to women when their training is under discussion, in my view this distorts the women's experience. The fact is that the opening of the academies was preceded by a huge expansion and variety of training opportunities which developed in response to the women's desperation to learn and their frustration at the state art academies' reluctance to let them in.

As the period opened, they could study with one of the male artists sympathetic to women: photographs of groups of women students clustered round their male teachers are the period's equivalent to Adrienne Abel de Pujol's early nineteenth-century painting of her husband's class for women students. If time, circumstance and locality were right, an artist could be responsible for training a cluster of successful women artists, as was the case with William Morris Hunt in Boston from 1868 or Charles Chaplin in Paris around the same time.

The one thing the women could not do was find everything they needed in one place, and so for them training at mid-century was a matter of piecing together the components of an artistic education as best they could. Though Elizabeth Butler was born into a family sympathetic to women's self-expression, she still had to build an art education for herself in the England of the 1860s when no complete and structured female course of study existed. When she was fifteen, she copied her teacher's copies of Edwin Landseer's works. In 1861 she enrolled in the elementary class of the Female School of Art in South Kensington, leaving in 1863 after deciding its stress on design was irrelevant to her needs. In 1866, after several years of travel with her parents, she enrolled once more at the Female School of Art, this time in the advanced class. After two months spent drawing from plaster casts for five hours a day, she graduated to the life class, which offered models in various types of fancy dress. Dissatisfied with this, she found a private life class where the 'undraped female' was on offer. Finally, she took anatomy lessons in Florence (her parents were great travellers) and in four years had produced her first masterpiece, *The Roll Call*.

Many women travelled all over Europe to get their education. In the first two decades of the period, Munich, Düsseldorf and Vienna were popular with painters, Rome with sculptors and London with watercolourists. Different nationalities tended to congregate in different centres – Vienna, for example, attracting the Poles and Munich the Russians. One of the travellers was the American May Alcott, immortalized as the luxury-loving sister Amy in Louisa May Alcott's *Little Women* of 1888. The success of her sister's novel meant that May, who had been a student of William Morris Hunt, was able to take study trips to London, Paris and Rome. In 1877 she had a still life accepted for the Salon, and in 1878 she married and settled in the Paris suburb of Meudon. She died in 1879, six weeks after the birth of

Marie Bracquemond, *Woman at Easel*, c. 1890. The artist, one of the four French women Impressionists, made this etching at a time when her career as an artist was fading, in part due to her engraver-husband's lack of encouragement.

her daughter. 1879 was also the year of the publication of her pamphlet, *Studying Art Abroad and How to do It Cheaply*, a guide to London, Paris and Rome for American women students. Given the prevailing view of the constricted lives of nineteenth-century women, some of the women's stories can seem surprising. For example, in 1864 Elizabeth Gardner, aged twenty-seven, turned up in Paris from Boston, Massachusetts, with commissions to copy paintings in the Louvre.

Not everyone could travel, not everyone had sympathetic parents, not everyone knew the names of the teachers who were sympathetic to women, but the point is that the opportunities were there and determined women could find them. The educational histories of the women associated with the early days of French Impressionism reveal the variety of learning paths that prepared them for practice in 1870s Paris. Berthe Morisot went from teacher to teacher until her contact with Manet enabled her to benefit from a mutual exchange of ideas and influences. Mary Cassatt attended women's classes at the Pennsylvania Academy of Fine Arts before touring Europe to study the great masters and refine her technique with an assortment of teachers. Eva Gonzalès did what ambitious men had done for centuries, starting with the fashionable portrait painter Charles Chaplin in his women's class and then deciding that her future demanded a time of study with the avant-garde Manet. Marie Bracquemond was a graduate of Ingres' studio whose knowledge of contemporary art expanded after marriage to the engraver Félix Bracquemond. Their commitment to Impressionism was backed by completely different educational experiences.

ART CLASSES FOR WOMEN

After about 1870, the familiar female routes to professionalism – family workshop, private lessons, male artist's studio – were joined by the introduction of all kinds of art classes for women. Naturally standards varied from school to school. In Paris, for example, the sculptor Mme Léon Bertaux opened a female sculpture class in 1873 and a school in 1879. The reasons for establishing such schools varied. Mme Léon Bertaux was devoted to the cause of women's artistic education and campaigned tirelessly for a better deal for women artists. Other women thought of it more as a money-making enterprise, and it is noticeable that a number of private single-sex art schools were set up by women painters after the death of a husband. After becoming widowed for the second time in 1884, Louise Jopling opened a school for girls featuring her famous demonstration class and an intake composed mainly of friends and amateurs. Judging by the aristocratic names on her register, the school for girls opened in London by Henrietta Ward in 1880 was inspired less by any desire to equip her pupils for a career than to exploit her connections as the painter of Queen Victoria's children.

By 1870 the most exciting destination for an aspiring woman artist was Paris. This development is the key to the way women artists felt about themselves in the period. By the end of the 1860s, word had reached the well informed that Paris was the centre of the art world, and by the 1880s information about the women's studios – the *ateliers* – was widely spread. Accounts of young women students in Paris, the capital of wickedness as well as of art, in which, it goes without saying, the women's lives were shown as innocence itself, began to appear in the illustrated press from the 1880s onward. Though other cities had their followers, it is impossible to overestimate the importance for an aspiring artist of time spent in Paris.

Obviously parental nervousness about their daughters going off to live in Paris could affect the women's opportunities. Beatrice Elvery's parents allowed her to leave Dublin to take up a three-week scholarship to the South Kensington School of Art in London at the turn of the century. 'Before I went my father said he wanted to warn me about some dangers I might encounter. I was embarrassed, as I thought he was going to talk about men. But he only wanted to tell me about a cousin of ours who had gone to England and become a Roman Catholic, and later, a nun.'4 However, while London for their sixteen-year-old daughter was acceptable, Paris a few years later to learn to carve in stone was not. 'My father seemed to think that for a young girl "going to Paris" was going to something worse than death. In every way he tried to dissuade me, saying, "If you go to Paris, who will help your mother with the children?" and adding, "If you go to Paris it will break your grandmother's heart." '5 So she stayed in Dublin and worked in the stained-glass studio set up by Sarah Purser.

The surprise is not that women had to deal with family nervousness about their travels but the fact that so many went off on their own. It was no longer necessary to have a male companion to steer one through the packet ships, inns and coaches of foreign travel, and companions tended to be sisters, mothers and friends of their own sex. There were a variety of travel arrangements, and one can make out no rules except to say that as girls got older their parents seemed more resigned to let them go off to study. Perhaps it was felt that their marriage prospects were shrinking. May Alcott Nieriker assumed that her American readers would travel alone to seek their artistic education in Europe.

It is impossible to overestimate the importance of a spell in Paris for the ambitious young women artist of the last third of the nineteenth century. The learning profiles of many of the well known women artists educated in the century's last three decades involve a period at one of the women's classes in Paris. Certain schools crop up repeatedly in the biographies of women painters. In the '60s and '70s it was the life class set up for women by the society portrait painter Charles Chaplin that attracted the ambitious, including two of the female

Sarah Purser, drawings of a female nude, 1878–79, and a male nude, c. 1879. By the late nineteenth century, women artists at private classes and schools in Paris were drawing from the nude model. Sarah Purser did studies of the female nude and probably also of the male nude during her months at the Académie Julian in 1879–80.

Impressionists, Eva Gonzalès, who studied with him from 1866 to 1867 before switching her allegiance to the more adventurous Manet, and Mary Cassatt in 1867. In the '70s and '80s, Julian's was the most exciting place for women students, training among others the Polish Anna Bilińska-Bohdanowicz, the Irish Sarah Purser, the Russian Marie Bashkirtseff and the American Cecilia Beaux. In the 1890s, women could study with men if they wished at the Académie Colarossi, or the Académie de la Grande Chaumière.

The point about Paris is that it offered an educational and living context for the women painters from all over the world who gathered there. It was actually set up for them. May Alcott Nieriker explained the local customs and ran through all the options available for women artists who wanted to settle there. She lists places where young women could go to eat an inexpensive meal or find respectable lodgings, and she prepared the American art students for what they would find:

> All Paris, however, is apt to strike a newcomer as being but one vast studio, particularly if seeing it for the first time of a morning, either in summer or winter, between seven and eight o'clock, when students, bearing paint-box and toile, swarm in all directions, hurrying to their course; or still more when artistic excitement reaches its height, during the days appointed for sending work to be examined by the jury of the Salon. Then pictures

literally darken the air, borne on men's shoulders and backs, packed in immense vans, or under an arm of the painter himself, all going to the same destination, – the Palais de l'Industrie on the Champs Elysées.[6]

Many young women had the time of their life in this city, which offered them friendship, freedom and a purpose. They left a life as daughters to enter a world where they had to take charge of their lives and where everything from whitewashing a wall to eating in a café was an exciting adventure. In the Paris studios, they met women from all over the world. Language barriers made close transnational friendships difficult, but they did occasionally come about: the life-long friendship between the Irish Sarah Purser and the Swiss Louise Breslau was facilitated by Sarah Purser's several years at school in Switzerland, so language was not a problem.

In Paris, women found a female version of the male *atelier* system which for a fee offered a model and weekly criticism from a well known artist, and then mostly left the students to themselves. Although there tended to be a studio style, the element of copying that was an inevitable result of the old master-pupil method was weakened in the *ateliers* since instruction came from a roster of visiting teachers.

Until the end of the century, most classes were single sex. In 1867, Louise Jopling, a young British mother living in Paris, was encouraged by the Baroness de Rothschild to attend Chaplin's class: 'His was the only *atelier* at that time where all the students were women, so that careful mothers could send their daughters there without any complications arising between the sexes.'[7] It was probably this popularity that encouraged Rodolphe Julian, the owner of the Académie Julian to change from the mixed-sex classes he started in 1867 to single-sex classes in the early '70s. Judging by their accounts of their training, it was helpful for many women to attend single-sex classes where hard work and competition with each other focused their ambition and protected them from debilitating attitudes about their capabilities. If and when they were finally faced with hostility, they had their training to give them confidence, and no reason to doubt their place in the art world. By the end of the century, single-sex education had begun to seem old-fashioned and it became more common for both

Marie Bashkirtseff, *Life Class in the Women's Studio at the Académie Julian, c.* 1881. This is a contemporary engraving of a picture painted while Marie Bashkirtseff was a student at the Académie Julian. She exhibited the original painting in the Salon of 1881 under the name of Mlle Andrey

sexes to study together. Some *ateliers* offered women a choice of segregated or mixed classes. In 1901 Kathleen Bruce, later to make her name as the sculptor Kathleen Scott, left the women's class at the Académie Colarossi in Paris in order to join the mixed sculpture class: 'Middle-aged women eating their hearts out year in year out, and for what? In order that on some day of an impossible future she may have a picture in the Salon.'[8]

The weekly criticism involved a ranking in order of merit. By releasing the caged competitive strand in women it helped develop the single-mindedness necessary to success, far more helpful in developing their abilities than the flattery and over-praise which tended to draw the teeth of women's urge to compete. Marie Bashkirtseff revealed her thoughts to her unshockable journal: 'That creature Breslau has done a composition *Monday Morning*, or *The Choice of a Model*. It is done correctly and the perspective is good, the likenesses, everything is there. When you are capable of doing a thing like that, you are certain to

(above) Edouard Manet, *Eva Gonzalès in Manet's Studio*, 1869–70. (right) Edgar Degas, *At the Louvre (Mary Cassatt)*, 1879–80. Manet's twenty-year-old pupil is painting her entry for the 1870 Salon, while Degas's fashionably dressed fellow-artist (here in her mid-thirties) is shown studying the paintings in the Louvre. Eva Gonzalès and Mary Cassatt – one French, the other American – found their way into the Parisian avant-garde through talent, ambition and openness to ideas.

become a great artist. You can guess, can't you? I am jealous. That is a good thing because it is an incentive.'[9]

Competition existed with the men as well as with each other. The women were not merely looking over their shoulders to check that they were doing as well as the men. They were checking to see that their opportunities were equal. Success was the goal, and they wanted nothing left out of their teaching that could bring it about. As Marie Bashkirtseff wrote in her journal: 'He says that sometimes his female students are as clever as the young men. I should have worked with the latter, but they smoke – and, besides, there is no advantage. There was a time when the women had only the draped model; but since they make studies from the nude, it is just the same.'[10] A belief that their training was as good as the men's encouraged them to work as hard as they could, and it is no chance that so many of the women who passed through Paris went back to their respective countries full of the sense of themselves as artists.

The women art students in Paris were remarkably independent. May Alcott Nieriker's assumption that it was perfectly acceptable for a woman to travel abroad to study art is a corrective to the conventional view of the nineteenth century with woman as angel of the house and man as master of the world outside. Marie Bashkirtseff's lament about her longing for the freedom of men to sit in the Tuileries has been much reported:

> What I long for is the freedom of going about alone, of coming and going, of sitting on the seats in the Tuileries, and especially the luxury of stopping and looking at the artistic shops, of entering the churches and museums, of walking about the old streets at night; that's what I look for; and that's the freedom without which one can't become a real artist....Curse it all, it is this makes me gnash my teeth to think I am a woman. – I'll get myself a bourgeois dress and a wig and make myself so ugly that I shall be as free as a man.[11]

May Alcott Nieriker had no time for such moans. She expected her Americans to go anywhere, even the notorious Seven Dials area of London, and recommended sturdy boots for the purpose, preferably made in England: 'A well made pair of London guinea boots will wear out three pairs of Paris make; so the conclusion is that for everything substantial, from national characteristics to matches and pins, one must go to England and the English!'[12]

The contrasting attitudes of Nieriker and Bashkirtseff show how hard it is to generalize. In fact, both women were right, and each woman could at times sound like the other. May Alcott Nieriker was aware of the difficulties of a woman loitering in public. Her practical solution to 'the impertinent rabble that immediately collects to look over one's shoulder' when painting a street scene was to hire a small

carriage by the hour, 'seated in which, with pencil or brush, they can catch a likeness of the passers or desired object, unobserved and unmolested.'[13] And Marie Bashkirtseff got her chance to go about with some friends from the studio:

> We walked about on the quays, looked at the old books and engravings, and talked art. Then in an open fiacre we went to the Bois…all would have gone well enough if we had not met the landau with all my family, which took to following us…they saw me, and I knew it, but did not care to speak to them before my artist friends…. I had my cap on my head and I looked untidy and uncomfortable. Naturally, my people were furious, and more than that, hurt with me.[14]

Whether family or rabble was responsible for the torment, women were forever made to feel self-conscious. But despite this, they would not be shaken from their goal.

In the summer, the more adventurous women, or those aware of the latest trends, found their way to the artists' colonies which had developed since the 1860s out of the fashion for painting in the open air and admiration for the unspoiled rural life. The village of Pont-Aven in Brittany, frequented by Gauguin in the 1880s is the best known, but every country had them, often sited by the sea where the changing light and vistas attracted artists in search of landscape and local colour. Their core of established artists attracted followers from the towns in the summer months in search of fun, cheap living and a chance to share in new developments.

Unlike the men, who had the opportunity of free art education at the Ecole des Beaux Arts, the women had to pay for everything, and often more than the men. At Julian's the women's fees were twice those charged for the men. Not all the women students were wealthy. May Alcott Nieriker aimed her advice at a woman who is 'a thoroughly earnest worker, a lady, and poor, like so many of the profession, wishing to make the most of all opportunities, and the little bag of gold last as long as possible.'[15] Many women had to scrimp and save to study in Paris. Sarah Purser was given £30 by her brother to last her six months; she managed by sharing a flat with the Swiss artists Louise Breslau and Sophie Schepper and the Italian musician Maria Feller. Marie Bashkirtseff, who had no money worries herself, was impressed with their boarding-house lodgings: 'Quite an artistic garret, and so clean that there is a look almost of wealth about the room…sketches, studies and a lot of interesting things about the room. This contact with artistic things, this atmosphere does me good.'[16] May Alcott Nieriker advised women furnishing a small apartment to buy at auction: 'Not perhaps quite new, but if carefully selected, suitable to adorn an American studio when no longer needed in France. And as household articles after a year's use, together with bric-à-brac which

belongs in the category of 'artist's tools of trade', can pass the customs free, the question of heavy duties in transporting such has not to be considered.'[17] The ever-practical Nieriker told her American readers to take their oldest underclothes to Paris: 'I say old underclothes, because the grime of London and the acid used by all Parisian *blanchisseuses* soon rot and spoil anything delicate or nicely trimmed, and as the old things become too thin for use, but invaluable as paint rags (which artists so often have to buy), they are easily replaced by ready-made strong ones at small expense.'[18] The women even found ways to save on fees. Kathleen Bruce won a competition at Colarossi's within months of arriving. 'I was then appointed *massier*, which meant

(above) Giovanni Fattori, *The Young Student at Her Easel by the Sea*, 1893.
(right) John Lavery, *Painting on a Summer's Day*, 1884. Impressionism brought with it the cult of painting outdoors, something previously reserved for watercolours. Artists' colonies became a feature of the last third of the nineteenth century. Usually presented as the rural or coastal summer habitat of male artists, Lavery here depicts a woman painting by the river at Grès-sur-Loing in France.

ARTISTIC FRIENDSHIPS IN PARIS
(top) Louise-Catherine Breslau, *Les Amies*,
1881. The artist paints the friends with whom
she rooms – musician Maria Feller, and,
sketching centre, Sophie Schepper.
(left) Sarah Purser, *Le Petit Déjeuner*, 1881,
showing Maria Feller – for one winter, Sarah
Purser also shared lodgings with them all.
(above) Harriet Backer, *Portrait of Kitty
Kielland*, 1883, a corner of which is seen
(opposite) in Kitty Kielland's *Studio Interior,
Paris,* 1883, a studio they both used.

Auguste Rodin, *Muse for the
Monument to Whistler in his
Studio, c.* 1906 (detail).
The artist Gwen John was the
model for this memorial sculpture.
She boosted her income in Paris
at this time by modelling
for other artists.

that, in exchange for working without paying, I was to be responsible
for posing the model on Monday morning, called "C'est l'heure" a
quarter before the hour for the model to rest, stoking the fire, and
opening the windows at lunch-time. There were plenty of men in the
class ready and anxious to do these jobs for me.'[19]

In order to make some money, the English artist Gwen John began
to work as a nude model in 1907. Her most famous client was Rodin,
who started an affair with her while she was modelling for his study
for his monument to Whistler, a sexual episode for him but years
of unrequited passion for her. She did not enjoy modelling and tried
to pose only for women, although she did not like it when they
attempted to kiss her – female models were sex objects for either sex
it seems. Her stories about the dreadful women who employed her
offer a neat reversal of artists' stories about their impossible models
which were a commonplace of the period. Although some became
friends, to go about with for the day or to offer sympathy for a cold
or utensils for the kitchen, Gwen John was acerbic about many of the
women who painted her, and one senses her female circle in Paris was
as much a matter of convenience as of choice.

NEW FREEDOM AND NEW FRIENDS

The excitement and friendships of their independent life can be felt in
the paintings they did to celebrate it. Much is made in the art historical
literature of the portraits the male painters did of each other – for
example, Gauguin and van Gogh in 1888 and Marquet and Matisse
in 1905 – but the women, full of their new-found freedom, did them,
too. In 1883, the Norwegian Kitty Kielland painted the Paris studio
she shared with Harriet Backer. This painting is a female variation
on the theme of a shared commitment to friendship and art, since on
the easel is Harriet Backer's portrait of Kitty Kielland and above
the desk is a landscape signifying their commitment to the new art
of light and colour. On a more informal level, it was common
practice for the women to draw and paint their friends. Sarah Purser's
sketchbook contains Louise Breslau's drawing of their flatmate Sophie
Schepper as well as her own sketch of Louise Breslau. This shared
use of a sketchbook is an evocative example of friendship.

Just as Rome in the eighteenth century was a place to improve one's
art and a place to begin to paint professionally, Paris served as both
in the nineteenth century. 'At last I am working with artists, real
artists, who have exhibited at the Salon, and who sell their pictures
and portraits – who even give lessons,' reported Maria Bashkirtseff
to her journal after starting at Julian's in 1877.[20] One of the great
encouragements to the women who studied in Paris was the chance
of having a painting hung in the Salon, the huge winter exhibition,
while they were still students. In the last two decades of the century,
a fifth of the exhibitors were female. Since a student's success

reinforced the reputation of her teacher, their tutors encouraged them to exhibit, even going so far as to suggest ideas. Julian was the source for Marie Bashkirtseff's Salon exhibit for 1881. 'As for the subject, it does not fascinate me, but it may be very amusing; and then Julian is so taken with it, and so convinced…. A woman's studio has never been painted. Besides, as it would be an advertisement for him, he would do all in the world to give me the wonderful notoriety he speaks about.'[21] Most had no money for models and so they modelled for each other. Sarah Purser's Paris flatmate, Maria Feller, was the model for her painting, *Le Petit Déjeuner* (Breakfast). Maria Feller also modelled for Louise Breslau's Salon painting of 1881 *Les Amies* (Friends), as did Sophie Schepper who is shown at work sketching. The fourth roommate, Sarah Purser, had gone back to Dublin by then. Her success in having two paintings chosen for the 1879 Salon exhibition, just months after she had begun to study at the Académie Julian, can be

Cecilia Beaux, *Les Derniers Jours d'enfance*, 1883–85. This painting won a prize in the 1885 show of the Pennsylvania Academy of the Fine Arts, and its success at the 1887 Paris Salon decided the artist to enrol at Julian's in 1889. In 1895 she became the first woman to teach full time at the Pennsylvania Academy.

matched by women from every country. The American Cecilia Beaux was encouraged by the Salon's acceptance of her painting *Les Derniers Jours d'enfance* in 1887 to travel to Paris to study. A young artist who had had a painting hung in the Paris Salon could work in her native country backed up by French recognition as well as French training.

It was a slow process but one by one, the national academies opened their doors – or rather, all their classes, as opposed to one or two – to women, forced to do so by changes in the educational and social climate and lobbying by the excluded. Women were in the British Royal Academy by 1861, but Louise Jopling had no illusions about the restrictions they faced. Recalling the 1860s, she wrote that although women had got into the Royal Academy schools, 'A female student was not allowed to study from what is euphoniously called, "the altogether." With such a handicap is it surprising that for a time women lagged far behind men in the race for fame?'[22] Women were finally let into the Royal Academy's life class, the sacred mystery of art education, in 1893. In France, the Union des Femmes Peintres et Sculpteurs under the leadership of Mme Léon Bertaux, campaigned through the '80s and '90s for the Ecole des Beaux Arts to open its doors to women, which it finally did in 1897. Such strategies were mirrored in other countries.

It is clear that by the time the national art academies decided to let the women inside their doors, the women had already found ways to get themselves an education that would equip them for their lives as artists. The provision of female art education had been improving through the century and the opening of the national art academies was little more than an underlining flourish. Furthermore, by the time they opened their doors to women, the national art academies were no longer the sole source of reputable academic art training. The state was increasingly taking on responsibility for education, and, as a result, new art schools were started, either state-supported as part of a national higher education system or with some sort of semi-official status. Exasperation with traditional educational methods, plus the liberating luxury of starting from scratch, meant that these new schools could incorporate modern ideas and teaching methods so that less time was spent copying from drawings and casts and more time experimenting and working from life. Most of these new schools extended this modernizing frame of mind to their intake and admitted women as students. Women did well at these schools, such as the Slade School of Art (founded in 1871 by the University of London in reaction to the conservative teaching of the Royal Academy Schools), the Glasgow School of Art (whose successful female students round the turn of the century were known as the Glasgow Girls), and the private but democratically run Art Students' League in New York which was sympathetic to women from its opening in 1875.

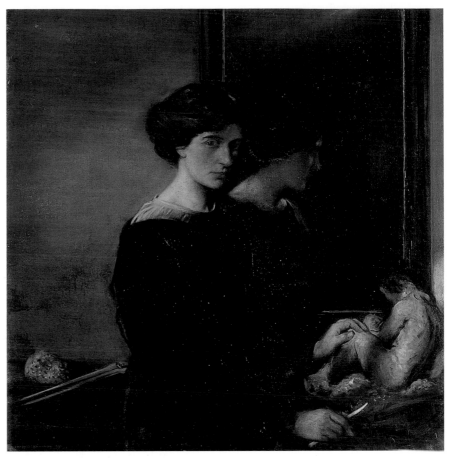

(above) Louise Jopling, *Phyllis*, 1883. One of the first English artists to study in Paris, she painted pictures with Pre-Raphaelite overtones, much appreciated in Britain.
(right) Charles Shannon, *Portrait of Miss Bruce*, 1907. Kathleen Bruce, who studied in Paris 1901–6, became known as a sculptor of modern heroes.

The way that official developments followed in the wake of change is shown by examining women's access to the nude male model, the key issue in their struggle for equality of training. The argument against allowing women to draw the nude was usually expressed as a horror of defiling natural female modesty, but was really the result of a knot of assorted attitudes which included men's, doubtless unexamined, attitudes to their own sexuality. The women were formed by these attitudes, too, and had to find arguments to counteract them. The young Marie Bashkirtseff's rationale for the nude model was that a beautiful body banished low thoughts: 'If, on seeing a woman naked, you feel that it is wrong, this woman is not the highest expression of beauty, since there is room in your mind for an idea other than that which should pass to your brain through your eyes. You forget the beautiful, to think of the nude.'[23] The thrice-married Louise Jopling wrote from the calmness of old age and the conviction that women were not aroused in a similar manner to men, that, 'It is no shock to a girl student to study from life. With youths it is, perhaps, different, owing to the survival of the monastic method of segregating them from girls of their own age.'[24] Despite Jopling's argument, the first sight of the male life model was a shock to some. The convent-educated twenty-three-year-old Kathleen Bruce, went to Paris with two friends in 1901 to study at the Académie Colarossi:

In the school where we three worked new figure models were chosen every Monday morning. On the first day, passing an open door of one of the studios, I saw Hermione standing at the back of the room near the door and went to join her. Hermione was standing composedly with her head critically on one side. At the end of the studio passed one by one a string of nude, male models. Each jumped for a moment on to the model throne, took a pose, and jumped down. The model for the week was being chosen. Before reason could control instinct, I turned and fled, shut myself into the lavatory, and was sick. How could my lovely Hermione stand there, so calmly appraising? How could she, how could she? Then I shook myself. "Fool! Puritan! They'll guess how you feel if you're not careful. Go back this moment and copy Hermione's nonchalance, you vulgar little thing!" It took a very short time for me too to cast an appraising eye over a model, as critically as a pianist running his fingers over the piano upon which he is about to play.[25]

There were ways round the system for those in the know. In the private classes, nudes were on offer. Sarah Purser's sketchbooks of 1878 to 1879 show a variety of nudes: completely nude women, men in a sort of underpant arrangement, men with no clothes on at all. In 1880 Marie Bashkirtseff wrote: 'Our studio is getting like the men's studio, that is to say we have the nude all day long, the same model in the same attitude.'[26] If the authorities did not supply a nude, then the women set about finding one for themselves – one more example of their determination to get what they wanted. In Paris in 1865, Elizabeth Gardner was one of a group of women who hired models to study from in the evenings. As a student at the Royal Academy in 1879, Margaret Dicksee helped organize a model to pose for some of her female student friends at her father's studio in Fitzroy Square.

It was in the state and semi-official sector that life drawing was a problem, for those in the business of public education were at the mercy of public opinion. The authorities did all they could to prevent the women coming face to face with complete nudity: semi-clad was the answer in most cases, and, if the demands of the women made full nudity unavoidable, then nude women were more acceptable than nude men, and this remained the case till the end of the century. The abortive attempts to get nudes and female students together which have become the myths of feminist art history come from the public not the private sector. When the Royal Academy Schools in London

'The Mixed Antique Class at the Slade School of Art', *Illustrated London News*, 1881. The Slade School, founded as part of London University in 1871, accepted students of both sexes, and women and men studied together in many of its classes.

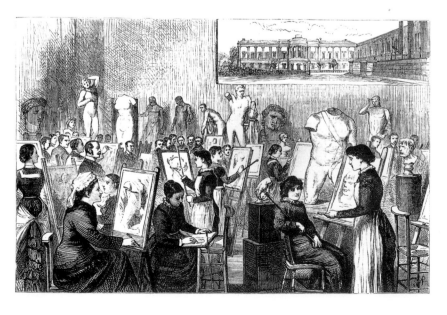

finally capitulated, the by-laws were changed to specify the precise details of undress of the male model in the female life class: the man had to wear a modest little underpant arrangement held up by a leather belt. The whole area made people very nervous. Beatrice Elvery recalled that her teacher encouraged the students at the Royal Hibernian Academy's School to watch the human body in action.

> We had a young male model, an Italian born in Dublin. Instead of returning into the model's cubby-hole in the corner of the room during the rests, Hughes encouraged him to associate freely with the students; he didn't really need any encouragement. Hughes said we must watch the human figure in movement; watch it all the time, not only while the model was posing. So during the rests we all sat on the hot pipes together. When the Inspector of the Board of Education came round, this behaviour led to some shocked comments. Hughes received an official instruction saying that the nude models were not to associate with the young lady students. Hughes was very angry and replied that he considered it part of the young ladies' artistic education to become familiar with the naked human form. The Board of Education decided to leave us alone.[27]

One advantage to women of their acceptance by the state schools was that it stopped them being at the total mercy of the private institutions whose prices and rules were imposed at the whim of the owner. The academic artist Hubert von Herkomer opened a school in 1888 on the outskirts of London which was well respected and accepted women artists – as long as they were single. It is just one more example of the arbitrariness of female training since both Julian and Chaplin had accepted married women back in 1860s Paris.

But the main benefit to women of access to the national art academies was the offer of a free, structured and fully rounded course of study. However good the women's *ateliers*, ambitious women still had to go elsewhere to study certain subjects that the state academies offered automatically as part of the curriculum. Shortly after starting at Julian's in 1877, Marie Bashkirtseff organized anatomy lessons for herself: in her journal she described a family guest kissing the charcoal-covered hand that had just been drawing bones. As late as 1893, when women's study patterns had drawn close to those of the men, the Polish artist Anna Bilińska-Bohdanowicz set off to find the anatomy instruction which was not on offer at her women's academy. In 1900, Paula Modersohn-Becker wrote to her father from Paris: 'I hope to learn a great deal, especially from the wonderful instruction in anatomy offered free at the Ecole des Beaux-Arts.... We girls can get instruction like that only here.'[28]

It is arguable that the real value of the national academies' acceptance of women was symbolic, in that it represented the state's official acceptance of a woman's right to enter the profession.

A ROOM OF ONE'S OWN

For women art students on their own in Paris, their rooms were a symbol of their freedom.

(top left) Gwen John, *The Artist in Her Room in Paris*, 1907–9. Gwen John painted her attic bedroom-studio several times.

(left) Paula Modersohn-Becker, *View from the Artist's Studio Window*, 1900. This small and roughly painted image conveys a sense of the young artist, alive with excitement at being in Paris and anxious to paint her surroundings.

(above) Alfred Stevens, *In the Studio*, 1888. This is an excuse for a charming scene showing three different female types, the painter, the model and the middle-class visitor. The artist's studio became a popular subject at the end of the century with its overtones of Bohemian glamour.

(opposite) Asta Nørregaard, *In the Studio*, 1883. The Norwegian trio of Nørregaard, Harriet Backer and Kitty Kielland came to Paris to study in the 1880s and went on to work as artists on their return to Norway. Women artists in the period were committed to their work, excited by art, in love with their freedom and ambitious. This self-portrait says it all, with its thoughtful artist dwarfed by her large palette and the huge canvas she is working on. The steps help her reach the top half of the painting.

When the Norwegian academy accepted women in 1905, it was decades after a number of important Norwegian artists, including Kitty Kielland, Harriet Backer and Asta Nørregaard, had obtained for themselves the French training on which they founded their professional success. But even though by the time they accepted women the national academies had lost their importance as the one sure route to expertise, the women were thrilled to have finally breached the castle walls. They felt the future was theirs as they proved their prowess by carrying off many medals and prizes for their work.

The studio was an extension of the artist's personality and the location of the artist's professional life. For some artists, the studio acted as a sort of modern salon, a space where the art and social worlds could meet. When Sarah Purser returned to Dublin, the studio she took in 1886 became a centre for the intellectuals, politicians and artists who met at her afternoon parties.

Photographs and paintings of the studios of successful male artists reveal glamorous spaces with objects, oriental rugs and paintings

(above) Photograph of the famous French animal-painter Rosa Bonheur in middle age.
(right) Rosa Bonheur, *The Horse Fair*, 1853–55. This huge painting created a stir when it was first exhibited, and made the artist's reputation. It was while she was sketching in the horse market as a young woman that the artist obtained permission from the Paris police to dress in male clothes on the grounds of comfort and in order to evade attention.

disposed on easels, floors and walls. Furnished with tables and armchairs, they present an appealing fusion of high Bohemianism and domesticity. Photographs of the studio designed in 1860 by Rosa Bonheur for her château near Fontainebleau conform to this pattern, the stuffed animal heads mounted on the walls befitting the greatest French animal painter of the age. These are status studios, an index of the owner's standing in the world. They are also shop windows: Rosa Bonheur, loath to go into Paris, sold work from her studio. At the other end of the scale were the lodgings that doubled as studios: the impecunious Paula Modersohn-Becker considered furnishing her room in Paris with crates.

Most studios fell between these two extremes: 'Statues and articles of vertu filled the corner, the whole being lighted by a great antique hanging lamp. We sipped our chocolate from superior china, served on an India waiter upon an embroidered cloth,' was how the Paris studio of Mary Cassatt was described by an American visitor in 1877, after she had enjoyed several years of modest success.[29]

ARTISTS' WORKCLOTHES

For centuries it had been conventional for women to show themselves in self-portraits in elegant dress. Now women artists were willing to paint themselves or to be painted in their workclothes.

(top right) Louise-Catherine Breslau, *Under the Apple Trees, Portrait of Mlle Julie Feurgard*, 1886. The artist was welcomed into the Feurgard family at the start of her career. Her friend Julie, shown here at Argenteuil and wearing a painter's blouse, died young.

(below) Anna Bilińska, *Self-portrait with Apron and Brushes*, 1887. The artist's hair escapes from its pins, and her apron is daubed with paint.

(below right) Alice Pike Barney, *Self-portrait in Painting Robe*, 1896. The wealthy Alice Pike Barney of Cincinnatti settled in Paris with her daughters to study art.

(opposite) John Singer Sargent, *The Fountain, Villa Torlonia, Frascati*, 1907. Jane von Glehn wrote about this informal oil: 'I am all in white with a white painting blouse and a pale blue veil around my hat.'

Perhaps the cloth in Mary Cassatt's studio came from the market known as the Temple, described by May Alcott Nieriker in her advice on furnishing studios and living quarters, as:

> Frequented by artists for the purchase of tapestry, portieres and rich stuffs of various kinds, found at low prices in the little stalls principally kept by Jews – though no one, under any consideration, is ever made to confess being a patron of this bazaar, as it is not at all *comme il faut* to be seen there, and a purchaser is occasionally haunted by the unpleasant idea that perhaps the seeds of the plague or small-pox lie hidden in the folds of the gorgeous material just bought.[30]

The wealthy Marie Bashkirtseff's list of the contents of the studio she set up while a student at at the Académie Julian could be used as a set designer's checklist:

> I have brought to it two bad Gobelins which hide the lower part of the wall, a Persian carpet, some Chinese mats, a large square Algerian cushion, a stand for the models, beautiful draperies, large satinette curtains of soft but warm colour. Many casts: the Venuses of Milo, of Medicis, and Nîmes; the Apollo, the Faun of Naples; an écorché, some bas-reliefs, etc; a coat-stand, a fountain, a mirror worth four francs twenty-four centimes, a clock worth thirty-two francs, a chair, a stove, an oak table with a drawer and the top arranged as a colour box; a complete teaset, an inkstand and a pen, a pail, a can, a quantity of canvases, some caricatures, some studies and sketches.[31]

There was also a samovar, beside which she and Tony Robert-Fleury, her teacher at Julian's, sat talking one day.

Paintings of the artist's studio, garret or stylish setting for the artist, were a popular theme of the period, part of the glamorization of the artist and his world, whether as a Bohemian or a successful member of society. I use 'his' intentionally because the scenes of male and female studios are different. The men's paintings of studios tended to follow a formula in which a woman was included to add charm to the scene. William Merritt Chase's *A Visit to the Studio* shows two women leafing through a collection of drawings, a classic image of the mixing of the social and artistic worlds. The second type of artist's studio painting was made by the Bohemian members of the avant-garde. In contrast to the former image of successful elegance, these artists often included female models in assorted stages of undress as a way to display their Bohemian credentials.

Women painted their studios, too, and the rooms that doubled as studios, sometimes as backgrounds to their self-portraits. Gwen John drew and painted several self-portraits in her much-loved room in the rue du Cherche-Midi in Paris where she moved in 1907. Paula

Modersohn-Becker offered a variation on this theme by painting views from her room in Paris. Louise Breslau painted *L'Artiste Anglaise*, a portrait of a solid woman seated amongst her canvases. But what they never did was reverse the male painter's inclusion of a woman and include a man. I suspect the reason has little to do with deferring to conventional notions of propriety; rather, it illustrates their understanding that an image of a woman painter with an admiring male onlooker was not one to carry any credibility. I also wonder if their sense of themselves as independent striving artists made men seem irrelevant. Women's studio paintings tend to be far more modest than those by men. Interestingly, one of the most glamorous depictions of a female painter's studio, in the stylish mode of William Merritt Chase, is by a man, the Belgian Alfred Stevens.

Like men, women signalled their commitment to art through their clothing. The most dramatic illustration of women's belief that they could equal men was their decision to dress in masculine clothes, extraordinary in an age which measured femininity by the circumference of a skirt. The paintings of Rosa Bonheur, though highly admired in their time, are today less known than her decision to dress in masculine clothes. In 1850, while making drawings in public for her huge painting *The Horse Fair*, she received permission from the Paris police to dress as a man in order to avoid the discomfort and inevitable attention resulting from her voluminous skirts. Although she feminized her clothes when necessary, for example when accepting the Légion d'Honneur, she kept to masculine-influenced dress for the rest of her life. Her clothing fascinated journalists, who hinted gently at the masculine twist to her garments while reassuring the nervous reader how prettily feminine she managed to remain.

The Rome-based American sculptor Harriet Hosmer was another who favoured clothing with a masculine edge. Nathaniel Hawthorne described her style: 'She [wore] a sort of man's sack of purple broadcloth, into the side pockets of which her hands were thrust as she came forward to greet us.... She had on a male shirt, collar and cravat, with a brooch of Etruscan gold.'[32] Elizabeth Gardner asked for police permission to wear clothing in order to attend the men's classes at the Gobelins School in Paris. Paula Modersohn-Becker wrote home from Paris to Germany, 'There is a Polish girl there who dresses like a man. She wears a man's smock and has masculine gestures.'[33] For some artists, lack of vanity was a sign of their seriousness. The Norwegian Asta Nørregaard was photographed in a jockey cap in piquant contrast to her companion's bonnet.

More conventional was the painter's blouse, a close relation of the male artist's smock or overshirt. Describing John Singer Sargent's painting of her at work, Jane von Glehn wrote, 'I am all in white with a white painting blouse and a pale blue veil around my hat.'[34] In 1896, Alice Pike Barney did a self-portrait in her painting robe. With its hint

Peder Severin Krøyer, *Hip, Hip, Hurrah! Artists' Party at Skagen*, 1884–88. The woman with the distinctive profile, right foreground, is Anna Ancher who, with Krøyer and her husband Michael, formed the centre of the artists' colony at Skagen in Denmark.

of snowy underwear beneath, it is a refined predecessor of Kirchner's challenging self-portrait in a zigzag patterned robe of ten years later.

By 1880, women in bib-topped aprons were everywhere. The smudges and blobs which adorn Anna Bilińska's apron and her hair escaping from its clips present a convincing picture of an artist at work, far removed from the self-portrait in best dress of earlier periods. An alternative to the apron was a full-length, unwaisted smock-like garment buttoned down the back. All the same, some of the young women stubbornly refused to lower their standards. Marie Bashkirtseff's 1881 painting of the women's class of the Académie Julian, an engraving of which appeared in an art journal a few years later, shows a woman seated in the foreground wearing a fashionably large-brimmed hat above her practical bibbed apron.

PARTNERS IN LIFE AND IN ART

As would be expected, artists' marriages reached epidemic proportions with the influx of women artists. Young people mixing informally, male teachers flattered by the attention of their pretty students, women's travels to artists' colonies all offered opportunities to meet and talk in an exciting atmosphere of study and ambition. At the Académie Julian in 1877, Elizabeth Gardner met the French academic painter Bouguereau: she became engaged to him in 1879 and married him in 1896. In 1885, the Canadian Elizabeth Armstrong, her mother in tow, arrived at Newlyn, an artists' colony in south-west England, via the Arts Students' League in New York and a period of study in Munich. Her marriage to Newlyn's star, the painter Alexander Stanhope Forbes, took place in 1889 following the successful reception of his masterpiece, *The Health of the Bride*.

Although many a woman's career took second place to her husband's, particularly after the birth of children, some managed to triumph over domestic demands. A few, such as Lilla Cabot Perry and Louise Jopling, took up the profession after having children, and went on to become successful artists. A number of married artist couples went off to take refresher courses in Paris. The Danes Michael and Anna Ancher spent the winter of 1888 to 1889 studying drawing with Puvis de Chavannes, and Henrietta Rae and her husband Ernest

Normand took time out of their successful life to study at Julian's and the artists' colony at Grès-sur-Loing, near Nemours, in 1890.

The new idea of equality in marriage crashed up against the old one of woman's secondary status. In 1875, Berthe Morisot lamented to her sister that she had to give up sketching on the Isle of Wight because the wind made her hair untidy: 'Today we have been to Ryde. I set out with my sack and portfolio, determined to make a watercolour on the spot, but when we got there I found the wind was frightful, my hat blew off, my hair got in my eyes. Eugène was in a bad mood as he always is when my hair is in disorder – and three hours after leaving we were back again at Globe Cottage.'[35] Although on that particular day she accepted her female duty to look appealing to her husband, she was not so cowed that she gave up her career. Louise Jopling's second husband was a watercolour painter, a reversal of the more common male oil painter, female watercolourist partnership: 'It was an odd sensation to me, having worked so long alone, to have a fellow-worker. I am afraid that, as an oil painter, I took the lion's share (although we each had our own model every other day), particularly as I started a big canvas, six feet by four, on which I painted *Five O'Clock Tea* – a bevy of Japanese maidens, seated on the floor, drinking tea.'[36] Paula Becker visited the Worpswede artists' colony on the north German coast and met Oskar Modersohn, her future husband. When neither the marriage nor Worpswede's brand of rural realism could satisfy her, she made trips to Paris for its avant-garde ideas – hardly the action of a fettered female.

Berthe Morisot and her sister had painted side by side until Edma's marriage in 1869: 'I am often with you, my dear Berthe. In my thoughts I follow you about in your studio, and wish that I could escape, were it only for a quarter of an hour, to breathe that air in which we lived for many long years.' In reply Berthe Morisot wrote: 'Come now, the lot you have chosen is not the worst one. You have a serious attachment, and a man's heart utterly devoted to you. Do not revile your fate. Remember that it is sad

Berthe Morisot, *Mother and Sister of the Artist*, 1870. Edma, left, is awaiting the birth of her first child, an event that ended her career as an artist. Her life away from Paris and the sister with whom she had trained and exhibited, also played its part by removing her from a sympathetic artistic context.

to be alone; despite anything that may be said or done, a woman has an immense need of affection. For her to withdraw into herself is to attempt the impossible.'[37]

But if marriage was not always easy, nor was being single. Forty years later, Frances Hodgkins wrote to her sister in New Zealand:

I do sympathize with you dear so much about your painting. I know that old familiar pain – growing stale and losing one's freshness of ideas – but wait a while old girl and don't try to force your brush – the children are growing older every day now and will soon cease to want your attention so much – and in the meantime what better work can you do than bring up four beautiful children? My work is as nothing compared to it – we poor spinsters must embrace something, if it is only a profession – I snapped at Mr Garstin when he said this but in my heart I know it is true – my art is everything to me – at least at present – but I know it is not the higher life or the right life for a woman.[38]

To marry or not to marry? In 1900, Anna Lea Merritt wrote an open letter to women artists which stated the problem as she saw it:

The chief obstacle to women's success is that she can never have a wife. Just reflect what a wife does for an artist; darns the stockings; keeps his house; writes his letters; visits for his benefit; wards off intruders; is personally suggestive of beautiful pictures; always an encouraging and practical critic. It is exceedingly difficult to be an artist without this time-saving help. A husband would be quite useless. He would never do any of these disagreeable things.[39]

From this standpoint, if a wife was not to be had, then remaining single was a better bet for success than having a husband. There was a strong feeling among some women that art not man should be the master, and I firmly believe that this commitment to art endowed the unmarried state with some dignity for women of the time.

Harriet Hosmer, *Beatrice Cenci*, 1857. After learning to sculpt in America, Harriet Hosmer completed her training in Rome with the English sculptor John Gibson. She made her reputation with huge works of heroines in marble which reached a wide audience through smaller copies.

Susan Durant, *Harriet Beecher Stowe*, c. 1863. A number of female sculptors searched for contemporary heroines as well as those from history and literature. This bust of the champion of women's rights, Harriet Beecher Stowe, made the reputation of this English artist, who numbered Queen Victoria among her patrons.

When it came to working professionally, there was nothing the women did not do. They painted murals and miniatures. They sculpted small portrait busts and cast huge statues to stand in public places. They painted scenes of charming domesticity and scenes of gritty social realism.

Though the insults peculiar to women continued, the women fought back. When the American sculptor Harriet Hosmer was accused of passing off work by her teacher, the English sculptor John Gibson, as her own, she fought the slur in a celebrated episode involving letters to the press. Men who found it difficult to cope with women's work that could not be labelled feminine, artspeak for weak and inferior, continued to call it 'masculine' as their greatest compliment. Some women challenged this particular mindset by suggesting a positive definition of a feminine art, based on the dissemination of moral virtues through their choice of subject matter. It was an artistic extension of the power that women were believed to possess of making men rise to meet their moral standards.

Although some of the critical hostility towards work done by women was disguised beneath emollient formulas of 'women's sensibility', the women understood that they were being patronized. But although it was probably impossible for most of them to forget that they were women, there is no evidence that they saw themselves as inferior. If theirs was a modest talent they stuck to their place, but there were some huge egos at large in the period which, encouraged by their education and their feeling that their turn had come, crashed through the criticism. Some of the most interesting work was done in defiance of contemporary views of female capabilities. The women who scoffed at the idea that there was such a thing as a female kind of art set out to deal a death blow to this belief by producing work whose size and subject matter could in no way be considered feminine. The period opened dramatically in 1851 with Rosa Bonheur's *The Horse Fair* which measured nineteen by twelve feet (nearly six by four metres): not only did it weaken the link between women and domestic subjects, it won her a gold medal and made her name. There was nothing these ambitious women would not try. Elizabeth Butler's battle scenes of the 1870s created such a stir that policemen had to guard them from the crush and push of Royal Academy visitors.

The strongest indication that women were flexing their artistic muscles was the number of female sculptors. As befitted a nation with fewer restricting patterns of womanhood than the countries of the Old World, the Americans produced a stream of strong sculptors. The first and most important in terms of her influence on others was Harriet Hosmer, who went to Rome in 1852 to study with John Gibson and stayed on to practise professionally. Hosmer was an inspiration to two generations of American women sculptors, most of whom came from liberal families where female independence was valued and indulged.

Henrietta Rae,
Songs of the Morning, 1904.
This large single-figure
painting follows the convention
of presenting the nude in an
allegorical guise. Henrietta Rae
and her husband, the artist Ernest
Normand, were a leading couple
in the academic artistic circles of
late nineteenth-century England.

In Rome they found a congenial environment. Mostly unmarried, they were part of a circle centred on the salon of the American actress Charlotte Cushman who had been influential in getting Hosmer to Rome and who from the end of the 1850s until her death in 1875 shared her life with the sculptor Charlotte Stebbins. When Nathaniel Hawthorne's novel *The Marble Faun* was published in 1857, it played as important a part in publicizing the activities of these female sculptors as media attention would today. For art-loving American visitors to Rome they became a tourist attraction to rival St Peter's and the Forum. A flow of white marble heroines emerged from their workshops, modern, like Harriet Beecher Stowe, as well as ancient, female equivalents to the heroes that were a staple of public sculpture.

Work based on the female nude was another sign of female ambition, and several artists around the turn of the century made this their speciality. In England, Henrietta Rae disguised her female nudes as classical characters in huge history paintings: *Psyche Before the Throne of Venus* painted in 1894 measured over ten by six feet (three by two metres), and contained fourteen figures. Only one taboo was left: the nude male. Though most women by the turn of the century drew them in their classes, they rarely painted them for their public.

Ironically, the women who worked in an Impressionist manner, the most advanced artistic movement of the 1870s, painted subjects thought of as typically female. The subject matter of Impressionism was comfortable for women. The flowers, women, children and locations of a pleasant domesticity were easily accessible, and it must have been liberating for women to deal in subjects that, though close to home, were favoured by the men in their group. Of course, as might be expected, the women dealt with them differently. Female visions of maternity are often less sentimental than those by men and their paintings of women offer a revealing glimpse into their middle-class lives. Berthe Morisot's depiction of two women in a boat on the lake in the Bois de Boulogne presents the constricted poses of the ladies, arms by their sides, elbows in, without a hint of that sexual prettiness that marks the male Impressionists' work. Mary Cassatt gave serious attention to the women in her circle, respectfully presenting the evidence of their busy lives, reading, driving a carriage, caring for children. Women at their mirrors have always fascinated male painters. Eva Gonzalès' versions of the subject show women in more practical mode, preparing themselves for their feminine role like actresses at the dressing-room mirror. The pretty woman in a box at the theatre offered an irresistible spectacle to male artists. The women saw her differently, depicting her with the power to look at the world through her opera glasses, surrogates for themselves perhaps.

The artistic concept of the avant-garde took root in this period. Once photography had shown it could mimic the world, some painters

felt they had lost their role and began to explore new areas like line and colour, shape and mood. Why pretend a flat canvas was three-dimensional? What was so admirable about replicating an object when it was possible to explore the vocabulary of art itself? Impressionism, which developed in the 1870s, defined itself against the dominant style of realism. Realism in art terms meant that the art work could be judged against its real-life counterpart and exhibited a finished style of painting: 'le fini', a polished finish, was the artistic requirement the Impressionists rebelled against.

These developments have been chronicled by historians who in the process have allotted moral values to the styles. The experimental Impressionism is good and demands respect, while the conservative realism is treated with disdain. Unfortunately, not all of those in the midst of things were in touch with this future reading of their world. May Alcott Nieriker referred to Mary Cassatt's colour sense but the

(above) Berthe Morisot, *The Lake in the Bois de Boulogne (Summer Day)*, 1879. An insight into the lives of middle-class women is given, no doubt unconsciously, by the constricted poses of the women in the boat. (right) Mary Cassatt, *Woman and Child Driving*, 1881. Here the woman and the little girl have pride of place, and the woman is in control, a predecessor of the woman car driver in the twentieth century.

(above) Anna Bilińska, *Woman With Opera Glasses*, 1884. In France in this period the woman at the theatre was a popular subject among artists, female as well as male. Anna Bilińska's portrait of a woman from below, gives her an air of stern impregnability. (right) Mary Cassatt, *At the Opera*, 1879. Cassatt's painting shows a woman in control of the scene she surveys. Both these pictures emphasize that a woman's power does not depend solely on her prettiness and vulnerability.

artist she points to as advanced is Jules Bastien-Lepage, an artist who borrowed a light palette and square and stubby brushstrokes from the new Impressionism to modernize his conventional way of working. Bastien-Lepage's diluted Impressionism influenced a generation of artists and many women, Marie Bashkirtseff among them, worked in his way – a way which has come to be seen as the wrong way.

The ideas of Impressionism developed in the 1860s in male social settings, in the cafés and bars to which women, aside from models or mistresses, had no access, and in the studios of charismatic male artists, like Edouard Manet, which meant that most women missed out on them. It was hard enough for men to discover where the action was – there are lots of stories of men who went to Paris to study in the 1870s and 1880s but never found Impressionism – but practically impossible for women.

The only card women possessed was the social card, and it was one they used. All four women involved in Impressionism in the 1870s, the first avant-garde movement of the modern age, had personal links to

the men in the group, learning, discussing and sharing ideas with their friends and partners in a uniquely female exposure to the avant-garde. Marie Bracquemond's husband was an intimate of the group. Eva Gonzalès was Manet's student and through her novelist father had access to intellectual circles. Mary Cassatt knew Degas. When Berthe Morisot was single, her mother made sure she socialized with the important figures of the intellectual and avant-garde worlds, including Mallarmé, Manet and Puvis de Chavannes. After her marriage to Manet's brother, her salon established her position at the hub of Impressionist developments. This is in no way to denigrate the women's talent. Mary Cassatt and Berthe Morisot are interesting artists who added their own flavour to Impressionism, and by the end of her short life Eva Gonzalès was producing paintings of an appealing and disconcerting oddness. But it is hard to imagine how as women, however talented, however in tune with avant-garde developments, they could have made their way into the masculine world of the avant-garde without these male bridges.

Accepting the hand of a man to pull one into the avant-garde would always be an option for women. Suzanne Valadon showed some drawings to Degas and to the artists she modelled for, and was encouraged to develop her strong and linear way of working. Anna Boch, the only woman to exhibit with the pointilliste-influenced group, Les Vingt, in Brussels in 1895, was a cousin of Octave Maus, the group's founder, and sister of the landscape painter Eugène Boch.

However, by the start of the twentieth century, a new pattern was emerging that made it easier for women to keep up with the newest ideas. As the pace of avant-garde developments speeded up, they were publicized and recorded as quickly as they happened through exhibitions and reports in the press, and women were able to learn about the new movements for themselves. Paula Modersohn-Becker's letters home to Worpswede from Paris at the start of the twentieth century reveal her excitement as she found out about the latest developments and went to see the new work for herself. In a very short time, the influences of primitive art and Gauguin, transmuted by her own particular way of seeing, appear in paintings that practically shout her signature.

The diaries and letters of the period show that, despite the modesty expected of them, the women were desperate to succeed and keen to be recognized. The fact that the skills of self-promotion and networking sat uneasily alongside the submissive qualities still so admired in women called forth a variety of responses. It explains Elizabeth Butler's professional need to distance herself from the majority of women with their headaches and her personal need to present herself as the respectable wife of an army officer. It explains the belief of some of the period's feminists that women could bring something uniquely and admirably feminine – to do with heart, family and morality – to the

subject matter of art. It throws light on the self-contained groupings and masculine clothing of the American sculptors in Rome or of Rosa Bonheur: sexual proclivities may have played a role but their clothes were as much a marker of their professionalism as of their private sexuality.

Literature students know all about the nineteenth-century women writers who sent their manuscripts to the publisher under a male pen name in the hope of improving their chances of serious consideration. George Eliot is perhaps the most famous, but there were many others. Fine-art versions of this practice also existed. Laura Herford, the first woman to be accepted for the Royal Academy Schools in London in 1861, won her place by submitting a drawing marked only with her initials. In 1875, the American sculptor Anne Whitney won a competition for a memorial to the abolitionist Clark Sumner with an anonymous design but was rejected when the judges learned she was a woman. The sculpture was finally erected in Cambridge, Massachusetts, in 1902, twelve years before her death. For years, the American painter Elizabeth Nourse signed her work 'E. Nourse' to avoid preconceived judgments about the quality of women's art. It was probably the acceptance of her painting, *La Mère* (The Mother), at the Salon of 1889 that helped to change her mind. Two years later, her new-found confidence enabled her to change the E to Elizabeth.

(above) Marie Bashkirtseff, *A Meeting*, 1884. The artist worked in the style taught at Julian's by Jules Bastien-Lepage.
(below) Theo van Rysselberghe, *Anna Boch, c. 1889–90*, is painted in the pointillist style of the members of the group Les Vingt with whom she exhibited in 1895.

Selling art involved putting one's goods before the public. Women were well aware of the importance of exhibiting. Many organizations and societies were set up towards the end of the century for just this purpose, and women were quick to find out which were sympathetic to their sex. Some women associated with a particular style or with a political belief, such as women's rights, aligned themselves with organizations within their field, whereas others with one eye on the market and one on their professional status joined everything they could. As well as offering a chance to exhibit, artists felt that membership brought them professional gravitas, networking opportunities and access to the world outside the studio, and it was common for them to belong to several groups.

As well as submitting their work to exhibitions and joining organizations, women knew they needed the services of a dealer, a nineteenth-century version of the intermediary. In return for a percentage of the sale, dealers promoted an artist's work, offered wall space in a private gallery, organized commissions, arranged for works to be reproduced, and occasionally kept an artist going with the payment of a small retainer.

As art became a luxury item to be chosen from an exhibition like a beautiful bracelet from a jeweller, the artists' need to publicize their work became more pressing. The profession was becoming crowded and it was important to stand out from the crowd. As a general rule journalists singled out women who did outrageously 'unfeminine' paintings, like Elizabeth Butler and Rosa Bonheur; or who confounded conventional expectations of womanly behaviour, like the American sculptors in Rome; or who showed a new and surprising kind of independence, like the women students in Paris. When it came to reviews, women married to successful painters or with social links to important men fared well: as the wife of Ernest Normand, Henrietta Rae's work was always noticed. Critics tended to collect all the female exhibitors together into a paragraph at the end of a review, however disparate their works. Magazines carried photographs of women's art if it conformed to stereotype – that is, if it was sentimental – or if it diverged from stereotype – that is, if it was powerful.

Female networks were strong all through the period. Feminism encouraged some women to join together in an assault on the art world, while their less political sisters joined societies dedicated to the promotion of educational and exhibiting opportunities for women. In Paris, the Union des Femmes Peintres et Sculpteurs, which held huge annual shows of women's work, was a most efficient pressure group for women's interests. Not only did it campaign to get women into

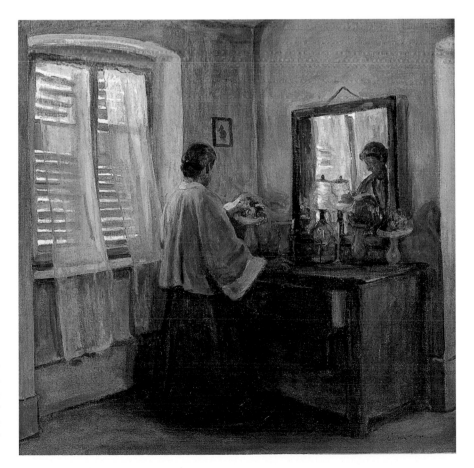

Elizabeth Nourse, *Les Volets Clos*, 1910. This painting, for which the artist's sister modelled, was bought for the French government's contemporary art collection. The artist arrived in Paris with her sister in 1887 when she was in her late twenties. She made France her home, and died in Paris in 1938.

the Ecole des Beaux Arts, but it also persuaded government officials to include its annual exhibition in their circuit of inspection when making their choices for state purchases and commissions, a great coup for women artists. Informal groups of like-minded women crop up all over the place, meeting to draw, to discuss, and to plan their strategies.

Networks could have a less public face. In Kristiana in Norway, Harriet Backer, Kitty Kielland and Asta Nørregaard took a house together in 1900, sharing the servants but each with her own private apartment. In 1883, Elizabeth Nourse painted a panel of flying geese for the fashionable Alice Pike Barney to put over a mantelpiece in her Cincinnati home, and was recalled the following year to paint her daughters Laura and Natalie. In the process she encouraged Alice Pike Barney to go off to study art in Paris. In her turn, Elizabeth Nourse saved the money she made from her female patrons in Cincinnati, and in 1887, aged thirty, sailed with her sister for France with $5000 from sales of her work and her father's estate.

The issue of whether to find solidarity in a female milieu or join the fray of the male art world took the shape it has today. Of the three Norwegians, only Asta Nørregaard joined the Association of Women Painters, founded in 1907. Kitty Kielland and Harriet Backer chose to put their mark on the wider world: 'By concentrating like a man, I serve the best interests of women,' said Backer, who became a member of the purchasing committee of the Norwegian National Gallery. [40]

As more and more women came to prominence, the question of rewards and honours grew more urgent. A few women broke through the arguments against admitting them as academicians – heard all over Europe as men worked out what to do about the inescapable female successes. More common was Elizabeth Butler's experience in the 1870s after she had stunned London with her military scenes:

> I remember, at one of the artistic London 'At Homes', Frith, R.A., coming
> up to see me with a long face to say if I did not send to the Academy,
> I should lose my chance of election. But I think the difficulties of electing
> a woman were great, and much discussion must have been the consequence
> amongst the R.A.s. However, as it turned out, in 1879 I lost my election
> by two votes only. Since then I think the door has been closed, and wisely. [41]

I suspect that for some women the excitement and publicity surrounding their potential admission was as satisfying as actually being elected. One way round the election problem was to offer a woman honorary membership: In 1890, Sarah Purser, by then Ireland's leading portraitist, was made honorary Royal Hibernian Academician. She had to wait until 1924 to become officially elected – the Academy's first female member.

The women came in for their share of public commissions. Charlotte Stebbins was responsible for the statue of Abraham Lincoln

that stands at the top of the steps of the Lincoln Memorial in Washington. Mary Cassatt and Mary Fairchild MacMonnies were commissioned to do the huge murals *Modern Woman* (Cassatt) and *Primitive Woman* (MacMonnies) for the Woman's Building of the 1893 World's Columbian Exposition in Chicago (the five-hundredth anniversary of Columbus's voyages). Louise Abbéma painted decorative works for French town halls in the early twentieth century.

Many women supported themselves and their families in comfortable style. Louise Jopling was enchanted by landscape: 'But one cannot choose one's way in life: circumstances are our master. I had to follow along the path that gave me the wherewithal to pay the grocer, the butcher and the baker.'[42] Others made small fortunes. Rosa Bonheur made enough money to retire to a château in 1860 when she was in her thirties. The Dutch portrait painter Thérèse Schwartze, whose reputation was so great in the 1880s that in 1887 she was invited to paint her portrait for the Uffizi's famous collection of artists' self-portraits, left a fortune and three houses at her death in 1918.

The development of female art classes and schools offered leadership opportunities to women teachers and a chance for them to encourage women's progress in the art world. Rosa Bonheur and her sister were the directors of the government school of design at mid-century. In England in 1879 Annie Swynnerton and Susan Dacre founded the Manchester Society of Women Painters for study from life and for exhibiting opportunities. The Austrian landscape artist Tina Blau was a co-founder in 1897 of the Kunstschule für Frauen und Mädchen in Vienna. In the 1890s a number of women's academies were started by graduates of the Paris educational experience on their return to their respective countries. Harriet Backer opened a school for women on returning to Norway from Paris in 1888. Cecilia Beaux returned from Paris in 1889 and in 1895 became the first woman to teach full-time at the Pennsylvania Academy. Women were also involved in running co-educational schools. The sculptor Marg Moll founded the Matisse school in Paris with her husband Oskar Moll in 1908. Overall, it is a triumphant period, with scarcely a well known artist without a barrier-breaking first to her name. In France, Rosa Bonheur was awarded the Legion of Honour in 1865, the first woman artist to be so honoured. In 1910, Elizabeth Nourse's painting, *Les Volets Clos* (Closed Shutters), for which her sister modelled, was bought by the French government for its contemporary art collection.

A new arrival on bookshelves was the life story of the contemporary artist. This genre, which tended to be the province of academic not avant-garde artists, offered an account in biographical or autobiographical form of the artist's rise to success, the enviable social life and the honours awarded. The fact that several women were the subjects of such books proves that they had a place in the art world. In fact, they probably thought they had changed it.

1910–1970
Profession: artist

*'I don't think I've ever thought of myself
as a* woman *painter.'*

BRIDGET RILEY

By the twentieth century, a woman could
regard a career in art as her right. Although
hostility, personal circumstances and
internalization of the female role could hold
them back, professional roles for women now
existed and a job, if not a career, was
increasingly taken for granted for bright
schoolgirls. A schoolteacher, herself the
recipient of professional training, could look
at the work of a talented pupil and
recommend art school as a further education.
Compared to earlier centuries, the battle
for equal treatment was over. Women studied
at the same art schools as the men, where they,
too, drew from the naked life model,
entered competitions, won prizes and were
awarded travelling scholarships.
They sold their work, they took part in the
activities of the art world, they represented
their countries in international exhibitions,
they accepted commissions.

CAST OF CHARACTERS

Some of the artists in this chapter who reconciled being a woman with being an artist.

EILEEN AGAR was born in Argentina in 1899 and came to England in 1906. Her studies as a painter culminated in two years at the Slade 1922–24. On her father's death she received a private income. During her first marriage (1925–29) she met the Hungarian writer Joseph Bard whom she later married (he died in 1975). From 1935 to 1940 she had a relationship with Paul Nash. Part of an artistic and intellectual circle in the 1930s that included Picasso and the French Surrealists, she participated in the 'International Surrealist Exhibition' at New Burlington Galleries in 1936 which brought Surrealism to Britain. She was elected Royal Academy Associate in 1990. She died in 1991.

ISABEL BISHOP was born in Cincinnati in 1902 and studied painting at the Art Students' League in New York from 1920 to 1924 under Reginald Marsh. Her paintings focus on the human figure. She visited Europe in 1931 and set up a studio in New York in 1934 in the year of her marriage to a neurologist. Her son was born in 1940; her husband died in 1962. She was the only full-time female teacher at the Art Students' League in 1936–37, and was the first female officer of the National Institute of Arts and Letters. She died in 1988.

GRACE HARTIGAN, born in 1922 in New Jersey, has had four marriages (one son b. 1942). She developed her art in the classes of Isaac Lane Muse, with whom she moved to New York in 1945. The 'New Talent' exhibition in New York in 1950 and the 'Ninth Street Show' in 1951 included her in the second wave of Abstract Expressionism. A powerful painter, awarded many honours, her work is held in museums and private collections. She lives in Baltimore.

(previous pages) Grace Hartigan, *Months and Moons*, 1950 (detail).
(this page, left to right) Eileen Agar, *Self-portrait*, c. 1927 (detail). Photograph of Isabel Bishop. Walter Silver, photograph of Grace Hartigan in her studio. Charles Gimpel, photograph of Barbara Hepworth (detail).

BARBARA HEPWORTH, born in 1903, studied at Leeds School of Art, then the Royal College of Art, London, 1921–24. She married sculptor John Skeaping in 1925, divorced 1933; their son died in 1953. With artist Ben Nicholson she had triplets in 1934. They divorced in 1951. In the '30s she was one of the British artists who, with European refugees (Mondrian, Breuer, Moholy-Nagy, Gropius, etc.), brought Modernism to Britain. Her most famous public sculpture is *Single Form*, 1964, in New York. She received many honours. She died in 1975.

FRANCES HODGKINS was born in 1869 in New Zealand, a solicitor's daughter. She came to Europe in 1901 to complete her training, settling in Britain in 1913. After 1918 her work developed from Impressionist-influenced watercolours to a more original vision inspired by Matisse, Picasso and Dufy. Her signature landscape/still-life hybrid was colourful and sensitive to atmosphere. She died in 1947, and in 1948 was a subject of the UK Penguin *Modern Painters* series.

ALICE NEEL, born in Pennsylvania in 1900, studied at the Philadelphia School of Design for Women. Married 1925–30, one of her two children died, the other was kept by her husband's family in Cuba. She had two sons from later relationships. A painter of portraits and urban life, she worked on federal art projects in the '30s. Discovered by the '50s Beats and the '70s feminists, she was elected to the American Academy of Arts and Letters in 1976. She died in 1984.

(left to right) Frances Hodgkins, *Self-portrait: Still life*, 1941 (detail). Käthe Kollwitz, *Self-portrait*, 1891–92 (detail). Photograph of Alice Neel, 1970 (detail). Alfred Stieglitz, *Georgia O'Keeffe: A Portrait – Head*, 1918 (detail). Ethel Walker, *Self-portrait*, c. 1930 (detail).

KÄTHE KOLLWITZ, born in Königsberg in 1867, trained as a painter in Berlin in 1885 and in Munich in 1888, devoting herself to print-making after 1890. In 1904, she studied sculpture at Julian's in Paris. Her print series, *A Weavers' Revolt*, 1895–98, made her name. After her son's death at the start of the First World War, the suffering of the powerless joined revolution as her main theme. The first woman member of the Prussian Academy of Fine Arts, she was asked to leave it in 1933 because of her anti-Nazi stance, and lost her studio. She died in 1945.

GEORGIA O'KEEFFE, born in Wisconsin in 1887, studied at the Art Institute of Chicago and the Art Students' League, New York. She met photographer Alfred Stieglitz in 1916, married him in 1924, and moved to New Mexico after his death. Her semi-abstract and simplified landscapes, cityscapes, flower paintings and bone pieces make her an important figure in early Modernism in the USA. Among her many honours and awards was membership of the American Academy of Arts and Letters 1962. She died in 1986.

ETHEL WALKER, born in Edinburgh in 1861, began exhibiting in London in 1898 after a protracted education which included a visit to European art centres and a spell at the Slade School of Art in London. She did not marry. A painter of portraits, flowers, seascapes and decorative scenes, she represented Britain at the Venice Biennale of 1930 and 1932. She was honorary president, 1932–51, of the Women's International Art Club; associate of the Royal Academy in 1940; and made Dame Commander of the British Empire in 1943. She died in 1950.

Gabriele Münter, *After Tea, II*, 1912. This is one of several paintings of the artist and her partner Wassily Kandinsky (who in 1911 had founded Der Blaue Reiter group) with Alexei Jawlensky and Marianne von Werefkin. They often all worked in Münter's house in Murnau.

Compared to earlier centuries, the battle for equal treatment was over. But, although things were vastly improved, women still found themselves in a special situation based solely on the fact that they were women. The self-belief of the women of the second half of the nineteenth century was powerful enough to drown the scoffers and the critics. But in the twentieth century, and particularly after the First World War, the picture became far less simple. There were more women artists than ever before, but they were still faced with situations unknown to the men and still had to operate with an awareness that they were women as well as artists.

On the surface and in theory there was no longer any difference between the position of male and female artists. The surface was that there was equality of opportunity, since education was open to women as well as men. And the theory was that talent would out. The trouble was below the surface. Equality of opportunity turned out in practice to be rather an illusion. Firstly because the artistic power structures remained male: despite the odd exception, it was the men who ran the art schools, had most power of patronage, were the most respected critics, chaired the trustees of the local museum. And secondly because the women who entered the art world did so against a background of unhelpful ideas about women and art – the same old ideas but modernized, with Freud brought in to support the 'difference' of women, and social realities used to argue for women to breed after two World Wars. Some ideas about women's artistic capabilities were little more than old-style criticism in modern dress. There were still teachers in the 1960s who believed that their women students lacked originality, did not take art seriously or were only at art school to catch a husband. These views had the status of facts, not merely of opinions.

The theory that talent would out was a problem for women. It went something like this. Success would come to those with talent. Artistic talent was genderless. If a woman possessed talent it would be recognized and there were enough successful women artists to prove it. The fact that there were few women teaching in art schools, few female members of national academies, fewer women than men in exhibitions, fewer women's works reproduced in books and journals had nothing to do with prejudice against women but was laid at the women's feet: their poor showing was due to their lack of interest in putting themselves forward, the diversion of their creativity into motherhood, their inability to wield the knife in institutional politics, the fact that they were just not good enough. When women made it into positions of importance or gained recognition for their art, instead of drawing attention to the smallness of their numbers, the climate of the time ensured that their success was used to prove that prejudice did not exist against them.

It was a mark of the time that huge numbers of conflicting ideas collided like waves in a splash and heave of confusion. Nothing was logical or formed a cohesive theory. Artistic talent was neutral, for example, but the artistic stereotype was male. Talent was blind to its owner's sex, yet women's creativity went into having children.

Suzanne Valadon, *The Fishermen*, 1914. Suzanne Valadon showed her work to the painters for whom she modelled in the late nineteenth century. Degas in particular encouraged her to become a painter. This work, typically bold in line and colour, was based on the body of her young lover and was painted in the year they married.

None of this was openly admitted. I cannot imagine a first-year student existed who doubted her training would lead to success. The confusion came out in odd ways. For example, jokes about artists' models were based on the assumption that the model was female and the artist male. What this said was that despite the influx of women artists, the norm for an artist was a glamorous man. Real artists were seen as male, mad and bad, like Picasso or Jackson Pollock, whereas women, poor creatures, were subject to the flow and flux of their bodies. The prevailing image of a woman artist in these years is nothing like as dashing as the rule-breaking male. It is slightly ridiculous and the word arty could almost have been coined for her: not so much a female type as a deviation from femininity.

Feminism survived, but without much appeal for artists in a period when female solidarity was not in fashion. Speaking up for art just because its maker was female had little credibility. Käthe Kollwitz's journal, January 1916, reads: 'My unpleasant position on the jury. I always find myself forced to defend the cause of a woman. But because I can never really do that with conviction, since most of the work in question is mediocre (if the works are better than that the other jury members will agree), I always become involved in equivocations.'[1]

The enclaves of artistic women that did exist were often based on sexual preference. In Paris in the interwar years, Natalie Barney, the daughter of the American artist Alice Pike Barney, was the centre of a lesbian circle which glittered with talented women, including the artist Romaine Brooks who was her lover and created the famous image of her with a model horse, a symbol of the name the Amazon that she was known by. In England, Gluck, the misfit daughter of the wealthy Gluckstein family, had a successful career amid a sophisticated and sympathetic social set. Like the American sculptors in Rome in the second half of the nineteenth century, the position of these women inside a safe circle of the like-minded made the opinion of the wider world irrelevant. Romaine Brooks was a link between the two groups and painted Gluck's portrait. Gluck began a reciprocal portrait, but never finished it, hindered perhaps by her dislike of Brooks's flamboyantly lesbian circle.

Although by now the training paths were clearly marked, some young women still had to fight hard for the opportunity to go to art school. Instead of trying to change her parents' mind, which was probably a hopeless task, Eileen Agar dealt with parental pressure to marry and settle down through apparent compliance, that time-tested strategy of the constantly thwarted. 'In 1921, I was admitted to the Slade to study Fine Art on a part-time basis, with the qualified approval of my parents who would only allow me to attend classes if the family Rolls took me to the door and picked me up. Rather than make an issue out of this, I made an arrangement with the chauffeur to drop me round the corner.'[2] She was twenty-two years old.

Gluck, *Self-portrait*, 1942. In this uncompromising self-portrait, the artist presents herself as a serious and searching painter.

(above) Romaine Brooks, *The Amazon, Portrait of Natalie Barney*, 1920. Natalie Barney, whose relationship with Romaine Brooks lasted forty years, was the centre of a lesbian artistic circle in Paris.
(right) Dorothy Johnstone, *Rest Time in the Life Class*, 1923. Women now received the same art education as men. This image suggests the girls' sense of entitlement to their training.

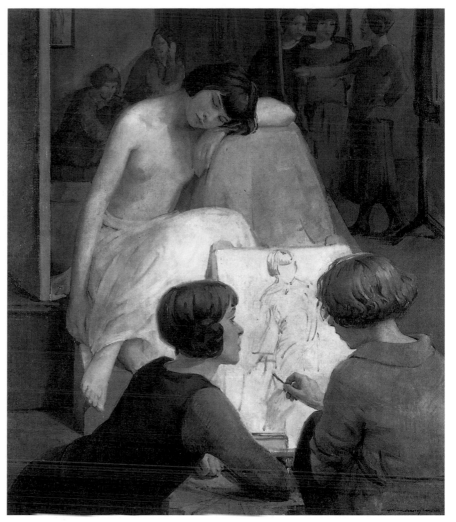

In contrast, Isabel Bishop's refusal to conform worked to her advantage. 'I was lucky,' she said of her education in the USA of the 1920s. 'I think if I had been a man, the relative who sponsored my whole studenthood might not have done so. Men are supposed to make their own way. Young women were supposed to marry. But a young woman putting so much time and effort – being so serious – that was different – that interested him. I don't think he would have subsidized me if I had been a boy.'[3]

THE HIDDEN OBSTACLES

Their experiences at art school were as individual as their fingerprints. Officially there was equality. Unofficially they had to find their way through a tangle of assorted attitudes. There were supportive teachers of course, as there always had been, but for every one of them there were probably ten whose attitudes were less than helpful. Nearly all of their teachers were male, and many of them held the conventional theories of the day about women not being serious, giving up work on marriage, only going to art school to find a husband, not having the drive that comes from genius, being good at taking orders and winning

prizes but lacking that vital spark of creativity. Henry Tonks, who taught several generations of women at the Slade School of Art in London from 1892 to 1930 wrote to a friend: 'Speaking generally they do what they are told, if they don't you will generally find they are a bit cracked. If they become offensive it may be a sign of love. They improve rapidly from about 16 to 21, then the genius that you have discovered goes off, they begin to take marriage seriously!'[4] One wonders what theories explained the serious women who did well and went on to make a career. The fact that a male tutor might pick out a talented male student to encourage and a talented female student to seduce was seen as life, not sexism. If the very real threat to art posed by relationships materialized in the form of marriage and motherhood, it was taken as confirmation that women lacked staying power.

Women coped with the prejudice against them by denying it existed – as was officially the case – or by getting on with their work regardless. Henry Tonks is an example of the type of teacher who was known for not being pleasant to women. Even the tactful Beatrice Elvery can not hide how much his comments still rankled forty years on. After working in Sarah Purser's stained-glass studio from 1905 to 1912, she took herself off to the Slade School of Art in London:

> Joseph Hone in his book on Tonks maintains that this great teacher was invariably kind to his pupils and an angel of consideration where the model was concerned. Actually, whether intentionally or not, he could be very crushing. In the life-class he stood before my easel and asked what I had been doing before I went there. I told him and he asked if I used living models for stained glass. I said 'No', that for years I had drawn and modelled from life, but for stained-glass cartoons I just drew out of my head. Tonks said, 'I only know of one painter who did that.' I asked 'Who?' and he answered, 'Daniel Maclise.' I said, 'But no one wants to draw like Daniel Maclise.' He said, 'You do.'[5]

(Daniel Maclise was an unfashionable Victorian narrative painter who delighted in smooth and obsessive detail.) Eileen Agar was made of sterner stuff. 'He had the reputation of making girls weep with his caustic remarks,' she recalled, 'but he drew no tears from me. He could be scathing, but he was not a destructive teacher.'[6]

Everywhere you look, you find women artists at work. As more women got a proper training, more stars appeared. Pick a letter of the alphabet and a procession of women artists leaps into life: Isabel Bishop, Louise Bourgeois, Barbara Hepworth, Eva Hesse. As well as the stars, hundreds of women made their living as artists, women with solid reputations and a clientele for their product. The British artist Ethel Walker is my monument to all these professional women who have nothing in common except their sex and the fact that they could claim 'career: artist' on their passports. Their names are often

(above) Ethel Walker, *Geraniums and Fruit, Robin Hood's Bay*, c. 1930; (right) *Self-portrait*, c. 1930. Ethel Walker is typical of the hundreds of women artists who had a career in art in the twentieth century. Her colour and free touch is a development of Impressionism.

unfamiliar, and yet on investigation they turn out to have spent a life in art, involved in its movements and activities, written about, collected and bought for posterity by museums. Every country has them.

Ethel Walker is little known today, and yet she was one of the five female and thirty-five male artists whom John Rothenstein, nearly thirty years the director of the Tate Gallery of Modern Art in London, considered worthy of an essay in his work *Modern English Painters* which came out in three volumes between 1954 and 1974. In this true seal of establishment approval, he called Ethel Walker, 'the best known woman artist', a designation she would doubtless have agreed with.[7]

Ethel Walker was born in 1861, but because she did not die until 1951 and because her greatest recognition came in the 1920s and 1930s, she is considered a twentieth-century artist. Her life was the quiet one of a woman who lived for her art. She loved painting and her dogs. She had a small circle of friends, did not marry, and for half a century travelled between her London studio by the Thames and her cliff-top home in Yorkshire. She was honorary president of the Women's International Art Club from 1932 until her death in 1951,

an associate member of the Royal Academy and a Dame Commander of the British Empire.

Her subjects were portraits, women, flowers, landscapes, seascapes and large decorations. She worked in an Impressionist-derived manner which she had learned at the turn of the century from men who had learned it from the masters. This combination of loose brushstrokes and light bright colour key with no apparent drawing underneath became as common a signature of the twentieth century as highly finished narrative paintings were of the nineteenth.

Ethel Walker belongs in this story because she was one of hundreds of working women painters who managed a career in art. Well known in her day, and forgotten now, an exhibition of her work would surprise with its competence and its evidence of a sustained commitment to art. While the portraits might strike the spectator as dated, the seascapes and flower pieces are timeless. Her problem is that she was not attached to any of the major stylistic movements of the twentieth century. Because the history of twentieth-century art is written in terms of styles which follow each other like a Biblical genealogy, such competent and pleasant painting rarely gets into the history books. The fact that the stylistic advances of the avant-garde are the organizing principle of twentieth-century art history does not detract from her talent; it merely makes her invisible. I have pulled her out of obscurity to make the point that, all through the period, women artists managed to make their way in an art world that neither actively hindered them nor put itself out to welcome them.

Lyubov Popova, *Painterly Architectonics*, 1916–17. This Suprematist and Constructivist artist extended her non-objective work to textiles, graphics and stage design after the Russian Revolution. She died aged thirty-five in 1924, in full creative flow, saved from the knowledge that the state would kill off experimentation.

WOMEN AND THE AVANT-GARDE

Many women did, however, work within the avant-garde: it was exciting and new, and women wanted to be part of it. An important French export of the late nineteenth and early twentieth centuries was

(above) Olga Rozanova, *Workbox*, 1915. This Russian artist gives a female twist to the still-life subject matter of classic French Synthetic Cubism. Always in the forefront of the Russian avant-garde, she died in 1918 aged thirty-six.
(below) Hannah Höch, *Strange Beauty*, 1929. A fascination with gender roles and expectations coloured much of this artist's work. In this montage, one of a series based on ethonographic images, she queries Western notions of beauty.

avant-garde art. Students took it with them when they returned home from their studies in Paris. As style succeeded style at the turn of the century and the avant-garde became increasingly important, private academies opened in several cities, often headed by an artist devoted to promoting the latest stylistic ideas. In 1901, the Phalanx School in Munich, run by Wassily Kandinsky, attracted the young Gabriele Münter; in 1902 they formed a professional and personal partnership that was to last fifteen years.

French art was also exported through exhibitions and aroused feelings of shock and excitement wherever it was shown. By 1910, it was possible for young artists to gain a knowledge of the most advanced art without ever leaving home. If and when they went to Paris, it was to build on their pre-existing knowledge. Several of the women who participated in the astonishing sequence of avant-garde exhibitions of Russian art in the ten years before the 1917 Revolution developed their styles in Russian art schools and in Russian artistic and intellectual circles. Alexandra Exter was already a recognized member of the Russian avant-garde when she went to study in Paris in 1908. Lyubov Popova had made a reputation as a neo-primitivist and Cubist-Futurist before her time at La Palette in Paris in 1912. Olga Rozanova, who between 1911 and her death in 1918, raced through several increasingly advanced styles from post-Impressionism to Suprematism, did not go to Paris at all. The notorious Natalya Goncharova (her religious subjects painted in a neo-primitivist style were branded pornographic at a Moscow exhibition in 1910) went to Paris for the first time in 1914 when she accepted Diaghilev's invitation to design costumes for the Ballets Russes. Her contribution to the development of a truly national brand of Russian Modernism was made through a mutually supportive relationship with the artist Larionov whom she met in 1900 at the Moscow School of Painting, Sculpture and Architecture. Their creative partnership, which allowed them each their own artistic identity, runs like a line of red paint through the movements, exhibitions, scandals and artistic manifestos of the pre-Revolutionary years.

Even though women had equal access to education and were less hampered by social convention, a link with the men in avant-garde circles could still be helpful. Hannah Höch was one of a group of Berlin Dada artists who had come together during the First World War with a personal philosophy of pacifism and an artistic one of anarchic expressionism. But without her seven-year relationship with the artist Raoul Haussman, which began in 1915 while she was a graphics student, it is possible that her talent would not have been so early recognized.

SURREALISM

The male Surrealists' fascination with the primitive and erotic aspects of Woman made them susceptible to beauty – a striking number of women Surrealists were beautiful. The movement also welcomed those with a visionary tendency.

(**left**) Leonor Fini, *Composition with Figures on a Terrace*, 1939. Although she never joined the group, the Italian-based Fini was friendly with the Surrealists, including René Magritte and Max Ernst. The foreground figure in this dreamlike painting has the artist's features.

(**below**) Dorothea Tanning, *Eine Kleine Nachtmusik*, 1946. The Illinois-born artist saw her first Surrealist works in New York in 1936. She painted this picture the year she became the fourth wife of Max Ernst. With its disruptions of scale, the long corridor with door opening on to – what? – the sleepwalking girls, the hair that winds its way through so many of these women's works and the inexplicable atmosphere of a dream – this is a quintessential Surrealist image.

(above left) Meret Oppenheim, *Object (Lunch in Furs)*, 1936. This fur-lined cup and saucer is one of the most disquieting Surrealist objects. Like Salvador Dalí's *Lobster Telephone* it unites disparate elements, but its inspired covering of china with fur arouses thoughts of mouths combined with liquid, and is far more disturbing than Dalí's joke. The Swiss artist exhibited with the Surrealists between 1933 and 1937.

(above) Eileen Agar, *Angel of Anarchy*, 1940. Eileen Agar came to Surrealism in 1929 and exhibited Surrealist works in the 1930s. This is the second version of this work in which she smothered a plaster cast of her husband's head with clothes and beads and feathers.

(left) Frida Kahlo, *Self-portrait with Cropped Hair*, 1940. Kahlo was the subject of all her art. This painting shows her, aged thirty, with shorn hair after her divorce from the Mexican artist Diego Rivera who had left her for another woman. Her hair writhes around her like sea snakes as she sits in a man's suit with a man's haircut, her scissors near her genitals, an image that expresses the collapse of her perception of herself as a desirable woman. Though she saw herself as a Mexican realist, André Breton claimed her as a Surrealist when he saw her work in 1938.

In 1920, this relationship worked to her professional benefit when George Grosz and John Heartfield refused to allow her to exhibit at the Dada Fair. The ban was only lifted when Raoul Haussman threatened to withdraw unless she was allowed to show her work. Let me be clear. This need for a man's helping hand says more about the workings of the art world than it does about women's talent. This kind of incident is typical of the wheeling and dealing of the art world, as it is of any world, and is the underside of the romantic belief that talent automatically rises to the surface like bubbles in boiling water. Men working together and helping each other have always been a feature of the art world, one which everyone takes for granted. It is only when a woman is involved that emotive points like favouritism and special pleading are made about the artist. If the incident had involved a man, it would be no more than an interesting footnote in the history of Berlin Dada.

The education offered by the new schools and the publicity surrounding new art movements gave women the chance to share in the newest developments of the art world. As education, exhibitions, artistic personalities and critical wars made the avant-garde public property, women were able to find their way into its most advanced areas. By the outbreak of the First World War in 1914, women's paintings and sculptures took in every area from male nudity to abstraction.

Every movement had a cluster of women artists connected to it like pins to a magnet. Of course, some were more sympathetic to women than others. Surrealism's fascination with the subconscious, with the erotic and with women – or more accurately 'Woman' – offered a way in for a certain kind of female artist, usually one with youth and good looks as well as talent. Eileen Agar used her personal style as a way of living out the principles of Surrealism. Remarking on how handsome the male Surrealists were, she added:

> The Surrealist women, whether painters or not, were equally good looking.... Our concern with appearance was not the result of pandering to masculine demands but rather a common attitude to life and style. This was in striking contrast to the other professional women painters of the time, those who were not Surrealists who if seen at all, tended to flaunt their art like a badge, appearing in deliberately paint-spotted clothing. The juxtaposition by us of a Schiaparelli dress with outrageous behaviour or conversation was simply carrying the beliefs of Surrealism into public existence.[8]

Eileen Agar did not shut her eyes to the realities of her art world. She was well aware of the problems women faced, but by turning the double standard to her advantage, managed to outwit the boundaries imposed by gender.

Among the European Surrealists double-standards seem to have proliferated, and the women came off worst. Breton's wife Jacqueline was expected to behave as the great man's muse, not to have an active creative existence of her own. In fact, she was a painter of considerable ability, but Breton never mentioned her work. The men were expected to be very free sexually, but when a woman like Lee Miller adopted the same attitude whilst living with Man Ray, the hypocritical upset was tremendous.[9]

She clearly felt that her liaison as a married woman in the 1930s with artist Paul Nash, entitled her to comment: 'Perhaps the English, ever discreet, managed to avoid such obvious confrontations.'[10]

The women were quick to see that because Surrealism was a movement in which technique was subservient to a poetic and imaginative vision, it offered an equal playing field to either sex. Though the men were the headline Surrealists, a number of women produced their own gender-nuanced version of Surrealism. If a visual idea was compelling, it could not be dragged down by suggestions that because it came from a woman's hand it was in some way second-rate. The women used the movement's hunger for powerful visual imagery to express their most complex – and shocking – thoughts and emotions. Surrealism is arguably the twentieth-century's most accessible art movement in that its strange imagery needed no art expert to elucidate its meanings. Its technique of dream-like juxtapositions of objects is still in use today, beloved by the creative departments of advertising agencies. As far as the public was concerned, it was solar-plexus art, and in that sense truly democratic. Once exhibited or reproduced, a shocking or surprising image could go straight to the public's psyche, and was not entirely dependent on critical or institutional mediation for success. Given this situation, it is no surprise that one of the icons of Surrealism, a fur-lined teacup and saucer, was the work of a woman.

While Surrealism was in some ways female-friendly, the abstract art that came out of New York in the mid to late 1940s most definitely was not. The New York abstract artists who took the world by storm were not receptive on a professional level to female artists. Abstract Expressionism was an all-male affair involving strong arms, huge canvases, buckets of paint and an army of male assistants who represented a mid-twentieth-century version of apprenticeship. These American men in their white T-shirts and blue jeans had nothing to do with the artist as aesthete. Their model was the troubled artist taken to extremes: Jackson Pollock was killed when he crashed his car; Mark Rothko committed suicide.

Abstract Expressionism was a classic case of a group of like-minded artists whose work was shaped and polished into an avant-garde movement by the cultural commentators of the day. In its early years, there was something of a closed circle about it and there was no way

(above) Lee Krasner, *The Seasons*, 1957–58. This huge work was painted after the death of Lee Krasner's husband Jackson Pollock in 1956, and is typical of her merging of the organic and abstract. (below) Helen Frankenthaler, *Mountains and Sea*, 1952.

of entering for a woman who hoped to gain glory from her art and not from her personal intimacy with the artist as his wife or mistress. Only when the first wave of excitement had subsided did the work by the female Abstract Expressionists get its chance. Grace Hartigan and Helen Frankenthaler who were part of the second wave at the start of the 1950s were helped by their personal links to the movement's leaders. Art classes taught by Grace Hartigan's partner Isaac Lane Muse introduced her into avant-garde circles; and in 1950 the young Helen Frankenthaler became friendly with Clement Greenberg, the critic and chronicler of the movement, after inviting him to an exhibition that she curated. This meant that at a critical point in their early development both had access to the circles of Jackson Pollock and Willem de Kooning, and were party to the discussions which were setting the agenda of the art world at the time. As Frankenthaler put it, she was able to develop in the context of the New York avant-garde of 1951.[11] Without these links these two women's talents ran a greater risk than the men's of being undervalued. Their contacts with the male leaders of the art world was a recasting in female terms of the traditional advantageous relationship between a teacher

Grace Hartigan, *Months and Moons*, 1950. This was painted when the artist was at the height of her Abstract Expressionist phase. She moved in Abstract Expressionist circles, drinking at Manhattan's Cedar Bar, going to the Artists' Club. She had her first one-woman show in 1951. Never one to follow a party line, figurative elements entered her bold and energetic paintings from the mid-'50s.

and a talented young student, or a famous painter and his assistant.

Whatever their private views about the fairness or otherwise of the art world's attitudes towards them, women wanted to be judged as artists pure and simple. An important strategy in achieving this for many twentieth-century women was to deny that their situation as women had any bearing on their reception by the art world. Even when they suspected that there were some 'ifs' and 'buts' to be considered, that male gate-holders and male attitudes about women affected their choices and advances, the overriding belief in talent outing itself made this an unacceptable point to make in public. Ideas have their time, and there are climates in which it is possible to complain and climates when it is not. Pointing out unfairness had no currency in a world where talent was seen as a magic dust which settled on random shoulders. Complaining was not an option when it was possible to point to women who made their living as artists. Most women were far too dignified to question the reception of their work, and to put one's failure down to institutionalized sexism, as we have learned to call it, would have received no sympathy. Instead women responded as individuals to the situation in which they found themselves. The American Alice Neel felt poorly treated by male artists. 'I always needed women's lib. I had it inside of me, but outside, these people ran all over me, even though I was a much better painter.'[12] She did not attempt to fight the setup of the art world. Instead she credited a psychologist in 1958 for getting her to the state where she could make an effort to put her work before the public.

One of the contradictions then was that, although talent was supposedly genderless, women constantly faced questions about whether their art was different from art by men. The simplest way of dealing with the questions was to refuse to admit there could be any difference. Sonia Delaunay developed a prismatic form of Cubist painting with her husband before the First World War. In 1965, during a Paris exhibition of women artists, she was asked about the differences between men and women artists: 'I don't see any difference. There are good ones and bad ones, the same as men.'[13]

Women were always afraid that if they admitted their work had specifically female qualities it was tantamount to labelling it as weak and in some way less than men's work. One can hear Barbara Hepworth's exasperation as she tried to avoid the trapdoors that threatened to drop her down to the inferior world of women's work:

(**above**) Isabel Bishop, *Tidying Up*, 1941. Although Isabel Bishop has produced many images of beauty and complexity, she is known for her female New York office workers, drawn from models. (**right**) Alice Neel, *Ethel Ashton*, 1930. Alice Neel painted nude portraits all her life, of men, children and couples as well as women – here a fellow artist.

'I have never understood why the word feminine is considered to be a compliment to one's sex if one is a woman, but has a derogatory meaning when applied to anything else. The feminine point of view is a complementary one to the masculine.'[14] It is quite out of the question to imagine Henry Moore, with whom Hepworth was constantly compared, being asked what was especially masculine about his family groups.

The women had to cope with the fact that the issue of gender-specific subject matter refused to die. Women artists in the public eye had to put up with the constant picking over of their art by critics and historians to find its 'feminine' component. The women took the question seriously, and, while some denied it, others tried to give a considered answer. Eileen Agar developed a theory about the importance of female creativity. For the fourth and last issue of a magazine in 1931, which she and her husband founded, she contributed a short piece 'proclaiming the new reign of womb-magic, the dominance of female creativity and imagination.'[15] During the years 1933 to 1934 she produced a work called *Autobiography of an Embryo*. Barbara Hepworth ventured a claim that her approach to sculpture was in part attributable to her being a woman:

I think that women will contribute a great deal to this understanding through the visual arts, and perhaps especially in sculptures, for there is a whole range of formal perception belonging to feminine experience. So many ideas spring from an inside response to form; for example, if I see a woman carrying a child in her arms, it is not so much what I see that affects me, but what I feel within my own body. There is an immediate transference of sensation, a response within to the rhythm of weight, balance and tension of the large and small form making an interior organic whole. It may be that the sensation of being a woman presents yet another facet of the sculptural idea. In some respects it is a form 'being' rather than observing, which in sculpture should provide its own emotional and logical development of form.[16]

Sexual difference was a minefield that they were loath to enter: 'Sculptors are workmen. They're not female, they're not anything' Barbara Hepworth said at one point. 'They're anonymous workmen.'[17]

Some artists made women their subject. Most of Hannah Höch's photomontages between 1918 and 1933 show her fascination with the way women were represented in the media and offered critiques of glamour, of women's roles and of prevailing standards of beauty. Alice Neel was fascinated by pregnant women and right from the start of her career she painted portraits of them nude. Isabel Bishop watched the New York City working girls and presented their small daily rituals on canvas with dignity and sympathy. In Germany, Käthe Kollwitz's sympathy for the suffering of women resulted in etchings

Käthe Kollwitz, *Woman with a Dead Child*, 1903. The artist's younger son Peter, later to die in the First World War, was the model for this print. The compassion for maternal suffering and the daily struggle for existence which mark this artist's work fuelled her radical left-wing politics.

and sculptures that heroicized their situation. In 1950, Grace Hartigan did a painting entitled *Months and Moons* which she explained as an attempt to show the relationship between women and the rhythms of nature. A strand of early Abstract Expressionism was a concern with archetypes. Her twist was to expand this to include a female content, just as women in earlier centuries had when they searched for heroines.

No less ambitious, no less serious than the men, the women worked out ways to pursue their careers. Whatever the attitudes of the art world, the women stood their ground. 'I was in the exhibition of the New York Group in 1938 at the ACA gallery – seven men and I,' said Alice Neel. 'They were so embarrassed because I was a woman, but I didn't feel any different from them. They didn't understand.'[18] Georgia O'Keeffe faced similar experiences in the 1920s: 'At first the men didn't want me around. They couldn't take a woman artist seriously. I would

Georgia O'Keeffe, *Light Iris*, 1924. Its close-up quality lends this an abstract element, and its large size takes it far from the realms of what is thought of as feminine flower painting.

listen to them talk and I thought, my, they are dreamy. I felt much more prosaic, but I knew I could paint as well as some of them who were sitting around talking.'[19] Gluck took her career very seriously, designing her own white frames for her exhibitions at London's Fine Art Society in the 1930s. But a phrase in a letter to her mother in 1936 shows that the amateur insult still haunted the woman artist: 'When you come to the show, tell no one you are Mrs Gluckstein. Just tell them you are my mother. You will help the sale of my pictures more than you know, because then I shall not be labelled "rich amateur" and your personality will not be swamped by the name either.'[20]

Just as the taint of amateurism refused to die, so did notions about women not needing to work to live. The truth is that this is exactly what women artists needed to do. When the painter Sonia Delaunay lost her income after the Russian Revolution she began to concentrate on applied and decorative art. Over two decades, she kept herself, her husband and her son financially afloat by making an international reputation as a designer of fabrics, costumes and interiors. 'Noble work,' she called it, 'as much as a still life or a self-portrait.'[21]

Ethel Walker had constant problems in making ends meet though fortunately she had her full share of artistic egotism to help her cope. A young friend recalled a particularly excruciating evening involving the seventy-two year old artist : 'Early in 1933, Sir William Rothenstein asked if he could visit her studio and see her work, which he admired so much, she invited him and other artists to an evening party.... The time was spent in looking at her pictures, which gave us all great pleasure but became somewhat exhausting as time wore on. The only available chairs were occupied by dogs and canvases, moreover our hostess demanded our undivided attention all the time.'[22]

Ethel Walker was tireless in trying to sell her work, which she did by citing the admiration of others. 'I want you so much to see my still life on the mantlepiece...also Mr Tylgat's portrait. The former is really the best flower piece I have ever painted. Mr Pissarro, who is a severe critic, says that in that work I have touched the goal.'[23] Like most artists, she was always short of money, and the self-praise was a sales strategy, though an inordinately clumsy one. In 1934, during her most successful decade, when she was seventy-three, she wrote:

It would give me the greatest satisfaction if *The Woman of Samaria* were chosen, because I love it. I have priced it as £150. Is that possible, do you think? If not shall I say £125. I am at least £30 overdrawn at the bank besides which I owe my builder here £81 for saving my house here from being precipitated into the sea through the past twenty-seven years' storms by its dangerous clay foundation. He has now pierced down to the solid rock, building a high cement wall extending 40 feet in length and made it safe for 100 years. I have paid him £200 already but not having sold anything since last March this £81 has not been forthcoming for him.[24]

FAMILY, ART, AMBITION

Although many a woman's talent shrivelled when faced by the responsibilities of marriage, motherhood and keeping the family afloat, others were not affected. Isabel Bishop's husband took it for granted that she would work after marriage in 1934 and the birth of her son in 1940. 'We left the house together every morning: he went on to his work and I went to my studio. There was never any question about it.'[25] One thing all women have in common is that, while the demands of marriage would never force a man to end his career, this can never be taken for granted by women.

The women were fierce about proving that their family responsibilities did not adversely affect their art. The intellectual climate made it hard for a woman who wished to be taken seriously to admit to any weakening of her art by her family or by her femaleness. The twentieth-century conviction that women's creativity went into having children (something women themselves might rephrase as their energy went into caring for their children) forced artists with their eyes on sales and critical respect to prove that it was untrue in their particular case. Barbara Hepworth claimed that far from hindering her, her children enriched her art and her art in its turn helped her through the worst maternal nightmares.

> There's an oval sculpture of 1943. I was in despair because my youngest daughter, one of the triplets, had osteomyelitis. In those days the war was on and you couldn't get anything. She was ill for four years. I thought the only thing I can do to help this awful situation, because we never knew if it would worsen, is to make some beautiful object. Something as clean as I can make it as a kind of present for her. It's happened again and again. When my son died, he was killed, it's the only way I can go on.[26]

Barbara Hepworth, *Oval Form*, 1943. Neither husbands nor children could stop Barbara Hepworth's production and inventiveness. Although privately she felt that she suffered professionally from being a woman, she never admitted this in public.

This way of coming to terms with distress and death was also experienced by Käthe Kollwitz when she conceived the plan for the memorial to her son Peter who was killed in 1914 at the start of the First World War. She wrote that the monument would have Peter's form, lying stretched out, the father at the head, the mother at the feet. It would be to commemorate the sacrifice of all the young volunteers. 'It is a wonderful goal and no one has more right than I to make this memorial.'[27]

In 1970, Barbara Hepworth's *Pictorial Autobiography* was published, showing her as woman and sculptor as if there were no conflict between the two. Every double-page spread combines evidence of her professional life in the form of reviews, catalogue covers and images of her art with personal snapshots of herself, her children, her husbands and her friends. The text presents a seamless picture of an artist, mother and wife. To placate those who feel a woman is unnatural if she ignores her family, a photograph shows her beaming at a baby daughter. To prove to those who feel a woman's domestic role must prevent her from devoting herself to work, the mother-and-baby photograph is faced by a photograph of an abstract sculpture and an article outlining her artistic manifesto. When she writes about the birth of triplets, she subtly suggests her temporary vulnerability, but counterbalances this with an equally subtle presentation of herself as a breadwinner alongside the children's father:

> I myself knew fear for the first time in my life as I was very weak.... It seemed as though it might be impossible to provide for such a family by the sale of abstract paintings and white reliefs, which Ben Nicholson was then doing, and by my sculptures; but the experience of the children seemed to intensify our sense of directions and purpose, and gave us both an even greater unity of idea and aim. When I started carving again in November 1934, my work seemed to have changed direction, although the only fresh influence had been the arrival of the children. The work was more formal, all traces of naturalism had disappeared, and for some years I was absorbed in the relationships in space, in size and texture and weight, as well as in the tensions between the forms. This formality initiated the explorations with which I have been preoccupied continuously since then, and in which I hope to discover some absolute essence in sculptural terms, giving the quality of human relationships.[28]

Barbara Hepworth never allows the reader to forget that she is a serious sculptor as well as a mother. The whole thrust of the book's text and photos is to show that her sculpture did not suffer because she had a family, and her family did not suffer because she was a sculptor. The book would not have been given the form it had were there not conflicts to disguise. In her private writings, Barbara Hepworth revealed that she understood all too clearly how being

Emilie Charmy, *Portrait of Berthe Weill*, c. 1917. Art dealing emerged as a new career for women in the twentieth century. Berthe Weill opened her first Paris gallery in 1901 for young artists. In 1902, she showed Picasso (no sales) and in 1905 Emilie Charmy for the first time.

a woman affected her position as a leading British sculptor. In 1943, she wrote an angry letter to Sir Herbert Read berating him for not including her in a show of British artists: 'I can give you four reasons why I was not chosen: 1. I am a woman. 2. I am an abstract artist. 3. I am a mother. 4. I am married.' Her reasons make chilling reading and could have been written by a woman today. But they were not to be stated in public in the 1940s.[29]

RECOGNITION

The women understood the importance of making records of their work, and to this end involved themselves in exhibitions, manifestos and publications that would be guaranteed to put forward their case and earn them the public's eye and ear. Art movements and factions were a feature of the century, and women were part of the numberless artistic groups devoted to one 'ism' or another which formed then reformed throughout the period, with a new manifesto every time. In 1937 Barbara Hepworth contributed an article on sculpture to *Circle*, the publication that symbolized Britain's involvement in the modern movement. In 1950 Isabel Bishop was involved in *Reality*, a magazine for the voices of figurative artists inspired by Raphael Soyer's irritation that Abstract Expressionism had become the American art world's only topic of discussion. Thanks to her friendship with the cultural commentator Clement Greenberg, the canvases stained with paint that were Helen Frankenthaler's contribution to the movement were written into art history as an influence on the art of Morris Louis.

As books, newspapers, reproductions, criticism and exhibitions became increasingly important in furthering an artist's reputation, women did their best to ensure they were represented in them all. They realized that in an age when agendas were set by by journalists it was necessary for a woman to be able to define her art. 'It is part of the artist's business to push towards an image,' Isabel Bishop believed. 'You have to fight for it. A new image, symbolic of its period, in the way we say a Roman head or an eighteenth-century man.'[30] Alice Neel's goal from the start of her career at the end of the 1920s was to sum up an era in her portraits. 'I think one of the things I should be given credit for is that at the age of 82, I think I still produce definitive pictures with the feel of the era,' she said at the start of the 1980s.[31] This dream of producing an art for their times was genuinely held, but it was also a shrewd way, in a century of branded goods, to fix one's own particular brand of painting in the public's mind.

In order to find more outlets for their work, the women tried to place their work with dealers, among whom could be found several women. In France, Emilie Charmy (from 1905), Marie Laurencin (from 1908) and Suzanne Valadon (from 1915) were represented by the dealer Berthe Weill: she did not limit herself to female artists – in fact most of her artists were men – but she had a sympathy towards them, revealed

by her personal writings. The dealers' priority as businesswomen, however, was not to bring women artists to the fore but to make a living or, if they were Peggy Guggenheim, collector, heiress and wife of the Surrealist Max Ernst, to showcase the artistic developments of the day. She opened her New York gallery, Art of the Century, in 1942. By the time it closed in 1947, she had introduced Jackson Pollock, Robert Motherwell and Mark Rothko to the world.

In order to establish a place in the art world, the women joined artists' associations, taking strength from the authority and status that membership gave them, and sharing in their busy worlds of meetings, discussions and exhibitions. A number of women's organizations were dedicated to exhibiting the work of their members. The support they offered was welcomed, but they did not achieve anything like the dramatic changes of the nineteenth century, in part because the women themselves were losing confidence. Experience was teaching them that the future was not in the palm of their hands as they had so hopefully believed at the end of the previous century. Artists' groups with left-wing leanings were particularly strong in the 1930s; they offered a new space for women to make their mark, although they could never be relied on to promote gender as strongly as class equality. Personal political commitment without actual group membership also gave women a sense of purpose. Käthe Kollwitz was all her life a champion of the poor, mothers, children and the victims of war. Her sculptures and etchings gave her fame and a special place in German art.

All the women mentioned in this chapter received recognition through exhibitions, publications, interviews and purchases by

Moses Soyer, *Women on WPA*, 1935 During the Depression, the American government ran a number of projects that supplied employment to artists. Both Lee Krasner and Alice Neel were employed on federal programmes, Alice Neel earning $26 a week as an easel painter.

Frances Hodgkins, *Wings Over Water*, 1931–32. Frances Hodgkins came to Europe from New Zealand in 1901, studying in Paris, travelling in Morocco, becoming the first female watercolour teacher at the Académie Colarossi in Paris in 1910, and settling in England in 1914. Her lyrical and always identifiable paintings are the product of a vision that was true to itself.

museums and galleries. Alice Neel painted her way through motherhood, breakdown, children, partners and the government-funded art projects of the 1930s before finally gaining recognition in the 1970s with a retrospective, just in time to save her from the bitterness of neglect. Isabel Bishop was early recognized: the Metropolitan Museum of Art bought a painting of hers while she was in her thirties, and she had a major retrospective in 1975. Barbara Hepworth achieved a double status. Internationally known for her sculpture, she is also figures in the story of modern art in Britain in the 1930s, a key character in every art history course on the subject.

As ever, academic honours failed to keep pace with the increased numbers and successes of the women. But it mattered less than before. The art world was in a state of change. In the face of the avant-garde, the values of the academy began to seem dusty and irrelevant, and the influence of the traditional honour-conferring institutions began to wane. As the academies lost their stranglehold on the dispensation of artistic honours, other routes to recognition became important. The New Zealand artist Frances Hodgkins, who had stubbornly spent her life refining her poetic visions of landscape and still life, must have felt totally vindicated when invited to exhibit with Britain's artistically advanced Seven and Five Society in 1929, or when the artist Graham

Sutherland recognized the singularity of her talent in the 1930s: 'She just seemed to know exactly what she wanted to do and there appears to be no question in her mind that she was being anything particularly pioneering.'[32]

By the 1960s, women were much more troubled by the attitudes of the men around them, and saw more clearly the contradictions that underlay the official equality. In California, an ambitious young student called Judy Gerowitz absorbed the attitude from her male tutors that women's work was inferior and tried to turn herself into an honorary man:

Louise Bourgeois, *Femme Maison* (Housewife), *c.* 1946–47. Louise Bourgeois left Paris for New York in 1939 with her American husband. The sculptural and installation work of her maturity offers disturbing explorations of terrors, sexuality and states of mind. These early works of women trapped in their roles created a stir when they were discovered by '60s feminists.

When I was an undergraduate, I had noticed that most of the serious students were men, and because I wanted to be taken seriously, I sought the friendship of these men. They often told me that I was 'different' from other women. I felt a warm glow of pride in my 'specialness' and enjoyed the status that I had as the result of being the only woman they took seriously. I can remember the men at school putting other women down, calling them 'chicks' and 'cunts'. Occasionally I joined in, feeling a little guilty but wanting to be 'in' with them…. I slowly and unknowingly began to absorb the culture's contempt for women, rationalizing my own femaleness, as the men did, by the fact that I was somehow 'different'.[33]

At the same time, on the other side of the country, at Yale, Jennifer Bartlett also found male supremacy the norm, but dealt with it differently with a display of open aggressiveness: 'I adopted a completely macho attitude of my own…. I was terrified my first semester but then I just started building huge stretchers that interfered with the people working near me.'[34]

Both women survived because of their characters. Judy Gerowitz (Judy Chicago) survived because of what she described as an 'irrepressible confidence' and an ability to 'separate myself from that social conditioning that prompted other women to relinquish their goals.'[35] And Jennifer Bartlett survived because of what she called her 'considerable anger' as well as the inspiration of discovering on arrival at Yale in 1963 that the students believed that they were the next generation of the avant-garde. 'There was no question in our minds that we would be showing at Leo Castelli's any day…. I remember hearing that Larry Poons had had his first show at Leo's when he was twenty-six; and it was perfectly clear to me that if I hadn't had a show by the time I was twenty-six, I was quitting.'[36] It was obvious that feminism was a movement waiting to happen.

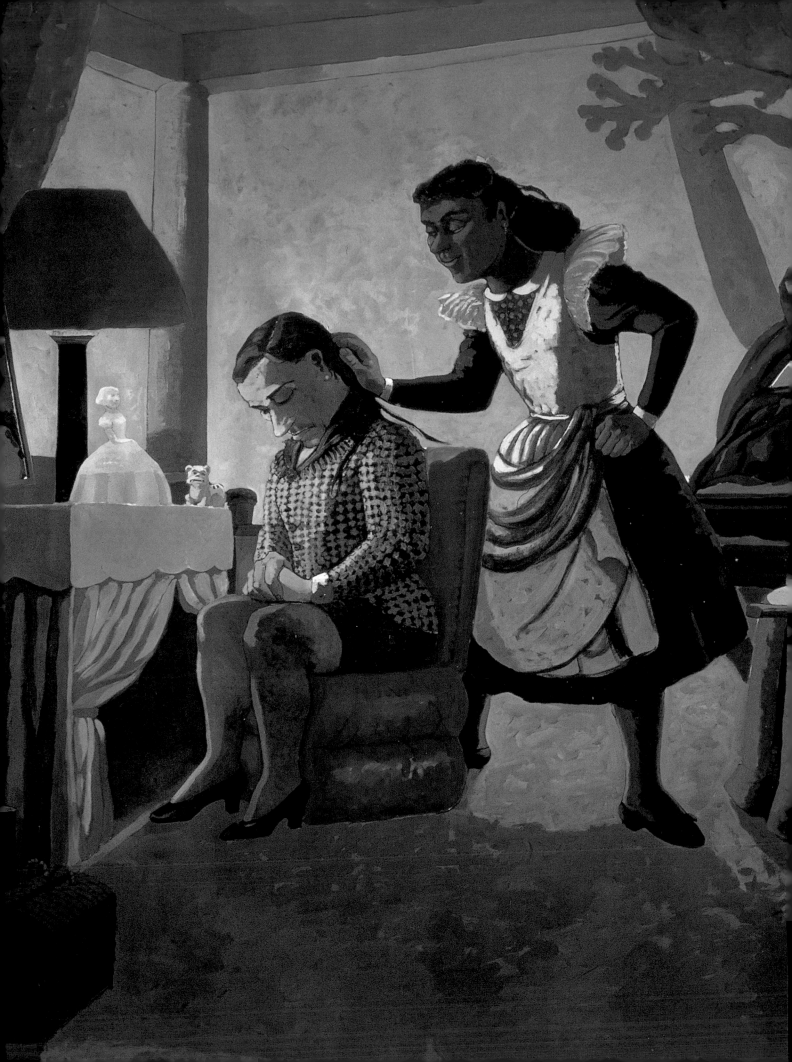

1970 and after
The feminist revolution

*'Anon, who wrote so many poems without
signing them, was often a woman.'*
VIRGINIA WOOLF

'I think art is anonymous.'
BARBARA HEPWORTH

Feminism was not new, but its use to analyse
art and the art world was. Its new way of
looking at the art establishment gave women
the confidence to express their feelings and
state their demands. Women artists wanted
success and recognition, as they had always
done, but this time they were willing to shout
for it in a manner that was not softened by any
genuflection to expectations of acceptable
feminine behaviour or to the standards of
the art world. The ambitious young artists
in turn-of-the-century Paris had shown
a similar desire to make their mark, but they
operated according to the rules of the world
that they longed to enter and conquer.
While nineteenth-century women wanted to
get the training that would enable them to play
the game, the 1970s feminists took their
training for granted and wanted to change
the rules of the art world.

CAST OF CHARACTERS

A few of the artists who have brought new voices to the art world.

JENNIFER BARTLETT, born in California in 1941, was a student at Mills College, then Yale University School of Art and Architecture. She makes large multi-part works uniting assorted materials. *Rhapsody* (1976) displays variations of the landscape vocabulary on steel squares. *In the Garden* (1980–81) is a series of drawings and paintings of a French garden. Boats, fences and sculptures extend her more recent paintings into the gallery space. Among her many corporate commissions and honours is the American Academy and Institute of Arts and Letters award, 1983.

JUDY CHICAGO, née Cohen, was born in 1939 and studied at the University of California, Los Angeles. In 1961 she married Jerry Gerowitz (killed in a road accident in 1962). She took Chicago as her name in 1970, and set out to create a feminist art practice. With Miriam Schapiro she developed the central core theory of female imagery and set up the ground-breaking Womanhouse in 1972. A seminal but controversial figure, her desire to change and enlighten produced *The Dinner Party*, 1975–79; *The Birth Project*, 1980–85; *The Holocaust Project*, 1993, with her third husband Donald Woodman. Her work has in recent years been reassessed and recognized for its foreshadowing of contemporary ideas.

(previous pages) Paula Rego, *The Maids*, 1988 (detail).
(this page, left to right) Photograph of Jennifer Bartlett (detail). Photograph of Judy Chicago, 1971 (detail).

MARY KELLY was born in Maine in 1941. She trained in fine art and music in the USA; fine art and aesthetics at the Pius XII Institute, Florence; St Martin's School of Art, London. After her marriage (one son, born 1973) she was based in Britain. A feminist conceptual artist interested in cultural theories, her mixed media works include *Post Partum Document*, 1973–78, a look at the mother-child relationship; *Interim*, 1984–89, which deals with the concerns of the middle-aged woman; *Gloria Patri*, 1992, an examination of the meaning of masculinity today. She now lives in New York.

MIRIAM SCHAPIRO was born in 1923. One of the second generation of New York Abstract Expressionist painters, she was influenced in the 1960s by feminist ideas. In 1971 she was appointed with Judy Chicago to teach at the California Institute of the Arts, where they initiated the Feminist Art Program and brought about the landmark Womanhouse (1972) which showcased artists whose work was concerned with women's issues. In the 1970s she developed femmage, a female version of collage, using materials in a semi-abstract style. She married the artist Paul Brach in 1946, and they have one son born in 1955. Now based in New York, she has received many honours.

FAITH RINGGOLD was born in New York in 1930 and received her MA from City College in 1959. Married twice, she has two daughters. She visited Europe in 1961, Africa in 1976. After a first career as a schoolteacher, she made her name as an artist with story quilts of paint and fabric depicting the lives of black women in the USA. In 1985 she was made a professor of art at the University of California at San Diego. She has received many honours and awards.

(left to right) Ray Barrie, photograph of Mary Kelly recording her son, 1975 (detail). Photograph of Miriam Schapiro, 1971 (detail). Grace Welty, photograph of Faith Ringgold.

Judy Chicago, two details from *The Dinner Party*, 1979: **(top)** *Georgia O'Keeffe Place Setting*; **(below)** *Artemisia Gentileschi Place Setting*. Though many felt that the female forms of this tribute to the great women of the past put too much stress on the biology that had always been blamed for women's poor professional performance, no one could ignore them.

Women's confusions and resentments over their role in the art world in the 1960s culminated in the new wave of feminism. By the early 1970s Judy Gerowitz and feminism had found each other. She changed the surname foisted on her by a patriarchal society and began her journey to fame as a feminist artist as Judy Chicago, liberated by her realization that male approval had been earned at the expense of the female-influenced content and form she had been forcing herself to repress. In 1972, she and Miriam Schapiro were the force behind Womanhouse, a landmark feminist art project in which their West Coast students transformed a derelict house into a collection of installations concerned with the new woman driven subject matter. Jennifer Bartlett, inspired by the assumption of her student years that she would inherit the mantle of the avant-garde, took a different route: her quarrel was with the chauvinist attitudes around her, not with contemporary art, and she made her career within the existing world of dealers and exhibitions.

The feminists did not care who they outraged because for the first time they were supported by a theory. It went as follows: the art world was male; all its institutions, beliefs and values were constructed from a male point of view. Like all the best theories, it explained everything. It was seamless, it was exciting and it gave women a cause. They understood for the first time why competing with men on equal terms, or accepting the cliché that art had no sex, had not delivered equality. And they saw as clearly as through a clean window that the attitudes and judgments accepted for centuries came out of the mouths of people, male people, with their own views about women and art.

As well as offering an explanation that made sense of the experiences of the women who had come through the '60s, feminism revolutionized the art made by women and it revolutionized art history. Feminism provided a moment of stock-taking for women. Its theories, its research and its conclusions gave women a grip on the world of art.

It was not all neat and tidy of course. Some research findings, such as the revelation that, while over half the art-school population was female, nearly all the teachers were male, or the constant under-representation of women artists in exhibitions, were unarguable facts. The real fun came with the theories. Factions developed, with one argument blaming women artists' failure to reach the heights on institutional hostility versus another that said internalized female attitudes were to blame. Some applauded the feminist artists who made art out of female experiences for bringing new issues into art. Others accused them of recycling the old belief that women could never rise above their biology. And so it went on. It was an exciting, bad-tempered, and creative time, and by bringing ideas and issues into the open, it gave women the courage to speak for themselves. Feminism caused a huge sea-change, so that even those whose sexual politics

were separated from their artistic interests became aware of the unfairness women faced in all areas of the art world.

In the past, the term women's art had meant any one of a number of things. It could be the patronizing definition coined by critics and commentators who thought women's art was everything pastel, small and second-rate. It could mean the art women did, watercolours or portraits of children, because it was all they were technically equipped to do or because it did not take up much space. It could refer to something more specialized like the claim in late nineteenth-century France that women's special contribution was an emphasis on moral, family-centred subjects, an extension of their civilizing role in society. It could be a style, pretty, intuitive and pulsating with sensibility.

The new women's art was different. It was defined by the women themselves. It was produced out of their acknowledgment of their situation as women. It explored issues of interest to women. And it offered a response to traditional attitudes towards women's art. Women's work was naturally small and dainty? Judy Chicago showed

Judy Chicago, *The Dinner Party*, 1979. The size of this huge installation and the contributions of many women to its making were two strategies of feminist art makers of the '70s.

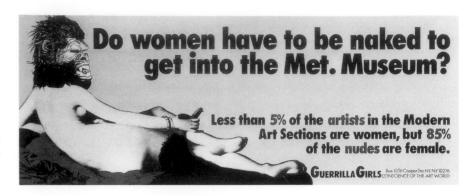

The Guerrilla Girls, *Do women have to be naked to get into the Met. Museum?* mid-1980s. Determinedly unfeminine, the Guerrilla Girls dressed anonymously in gorilla masks and assailed New York with art's new feminist facts.

what she thought of this kind of criticism by producing her huge triangular *Dinner Party* installation in 1979. Five years in the making, each of its 48 foot (14.6 metre) sides carried place settings celebrating thirteen legendary women, and it demanded a vast exhibition space to house it and the hordes of visitors who came to see it. Elizabeth Butler had reacted in a similar way when she painted her series of huge battle scenes in the 1870s, in contemporary eyes making her statement even stronger by borrowing 'male' subject matter. The difference was that Judy Chicago was showcasing the female contribution to the world.

The artists grouped under the feminist banner 'the personal is the political' included women of colour, women who had begun to feel uneasy about the assumptions of the art world, lesbians, and socialists who believed that women's fate depended on a changed society. Their disparate histories and views brought new types of content into art galleries. Issues of colour and ethnicity; illnesses of particular concern to women; obsessions like weight and diet; specifically female areas like sex, keeping a home and motherhood (in its daily childcare aspect not the Holy Mother image); taboo subject matter like menstruation – all found their way into art and all from a female point of view. Materials and techniques were used with a nod to the traditional female skills. Soft sculpture, as used to make soft toys and quilts, embroidery as used to decorate domestic objects, knitting and sewing as used to make clothes for the family were used by artists from a variety of cultural backgrounds to show that female crafts were worthy of inclusion in the Western high art tradition. Miriam Schapiro's interest in 'femmage' (her word for the feminist version of the artistic term 'collage') led her to combine fabric with painting in huge semi-abstract works. Faith Ringgold told her tales of African-American women through story quilts, narrative works of paint and quilting, which unite her fine art training in American art schools with her family background of African crafts.

Women did not invent performance art, an honour that can be laid at the feet of the Futurists, but they exploited its potential. They explored a number of issues through this medium, in particular those to do with the rôle-playing that women undertook without ever thinking about it. Artists applied and took off their makeup, and they

scrubbed the floors of art galleries and prepared family meals, sometimes in slow motion or in endless repetitions. In an attempt to take the female body out of art history where it existed as an artistic category of its own – the nude – and take ownership of it of themselves, some women made their artistic points in the nude. There was never total conviction that the strategy actually achieved its intended goal, but on the positive side, this kind of body art played an important part in giving feminist art its high profile.

Besides encouraging new artists, new subject matter and new ways of making art, the feminists suggested new ways to look at artists currently at work. Louise Bourgeois was in her fifties when the American critic Lucy Lippard began to champion her in the mid-'60s. Although she had a track record and a reputation, her current position as a leading artist of our time owes much to feminist recognition of

(above) Faith Ringgold, *Mrs Jones and Family*, 1973. By borrowing from African masks, the artist makes a point about her all-American Joneses.
(right) Miriam Schapiro, *Me and Mary Cassatt*, 1976. Miriam Schapiro worked with Judy Chicago to set up the landmark Womanhouse project at California Institute of the Arts in 1972. In this acrylic collage she pays tribute to an earlier American woman artist. The Cassatt painting she chose raises questions: what does a woman see when she looks in a mirror? What do modern women see when a woman from history looks in a mirror?

CHALLENGING TABOOS

The feminist artists of the 1970s broke taboos as part of their strategy. It is an aim embraced by many of today's artists, whether they call themselves feminists or not.

(above right) Tracey Emin, *My Bed* (Installation Shot: Tate Gallery, London), 1998. The presence of this British video and installation artist is revealed in the traces of her bodily fluids, used underwear and litter. This work can also be read as a contemporary extension of the self-portrait.

(right) Jenny Saville, *Plan*, 1993. This is one of a series of huge paintings the artist based on herself which takes self-portraiture into the realms of issues of concern to women. The subject here is bodily self-image. The mountain of flesh is marked with geographer's contour lines that show the shape and the height of the land. They also suggest the marks made by plastic surgeons before they cut into the body for cosmetic surgery.

(opposite) Kiki Smith, *Untitled (Train)*, 1993. Menstruation was introduced into art by the feminist artists of the early '70s in an attempt to tell a female truth about women's bodies. Though female nudes were an accepted artistic genre, they were nudes turned into a male idea of beauty. This American artist's use of beads for the flow from the waxen body suggests a link with the glamour and costliness of jewelry .

the questioning mind that lay behind her disturbing, sexual and unclassifiable drawings, sculptures and installations.

Because its subject matter was based on women's concerns and experiences, feminist art spoke clearly to its audience – a huge audience, half the population, that did not need to be knowledgeable about art to appreciate the concerns enacted before its eyes. The existence for the first time of an art that was by women for women made even women who were customarily closed to art receptive to its methods and messages.

WOMEN'S OWN ARTISTIC WORLD

Feminism brought one of the strands of this book to a head: the ideal of a female artistic community. Lavinia Fontana had a female circle of patrons in sixteenth-century Bologna. Female circles of aristocrats and artists existed in the eighteenth century. Women students shared experiences in late nineteenth-century Paris. Many artists joined the female exhibiting societies which were a feature of artistic life from

Marina Abramović, *Rhythm 4*, 1974. This photograph is from a 1974 performance in which the Belgrade-born artist's face was distorted by a powerful air blower, culminating in her loss of consciousness. To the audience, watching on video in a separate space, it seemed as if the artist was under water.

(opposite above) Sophie Calle, *The Striptease*, 1989. One strategy of the feminists was to take ownership of the art-gallery nude by inhabiting it themselves. (opposite below) Janine Antonini, *Loving Care*, 1993. Loving Care is the name of the most famous hair dye of them all. Here the artist applies colour not to beautify herself but to make a work of art with her hair on a gallery floor.

the mid-nineteenth to the mid-twentieth centuries. But now, with the realization that the male world of art would never be wholly welcoming to women, the dream of a self-sufficient female world of art took hold.

The feminist drive for a world of female structures and institutions was more ambitious than anything that had previously been seen. For example, feminist research had shown that most dealers and gallery owners, whether they were male or female, had no particular sympathy for women artists, and that women's work was consistently exhibited less often than art by men. Feminism made this an issue, and groups and galleries run by and for women became a feature of the period. There were women's art and art history courses, women's art spaces, women critics, women's art magazines. Sylvia Sleigh chronicled the women of the New York feminist art scene of the 1970s, valorizing them as male artists had done their colleagues for centuries.

Although female solidarity helped women explore their ideas in an atmosphere of support and excitement, not everyone agreed with the idea of a separate women's world, and a debate ensued about where to operate – in a self-contained women's state where there was a risk of speaking only to the converted or in the wider world of art. In the event the lines were never clearly drawn. With hindsight, the feminist world can be seen as the research and development arm of the art industry. Curators and cultural commentators were conditioned to search for the next big thing wherever it appeared, and the women's work attracted their attention. In general the work of the openly issue-based feminists was of less interest to those in positions of power than work that could be intellectualized, or that

Sylvia Sleigh, *Soho 20 Gallery*, 1974 (diptych). In the heady days of American feminism the ideal was a network of dealers, galleries and writers in support of women artists. To a degree this did happen. This diptych commemorates the women associated with New York's Soho 20 gallery. Sylvia Sleigh (standing left, right-hand panel) was a British artist who settled in the city in 1961.

used the techniques of the avant-garde, which in the establishment's view was the sign of contemporary art. Now that time has passed, it is clear that there was much more common ground between the groups than seemed at the time. Representing the heroine wing of the feminist movement is Judy Chicago's *Dinner Party*, 1974–79, her homage to thirty-nine influential women expressed through thirty-nine precisely measured table settings of sculpted and painted porcelain plates set on embroidered cloths, an acknowledgment of the traditional female skills of china painting and needlework. Representing the conceptual and psychoanalytic wing is Mary Kelly's *Post Partum Document* (1973–78), an intellectual consideration of the relationship between maternal loss and a child's developing sense of self. One section featured a series of neat white panels on the gallery walls which on inspection turned out to be her son's washed nappies accompanied by summaries of his food intake. From the world of the avant-garde comes Jennifer Bartlett's *Rhapsody* (1975–76), a portable mural needing 153 feet of wall (46.6 metres) to display its variations on a house, two trees, a mountain and an ocean silk-screened on to grids of small enamelled steel plates: 'The most ambitious single work of new art that has come my way since I started to live in New York,' wrote the critic John Russell.[1] Whatever their political and artistic differences, all three women displayed the art world's interest at the time in systems and modules.

Side by side with the new art went the research into the history of women artists. The feminists suggested new questions to ask art history. Where are the women artists? Why don't we know more about them? Working like archaeologists to fill in the gaps of the history of women in art, they produced biographical details and bodies of work for women artists who until then had been footnotes in other people's stories, wives and daughters and students of more famous men. Fitting women into the history of art like pieces of a jigsaw is a project that continues today. In the process, realizations about how art history had been written put historians in the dock for helping to bury women.

My own favourite example of art history's inability to give full praise to woman artists comes from the declaration in the discussion of Berlin Dada in the *Pelican History of Art* that the collages of Hannah Höch, personal and professional companion to Raoul Haussmann, are 'scarcely inferior to his.'[2] Scarcely inferior? Was it too difficult to say as good as? But why make that kind of comparison in the first place? Was Braque 'scarcely inferior' to Picasso in the days they developed Cubism together? A sort of ladder mentality comes into play when male and female artists' work is compared. There is room for a cluster of male artists in a movement without one reputation being harmed at the expense of another. But when a woman is added to the group, she is seen as reaching only to the men's shoulders, that traditional image of male and female pairing. The ability to resist ranking in discussing the shared traits of those engaged in similar artistic projects has always been beyond male critics' ability when male and female artists are under discussion.

By clarifying women's experiences in the art world, feminist research made a huge difference to the way we look at women artists. It documented their exclusion from training. It detailed the kind of criticism they received and the belief system about women's incapacity to make great art that lay behind it. It showed how to all intents and purposes a quota system had always been imposed on women when it came to honours, exhibitions and membership of societies, the

(above) Mary Kelly, *Post Partum Document: Documentation Prototype, Analysed Faecal Stains and Feeding Charts,* 1974. This multi-part work was a psychoanalytically informed look at the mother-and-child relationship. Its form owes much to the contemporary art world's interest in systems, exemplified by Jennifer Bartlett's *Rhapsody,* 1975–76 (right). In this huge work, of which a detail is shown here, the American artist produces a contemporary variation of the traditional theme of landscape.

syndrome of 'we've already got a woman'. There was not one area of women artists' lives that did not have a torch shone on it. The feminists replaced the traditional search for feminine content by starting from the women artists' social position, not from an innate and mysterious essence of woman. They questioned the myth that talent would out by showing that artists who were not appreciated until they died, or artists who were wildly appreciated in their life to the mystification of their successors, illustrate the fact that contemporary judgment can affect success. In the case of women, their second-rate education and lack of access to art world ideas, made it doubly unlikely that their talent would automatically rise like cream to the surface.

So convincing were the findings that they have become the only way to see into the past. The shock of the discoveries about the way women had been treated set the agenda for feminist art history. Favourite kinds of artists emerged. Proto-feminists, women who had a sense of the injustices they faced in the centuries before feminism had been thought of, became the feminist art stars. Artemisia Gentileschi, who was raped by the man who was hired to teach her perspective and then produced a series of paintings of Judith cutting off the head of Holofernes, became the subject of research and outraged sympathy.

Certain types of subject matter were favoured. Work which revealed evidence of its maker's situation as a woman was the most respected. Artemisia Gentileschi's images of Judith allowed for biographical readings in the light of her rape – revenge art. Hannah Höch's collages questioned received ideas of femininity in a way that her modern sisters recognized. The female Impressionists' subtle inflection of the domestic content they held in common with the men revealed their experiences of society. Frida Kahlo's painted account of her pain, her passions and her beliefs offered a record of a marriage from a woman's point of view.

Certain kinds of experience were privileged. The horror stories have taken on the status of holy writ, so that it feels like a travesty of the truth to talk about women artists' marriages without appending a catalogue of sad examples, or about women's advances in the early twentieth century without noting the art establishment's unwillingness to let them into positions of importance and authority. Always shocking is Renoir's view that women should not be painters – singers and dancers, yes, but painters, never – and that in a world where he was a welcome guest to the home of Berthe Morisot, painter, friend, success. Or Fantin-Latour's letter to Manet that, 'The Morisot girls are charming. It is a pity they are not men. However, as women, they could further the cause of art by each marrying an academician and stirring up trouble in the camp of these old fogeys.'³ These have become the mythology of feminist studies, guaranteed to draw a gasp from the audience, a kind of shorthand definition for what women artists had to face in the past. It is our victim mindset that encourages

us to alight with triumph on the English artist Dora Carrington's lament in 1920:

> Clive Bell and Mrs Hutchinson came here last weekend. They aren't my style. Too elegant and eighteenth-century French, for that's what they try to be – I felt my solidity made them dislike me. Then I had to make their beds, and empty chamber pots because our poor cook Mrs Legg can't do everything and that made me hate them because in order they should talk so elegantly, I couldn't for a whole weekend do any painting, and yet they scorned my useful grimy hands.[4]

I believe that sticking so closely to this agenda distorts the experience of women. There is only one Artemisia Gentileschi after all, a gift to those who write about women and art, but a one-off none the less. As a fictional character we would laugh at her in disbelief, a woman artist revenging herself through her paintings. There are drawbacks to this agenda. Anne Vallayer-Coster, the still-life painter to Queen Marie Antoinette, was an immensely successful artist in her day. She was admitted to the Académie Royale in 1770, made painter to the Queen in 1780 and given lodgings in the Louvre in 1781. Admired, successful and married, she seems to have led a quiet and proper life. Unfortunately for her subsequent reputation, she did not suffer for her gender or for her art.

CELEBRATING SUCCESS

Because suffering has been promoted as the badge of the true woman artist, we tend to ignore the fact that so many women had a wonderful time in their profession. 'I know I have often said, my dear, how untypical my life was for a young woman; for my talent, feeble though it might have been compared with the great masters, made me welcome, nay sought after, at all the salons. Sometimes I became the recipient of, how shall I put it, public acclaim; I must admit, this was a source of great satisfaction to me.'[5] Elisabeth Vigée-Lebrun was not the only woman to feel pleasure in the glamorous life that being a woman and an artist brought her. Other women loved being special among their sex. The twentieth-century British artist Laura Knight said of her husband, the painter Harold Knight: 'He was a wonderful man. But one makes a husband unhappy as well you know. He was a much greater artist than I was. I felt I stole his thunder being a woman. It gave me a pull. It was rare for a woman to give up her life for painting.'[6] Alice Neel loved confounding expectations of what kind of work a woman should do:

> I didn't let being a woman hold me back. There was a man on the project: 'Oh, Alice Neel! The woman who paints like a man.' And I went to all the trouble of telling him that I did not paint like a man but like a woman –

but not like a woman was supposed to paint, painting china. I felt it was a free for all. And I never thought it was a man's world. I thought women were always there, even though they may not have participated fully. Art doesn't care if you are a man or a woman. One thing you have to have is talent, and you have to work like mad.[7]

A drawback of the feminist agenda is that we don't listen to the artist's words. We only hear what we want to. When Isabel Bishop was asked if her work was recognizably the work of a woman, she replied:

> I couldn't consciously make them feminine but I think they are. I hate feminine-looking work – the word feminine is derogatory in this context, but I think it would be reasonable for critics to look upon the art scene and ask themselves, 'What are women thinking about the world?' Then the critics could look at women's work from the point of view of finding content different from men's there, whether the women have consciously put it there or not. It seems the work should have it if it's genuine.

So far so good. But then she added: 'I think this should be done by men critics because women would be so apt to rationalize – to see what they want to see. If men seriously said, "What are women? How are they responding to life as shown in the art?" It would be so interesting.'[8] Not an easy response for a feminist to deal with, but one to remember when thinking about the women's experiences and beliefs, not the experiences and beliefs that we think they should have.

One of the dangers of applying feminist assumptions to artists is that it makes us feel we know better than the artists themselves. When their words do not accord with our theories, we doubt their version of events. In 1953 and 1954 at the time of Grace Hartigan's first solo shows, when she was painting canvases that, if they were racehorses, would be described as 'figurative out of Abstract Expressionism', Grace Hartigan decided to call herself George, not Grace. When asked whether the art world hostility towards women was the reason she had tried to hide the fact that she was a woman, she replied:

> I will never be able to correct that misunderstanding. It had absolutely nothing to do with the feeling I was going to be discriminated against as a woman. It had to do with a romantic identification with George Sand and George Eliot. George Eliot is a great writer. I don't think of George Sand as a great writer but she certainly was a great force historically. I wanted to identify myself with these two great women.... I respected Georgia O'Keeffe but I didn't feel that the kind of life I had in New York was similar to her kind of life there or in New Mexico where she had, by then, moved. I really didn't identify with her. A couple of years after I had done the identification part, it just didn't seem to make any sense any more. So I dropped it.[9]

Though the well documented locker room atmosphere of the early years of Abstract Expressionism makes it tempting to assume that her adoption of a male identity was born of frustration at her difficulties in being taken seriously, her reply denies this. Rather than dismiss her as self-deluded, we should stop and think about her words. Surely by refusing to allow herself to be co-opted into a version of events that made her adoption of a male name the action of a woman desperate for a non-sexist assessment of her talent, she is warning us to be careful how we judge the behaviour of earlier artists. Grace Hartigan's colourful life, with its four husbands, alcoholism and devotion to artistic self-expression, could rival the picaresque career of any male Abstract Expressionist, and she of all people could quite convincingly have adopted a male *nom de plume* out of cussedness and a spirit of 'I'll show them'. And even if her explanation has evolved over time, her need to present it in this manner makes an important point about a woman's need to be selfconscious about the way she presents her story to the world.

Considering the artists only in terms of the unfairness they faced and the hard times they experienced makes us forget that these are real women under discussion, not illustrations of a theory, women who brought their individual mix of character and experience to their dealings with the art world. In 1901, Frances Hodgkins wrote to her mother in New Zealand recounting her teacher's encouraging advice:

> Mr Garstin refuses to accept me as a pupil and will not let me pay a penny he seems to think I have nothing to learn which is absurd and any help he gives me he says is merely from one brother artist to another. He wants me to work here for a while and then go down to Spain for the winter, get plenty of material there then go back to Penzance and take a studio there for a while and get all my sketches in order and then have a show in London in the spring. He has promised to write me up in *The Studio* he writes a lot for that paper and he has influence.[10]

Frances Hodgkins' letter makes a good contrast with Dora Carrington. Dora Carrington was rarely willing to put as much time into her art as into her relationships and was writing out of grumpiness, while Frances Hodgkins, whose proposed exhibition never happened, at least not the following year, was writing out of the euphoria of finally, aged twenty-nine, being in Europe and being an artist. It is, of course, possible to argue that both women's experiences were a result of their being women in a world where male views, rules and expectations held sway. But that analysis is too broad to be useful. The women are not at all alike. They have different approaches to art. They are writing in different moods and in different circumstances. Yet only Carrington's letter, so vivid, so understandable, so outraged and so outrageous has become the one that speaks for the situation

THE WORLD OF WOMEN ARTISTS

All the images on these pages are concerned with the sinister side of sexuality, domesticity and maternity.

(opposite, above) Louise Bourgeois, *Spiral Woman*, 1984. A woman dangles helplessly above a dark circle.

(opposite, below) Cindy Sherman, *Untitled No. 305*, 1994. Ecstacy, unease, childhood and the forbidden are conjured up in this photograph of two dolls' heads by American artist Cindy Sherman.

(below) Rachel Whiteread, *House*, 1993–94. Now demolished, this ghostly white cast of the inside of a house stood for a time on its London corner defying description but encouraging thoughts of past lives, wasted lives, women's lives. A kind of monument to domesticity, its bleak form proposed the emptiness of domesticity against a more conventional view of domesticity as warm and comforting, a *memento mori* of the twentieth century.

(below) Mona Hatoum, *Incommunicado*, 1993. This work by the Lebanese-born but British-based installation artist reveals its chilling secret slowly. Instead of springs, thin wires are stretched along the base of the crib, like the slicers used for hard-boiled eggs. The link made by the mind between crib base and the baby's body equal the horrors of any folk tale.

(bottom) Susana Solano, *La Bella Dormiente* (Sleeping Beauty), 1986. The Catalan artist shows that a cradle confines as well as protects.

of the woman artist. It is not that one is right and one is wrong. It is that they are both right. Happiness and excitement were as much a part of women artists' experience as frustration.

In 1975, Cindy Nemser published *Art Talk*, a book of interviews with contemporary women artists. It appeared in the most passionate days of the feminist fascination with women and art, and inevitably dealt with the problem of reconciling being a woman and being an artist. Rereading the book twenty years later, I was struck by the way that every woman dealt with the problems in a different way. Responses to motherhood are an example. Grace Hartigan explained how her son had suffered from her devotion to art and at the age of twelve had gone off to live with his father. 'It is a very bitter relationship,' she said. For her, there was an insoluble conflict between motherhood and making art. In contrast, Barbara Hepworth saw no conflict, claiming that her creative and maternal roles mutually enriched each other.

Despite this disagreement, both artists shared an unwillingness to blame their problems on their sex, and both took great pains to present themselves as artists rather than women. Neither was willing to go on record against the official line of the art world that talent had nothing to do with gender. When Grace Hartigan was asked about the way in which the men's attitudes encouraged competition between the women Abstract Expressionists, she replied that the women fought among themselves as artists as the men did: 'I think that women are competitive too.'[12] She was still fighting in the interview, against being cast as a female and therefore an inferior member of the group. She had no desire to be an example in someone else's belief system that might in any way make her pathetic. She wanted to be judged as an artist pure and simple.

An unwillingness to be seen as one of the company of women artists, as opposed to being seen as an artist pure and simple, was why Bridget Riley declined to be interviewed for Cindy Nemser's book:

> For the artist who is also a woman, I would not deny that society presents particular circumstantial problems. But in my opinion these are on the wane and, in any case, few male artists have avoided analogous physical and sociological problems of one sort or another: for example, poverty, illness, unsympathetic marriages, alcoholism, geographical isolation, etc. Women's liberation, when applied to artists, seems to me to be a naive concept. It raises issues which in this context are quite absurd. At this point in time, artists who happen to be women need this particular form of hysteria like they need a hole in the head. [13]

Bridget Riley was not the only successful woman unwilling to be used as material for feminist theories. Georgia O'Keeffe was among the artists who wanted nothing to do with the theory of female imagery unveiled in 1973 by Judy Chicago and Miriam Schapiro:

Women artists have used the central cavity which defines them as women as the framework for an imagery which allows for the complete reversal of the way in which women are seen in the culture. That is: to be a woman is to be an object of contempt, and the vagina, stamp of femaleness, is despised. The woman artist, seeing herself as loathed, takes that very mark of her otherness and, by asserting it as the hallmark of her iconography, establishes a vehicle by which to state the truth and beauty of her identity.[14]

Judy Chicago defined Georgia O'Keeffe as an artist who made a connection between herself and her work. 'In her paintings, the flower suggests her own femininity through which the mysteries of life could be revealed.'[15] It must have been disturbing for an artist like Georgia O'Keeffe, who for decades had fought to prove that her art had nothing of the tainted femininity about it, to be connected with it again in the 1970s. Never mind that those asking the questions were feminists and on the side of the artists. Never mind that they were offering evidence that women, in a hostile male world, had managed to produce successful work that spoke of women's lives. Never mind that the object of the exercise was to show that women had always found ways to speak in their own distinctive voices. For Georgia O'Keeffe, who had lived through the frustrations of having constantly to prove how seriously she took her art – an art that stood as art pure and simple, as good as work by men as the thought of her day would have put it – it was exasperating to see her work presented as an icon of the essence of woman.

One of the wonderful things about writing about women artists is the way in which their endless permutations of talent, circumstances and personality mean that they constantly escape the definitions and theories imposed on them. I have tried to show that it was not automatically dispiriting to be a woman artist in a male world, and that many women were more than up for the battle. Some women did not even think there was a battle. I accept completely the feminist fact that the art world was male, that it set the rules, that women in a way were only in there on sufferance. I accept the fact that many women failed or did not fulfil their potential. And yet, within this framework and despite the disadvantages, many women did manage a career in art which was financially, professionally and personally rewarding. Perhaps it is time to move the telescope round a few degrees to pick out a less depressing view of the women artists' lives, one that focuses on their resilience.

NOTES

PREFACE
1 Manners, p. 380

INTRODUCTION pp. 8–13
Opening quotation: Alice Neel 1980,
 in Hills, p. 11

CHAPTER 1 pp. 14–49
Opening quotation: Vasari, vol. 5, p. 124
1 Alberti, p. 64
2 Cennini, ch. 29, p. 16
3 Alberti, p. 66
4 Castiglione, p. 211
5 Vasari, vol. 5, p. 124
6 Vasari, vol. 8, p. 48
7 Cennini, ch. 104, pp. 64–65
8 Vasari, vol. 8, p. 42
9 Castiglione, p. 216
10 Vasari, vol. 5, p. 127
11 Perlingieri, p. 120
12 Roberts, p. 204
13 Gaze, entry on Plautilla Nelli
 by Catherine King
14 Gilbert, p. 112
15 Wood, p. 138
16 Vasari, vol. 5, p. 126
17 Jacobs, p. 181
18 Perlingieri, p. 67
19 Perlingieri, p. 67
20 Vasari, vol. 5, p. 127
21 Perlingieri, p. 126
22 Perlingieri, p. 122
23 Vasari, vol. 5, p. 125
24 Wood, p. 134
25 Perlingieri, p. 95
26 Vasari, vol. 8, p. 48
27 Hilliard, p. 63
28 Vasari, vol. 9, p. 155
29 Murphy, p. 190
30 King, p. 402
31 Murphy, p. 190
32 Vasari, vol. 8, p. 47
33 Vasari, vol. 9, pp. 268–69;
 vol. 5, p. 125; vol. 8, p. 46
34 Jacobs, p. 175
35 Jacobs, p. 181
36 Perlingieri, p. 204

CHAPTER 2 pp. 50–77
Opening quotation: Garrard, p. 394
1 Garrard, p. 390; p. 394; p. 397
2 Garrard, p. 385
3 Hofrichter, p. 29
4 Walsh and Jeffree, p. 14
5 Finaldi, p. 32
6 Garrard, p. 393
7 Garrard, p. 400
8 Garrard, p. 379
9 Garrard, p. 397
10 Garrard, p. 398
11 Garrard, p. 379
12 Carriera, p. 297
13 Proske, p. 128
14 Garrard, p. 391
15 Barber, p. 77
16 Carriera, p. 263; p. 325; p. 326
17 Garrard, p. 380
18 Proske, p. 128
19 Gaze, vol. 2, p. 820

CHAPTER 3 pp. 78–121
Opening quotation: Vigée-Lebrun,
 Letter 10, p. 63
1 Manners, p. 380
2 Gainsborough, p. 151
3 Foreman, pp. 106–7
4 Austen, *Sense and Sensibility*, ch. 3
5 Vigée-Lebrun, p. 13; p. 16
6 Vigée-Lebrun, p. 27

7 Vigée-Lebrun, pp. 16, 17
8 Waller, pp. 31, 32
9 Manners, p. 380
10 Waller, p. 34
11 Vigée-Lebrun, p. 15
12 Knox, pp. 12–13
13 Knox, pp. 12–13
14 Berry, p. 19
15 Burney, vol. 2, p. 4
16 Vigée-Lebrun, p. 28
17 Ballot, pp. 38–39
18 Ingamells, p. 367
19 Forbes, f.132, 26 Oct. 1772
20 Manners, p. 380
21 Vigée-Lebrun, p. 28
22 Forbes, f.123
23 Diderot, p. 223; p. 222
24 Austen, *Northanger Abbey*, ch. 14
25 Austen, *Northanger Abbey*, ch. 14
26 Berry, p. 40
27 Roworth, p. 102
28 Burney, p. 68
29 Forbes, f.124
30 Forbes, f.142
31 Forbes, f.139
32 Forbes, f.130
33 Forbes, f.136,
 17 Nov. 1772.
34 Vigée-Lebrun, p. 354
35 Burney, p. 70
36 Farington, vol. 3,
 p. 1048, 19 Aug. 1798
37 Ballot, p. 212
38 Lloyd, p. 46
39 Réau, p. 79
40 Réau, p. 99
41 Réau, p. 77
42 Waller, p. 48–9
43 Waller, p. 51
44 Réau, p. 257
45 Waller, p. 48
46 Réau, p. 60
47 Diderot, p. 224
48 Smith, vol. 1, p. 69
49 Vigée-Lebrun, pp. 27–8
50 Lloyd, p. 45
51 Manners, p. 380
52 Burney, vol. 2, pp. 70–1
53 Forbes, f.137
54 Roworth, p. 141
55 Vigée-Lebrun, p. 38
56 Vigée-Lebrun, p. 33

CHAPTER 4 pp. 122–65
Opening quotation: Bashkirtseff, p. 290
1 Modersohn-Becker, p. 113
2 Howitt, vol. 1, pp. viii, ix
3 Butler, p. 20
4 Campbell, p. 24
5 Campbell, p. 39
6 Nieriker, p. 43
7 Jopling, p. 3
8 Bruce, p. 27
9 Bashkirtseff, p. 292
10 Bashkirtseff, p. 275
11 Bashkirtseff, p. 347
12 Nieriker, p. 55
13 Nieriker, p. 55
14 Bashkirtseff, pp. 284, 85
15 Nieriker, p. 7
16 Bashkirtseff, p. 291
17 Nieriker, p. 44
18 Nieriker, p. 9
19 Bruce, p. 30
20 Bashkirtseff, p. 275
21 Bashkirtseff, p. 444
22 Jopling, p. 5
23 Bashkirtseff, p. 277
24 Jopling, p. 6
25 Bruce, p. 26

26 Bashkirtseff, p. 435
27 Campbell, p. 27
28 Modersohn-Becker, p. 156
29 Mathews, p. 131
30 Nieriker, p. 71
31 Bashkirtseff, p. 385
32 Hawthorne, vol. 14, p. 185
33 Modersohn-Becker, p. 355
34 Stebbins, p. 256
35 Morisot, 1875, p. 102
36 Jopling, p. 68
37 Morisot, 19 March 1869, p. 33
38 Hodgkins, p. 98
39 Gorokhoff, p. 237
40 Wichstrom, p. 39
41 Butler, p. 153
42 Jopling, p. 26

CHAPTER 5 pp. 166–93
Opening quotation: Riley, p. 21
1 Kearns, p. 146
2 Agar, p. 43
3 Yglesias, p. 12
4 Hone, p. 45
5 Campbell, 50
6 Agar, p. 43
7 Rothenstein, Ethel Walker essay,
 third paragraph
8 Agar, p. 120
9 Agar, p. 120–1
10 Agar, p. 121
11 Rose, p. 24
12 Hills, p. 77
13 Baron, p. 171
14 Docherty, p. 165
15 Agar, p. 99
16 Docherty, p. 165
17 Docherty, p. 165
18 Hills, p. 77
19 Robinson, p. 291
20 Souhami, p. 154
21 Baron, p. 72
22 Tate Gallery Archive,
 716.81, p. 508
23 Tate Gallery Archive,
 817.35
24 Tate Gallery Archive, 8726.3.4.,
 9 April 1934 to Dr Rothenstein
25 Yglesias, p. 17,
26 Nemser, p. 19
27 Kearns, p. 136
28 Hepworth, pp. 31 and 34
29 Curtis, p. 158
30 Yglesias, p. 19
31 Hills, p. 167
32 Hodgkins, pp. 10–11
33 Chicago, pp. 27–8
34 Goldwater, Smith, Tomkins, p. 12
35 Chicago, p. 29; p. 30
36 Goldwater, Smith, Tomkins, p. 11

CHAPTER 6 pp. 194–215
Opening quotations: Virginia Woolf,
 A Room of One's Own, pp. 50–1;
 Barbara Hepworth in Nemser, p. 15
1 Goldwater, Smith, Tomkins, p. 29
2 Hamilton, p. 249
3 Fantin-Latour, 26 Aug. 1878,
 quoted in Courthion, p. 86
4 Carrington, p. 152
5 Vigée-Lebrun, p. 24
6 Fox, p. 84
7 Hills, p. 77
8 Nemser, p. 317
9 Nemser, p. 129
10 Hodgkins, p. 92
11 Nemser, p. 132
12 Nemser, p. 146
13 Riley, p. 39
14 Chicago, p. 143–44
15 Chicago, p. 142

SELECT BIBLIOGRAPHY

Books referred to in the Notes:

Agar, Eileen, *A Look At My Life*, London, 1988

Alberti, Leon Battista, *On Painting*, trans.
J.R. Spencer, London and New Haven, 1956

Austen, Jane, *Northanger Abbey*, London, 1818

—, *Sense and Sensibility*, London, 1811

Ballot, M.J., *La Comtesse Benoist*, Paris, 1914

Barber, Tabitha, *Mary Beale*, exhib. cat., Geffrye
Museum, London, 1999

Baron, S., with J. Damase, *Sonia Delaunay*,
London, 1995

Bashkirtseff, Marie, *The Journal of Marie
Bashkirtseff*, trans. Mathilde Blind, first
published London; 1890; republished introd.
by Roszika Parker and Griselda Pollock,
London, 1985

Berry, Mary, *The Berry Papers...Correspondence
of Mary and Agnes Berry, 1763–1852*, Lewis
Melville (ed.), London, 1914

Bruce, Kathleen, *Self-Portrait of an Artist: from
the diaries and memories of Lady Kennet,
Kathleen Lady Scott*, London, 1949

Burney, Fanny, *The Early Journals and Letters
of Fanny Burney*, vol. 2, 1774–77, Lars Troide
(ed.), Oxford, 1990

Butler, Lady Elizabeth (formerly Thompson),
An Autobiography, London, 1922

Campbell, Beatrice, Baroness Glenavy,
Today We Will Only Gossip, London, 1964

Carriera, Rosalba, *Journal de Rosalba Carriera
pendant son séjour à Paris en 1720 et 1721*,
trans. A. Sensier, Paris, 1865

Carrington, Dora, *Carrington: Letters and Extracts
from Her Diaries*, David Garnett, (ed.),
London, 1970

Castiglione, Baldassare, *The Book of the Courtier*,
trans. G. Bull, Harmondsworth, 1967

Cennini, Cennino, *The Craftsman's Handbook*,
trans. D.V. Thompson, New York, 1960

Chicago, Judy, *Through the Flower*, Garden City,
N.Y., 1977

Curtis P., 'What is Left Unsaid' in *Barbara
Hepworth Reconsidered*, D. Thistlewood (ed.),
Liverpool, 1996, pp. 155–62

Diderot, Denis, *Diderot On Art*, J. Goodman (ed.),
vol. II, New Haven, 1995

Docherty, C., 'The Essential Hepworth' in *Barbara
Hepworth Reconsidered*, D. Thistlewood (ed.),
Liverpool, 1996, pp. 163–72

Fantin-Latour, Henri, letter to Edouard Manet,
26 August 1878, quoted in Pierre Courthion,
Manet, concise edn, London, 1988

Farington, Joseph, *The Diary of Joseph Farington*,
K. Garlick and A. Macintyre (eds.), vol. 3,
New Haven, 1978–84

Finaldi, G., ed., *Orazio Gentileschi at the Court
of Charles I*, exhib. cat., National Gallery,
London, 1999

Forbes Letters, 1772–73, National Library of
Scotland, Edinburgh

Foreman, Amanda, *Georgiana, Duchess of
Devonshire*, London, 1998

Fox, Caroline, *Dame Laura Knight*, Oxford, 1988

Gainsborough, Thomas, *The Letters of Thomas
Gainsborough*, M. Woodall (ed.),
London, 1961

Garrard, Mary D., *Artemisia Gentileschi*,
Princeton, 1989

Gaze, D. (ed.), *Dictionary of Women Artists*,
2 vols., London and Chicago, 1997

Gilbert, Creighton E., 'Tuscan Observants
and Painters in Venice c. 1400' in
Interpretazioni Veneziane,
D. Rosand (ed.), Venice, 1984

Goldwater, M., R. Smith and C. Tomkins (eds),
Jennifer Bartlett, Walker Art Centre,
Minneapolis, exhib. cat., New York, 1986

Gorokhoff, Galina, *Love Locked Out: the Memoirs
of Anna Lea Merritt*, Boston, Mass., 1982

Hamilton, George Heard, *Painting and Sculpture
in Europe, 1880–1940 (Pelican History of Art
series)*, Harmondsworth, 1967

Hawthorne, Nathaniel, *Nathaniel Hawthorne:
The French and Italian Notebooks*,
T. Woodson (ed.), vol. 14, Columbus,
Ohio, 1980

Hepworth, Barbara, *A Pictorial Autobiography*,
Bath, 1970

Hilliard, Nicholas, *A Treatise Concerning the Arte
of Limning*, R.K.R. Thornton and T.G.S.
Cain (eds), Ashington, 1981

Hills, Patricia, *Alice Neel*, New York, 1983

Hofrichter, Frima Fox, *Judith Leyster: A Woman
Painter in Holland's Golden Age*,
Doornspijk, 1989

Hodgkins, Frances, *The Letters of Frances
Hodgkins*, L. Gill (ed.), Auckland, 1993

Hone, Joseph, *The Life of Henry Tonks*,
London and Toronto, 1939

Howitt, Anna Mary, *An Art Student in Munich*,
2 vols., London, 1853

Ingamells, John, *A Dictionary of British and Irish
Travellers in Italy 1701–1800*,
New Haven, 1997

Jacobs, F.H., *Defining the Renaissance Virtuosa*,
Cambridge, 1997

Jopling, Louise, *Twenty Years of My Life: 1867–87*,
London and New York, 1925

Kearns, M., *Käthe Kollwitz: Woman and Artist*,
Old Wesbury, 1976

King, Catherine, 'Looking A Sight: Sixteenth-
Century Portraits of Women Artists', in
Zeitschrift für Kunstgeschichte, vol. XVIII,
Munich, 1995

Knox, Katharine McCook, *The Sharples*,
New Haven, 1930

Lloyd, S. (ed.), *Richard and Maria Cosway*, exhib.
cat., Scottish National Portrait Gallery,
Edinburgh, 1995

Manners, Lady Victoria, 'Catherine [*sic*] Read:
The English Rosalba', *Connoisseur*, vol. 88,
London, 1931, pp. 376–86; vol. 89, 1932,
pp.35–40, 171–8

Mathews, M. Mowll, *Cassatt and Her Circle*,
New York, 1984

Modersohn-Becker, Paula, *The Letters and
Journals of Paula Modersohn-Becker*, G. Busch
and L. von Reinken, (eds), New York, 1983

Morisot, Berthe, *The Correspondence of Berthe
Morisot*, Kathleen Adler and Tamar Garb
(eds), London, 1986

Murphy, Caroline P., 'Lavinia Fontana and "Le
Dame della Città": Understanding Female
Patronage in Late Sixteenth-Century Bologna'
in *Renaissance Studies*, vol. 10, No. 2, Oxford,
June 1996, pp. 190–208

Nemser, Cindy, *Art Talk: Conversations with 15
Women Artists*, 1975, reprinted New York,
1995

Nieriker, May Alcott, *Studying Art Abroad and
How to do it Cheaply*, Boston, Mass., 1979

O'Grady, John, *The Life and Work of Sarah Purser*,
Dublin, 1996

Perlingieri, Ilya Sandra, *Sofonisba Anguissola*,
New York, 1992

Proske, B.G., 'Luisa Roldán at Madrid',
Connoisseur, vol. 155, London, 1964,
pp. 126–32; pp. 199–203; pp. 269–73

Réau, L., ed., *Correspondance de Falconet avec
Catherine II, 1767–1778*, Paris, 1921

Riley, Bridget, *The Eye's Mind: Bridget Riley,
Collected Writings 1965–99*, R. Kudielka (ed.),
London, 1999

Roberts, Ann M., 'North Meets South in the
Convent: The Altarpiece of Saint Catherine of
Alexandria in Pisa', in *Zeitschrift für
Kunstgeschichte*, vol. I, Munich, 1987

Robinson, Roxana, *Georgia O'Keeffe: A Life*,
London, 1990

Rose, Barbara, *Frankenthaler*, New York, 1972

Rothenstein, John, *Modern English Painters*,
2 vols, London, 1952

Roworth, Wendy Wassyng (ed.), *Angelica
Kauffman: A Continental Artist in Georgian
England*, London, 1992

Smith, John Thomas, *Nollekens and His Times*,
2 vols, London, 1828

Souhami, Diana, *Gluck: Her Biography*,
London, 1988

Stebbins, T.E., *The Lure of Italy: American Artists
and the Italian Experience*, Boston, Mass., 1992

Vasari, Giorgio, *Lives of the Most Eminent
Painters, Sculptors and Architects*, trans.
Gaston du C. de Vere, 10 vols,
London, 1912–15

Vigée-Lebrun, Elisabeth, *The Memoirs of Elisabeth
Vigée-Lebrun*, S. Evans (ed.), London, 1989

Ethel Walker, Tate Gallery Archive

Waller, Susan, *Women Artists in the Modern Era*,
London and Metuchen, N.J., 1991

Walsh, E., and R. Jeffree, *The Excellent Mrs Mary
Beale*, Geffrye Museum, exhib. cat.,
London, 1975

Wichstrom, Anne, 'At Century's End' in *Norwegian
Artists and the Figurative Tradition,
1880–1990*, exhib. cat., Henie-Onstad Art
Center, Hovikodden, 1995; National
Museum of Women in the Arts,
Washington, D.C., 1995–96

Wood, Jeryldene M., *Women, Art and Spirituality*,
Cambridge, 1966

Woolf, Virginia, *A Room of One's Own*, (first
published London, 1929) London, 1975

Yglesias, H., *Isabel Bishop*, New York, 1988

*The following list includes a selection of books
consulted but not quoted in the text:*

Broude, N. and M.D. Garrard, *The Power of
Feminist Art*, London and New York, 1994

Cantaro, Maria Teresa, *Lavinia Fontana Bolognese:
pittura singolare, 1552–1614*, Milan, 1989

Chadwick, Whitney, *Women, Art and Society*,
revised edn, London and New York, 1996

—, *Women Artists and the Surrealist Movement*,
Boston, Mass., and London, 1985

Fortunati, Vera, *Lavinia Fontana of Bologna,
1552–1614*, exhib. cat., National Museum of
Women in the Arts, Washington, D.C., 1998

King, Catherine, 'Medieval and Renaissance
Matrons, Italian-style', in *Zeitschrift für
Kunstgeschichte*, vol. xviii, 1992

Murphy, Caroline P., 'Lavinia Fontana and Female
Life Cycle Experience in Late Sixteenth-
Century Bologna' in *Picturing Women in
Renaissance and Baroque Italy*,
Cambridge, Mass., 1997

Novellis, Mark De, *Pallas Unveil'd, The Life and
Art of Lady Dorothy Savile, Countess of
Burlington, 1699–1758*, exhib. cat., Orleans
House Gallery, Twickenham, 1999

Perry, G., *Paula Modersohn-Becker*,
London, 1979

Pollock, Griselda, *Mary Cassatt: Painter of Modern
Women*, London and New York, 1998

Quintana, J.T., 'Educating Women in the Arts:
Mme Campan's School', in *Eighteenth-century
Women and the Arts*, F.M. Keener and
S.E. Lorsch (eds), New York, 1988

Rubinstein, C.S., *American Women Sculptors*,
Boston, Mass., 1990

Sani, Bernardina, *Rosalba Carriera*, Turin, 1988

Valone, Carolyn, 'Roman Matrons as Patrons:
Various View of the Cloister Wall',
in *The Crannied Wall: Women, Religion
and the Arts in Early Modern Europe*,
C.A. Monson (ed.), Ann Arbor, 1992

LIST OF ILLUSTRATIONS

Measurements are given in centimetres, followed by inches, height before width before depth. Page numbers reflect the page on which the illustration appears.

110 Marie-Guillemine Benoist, *Pauline Bonaparte, Princess Borghese*, 1808. Oil on canvas, 200 x 142 (78¾ x 55⅞). Musée National du Château, Versailles. Photo © RMN/Arnaudet/J. Scho

111 Marguerite Gérard, *Bad News*, exhibited at the Salon of 1804. Oil on canvas, 63.5 x 50.5 (25 x 19⅞). Musée du Louvre, Paris. Photo © RMN/J.G. Berizzi

112 Marie-Anne Collot, *Monsieur Falconet*, 1773. Marble bust. Hermitage, St Petersburg

112 Marie-Anne Collot, *Diderot*, before 1776. Marble bust. Hermitage, St Petersburg

114 Louis-Léopold Boilly, *Studio of a Woman Artist*, 1800. Oil on canvas, 65 x 54 (25⅝ x 21¼). Pushkin Museum, Moscow. Photo Scala

117 Johann Georg Schütz, *Anna Amalia von Weimar and Her Suite at Villa d'Este, Tivoli*, 1789. Pen and watercolour on paper, 5.7 x 7 (2¼ x 2¾). Private collection

118 Johann Zoffany, *The Academicians of the Royal Academy*, 1771–72. Oil on canvas, 120.6 x 151 (47½ x 59½). The Royal Collection © 2000. Her Majesty Queen Elizabeth II

119 Mary Moser, *Female Nude, Whole Length Standing*, late 18th century. Black and white chalk on paper, 49 x 30.2 (19¼ x 11⅞). Fitzwilliam Museum, Cambridge

120 Sketching seat and easel combined. From a Winsor & Newton catalogue, 1849. Courtesy Winsor & Newton

122–23 Eva Gonzalès, *Box at the Théâtre des Italiens*, c. 1874 (detail). Oil on canvas, 98 x 130 (38⅝ x 51⅛). Musée d'Orsay, Paris. Photo AKG, London/Erich Lessing

124 Marie Bashkirtseff, *Self-portrait with Jabot and Palette*, c. 1880. Oil on canvas, 92 x 73 (36¼ x 28¾). Musée des Beaux-Arts, Nice

124 Elizabeth Butler, *Self-portrait*, 1869 (detail). Oil on card, 21.9 x 18.1 (8⅝ x 7⅛). By courtesy of the National Portrait Gallery

124 Edgar Degas, *Mary Cassatt*, c. 1880–84 (detail). Oil on canvas, 71.5 x 58.7 (28⅛ x 23⅛). National Portrait Gallery, Washington, D.C.

124 Harriet Hosmer, *Zenobia in Chains*, 1859 (detail). Marble, h. 124.5 (49). Wadsworth Atheneum, Hartford, CT

125 J. M. Whistler, *Harmony in Flesh Colour and Black (Portrait of Louise Jopling)*, 1877 (detail). Oil on canvas, 192.5 x 90 (75¾ x 35⅜). © Hunterian Art Gallery, University of Glasgow

125 Paula Modersohn-Becker, *Self-portrait with Camellia Branch*, c. 1907 (detail). Oil on canvas, 61.7 x 30.5 (24¼ x 12). Museum Folkwang, Essen

125 Edouard Manet, *Berthe Morisot with a Bunch of Violets*, 1872 (detail). Oil on canvas, 22 x 27 (8¾ x 10¼). Private collection

125 Rose Peckham, *Portrait of May Alcott Nieriker*, 1877 (detail). Photograph courtesy of the Louisa May Alcott Memorial Association

126 'Lady Students at the National Gallery', from the *Illustrated London News*, 21 Nov. 1889

127 'The Female School of Art', from the *Illustrated London News*, 20 June 1868

128 Elizabeth Butler, *The Roll Call*, 1874. Oil on canvas, 120.7 x 213.4 (47½ x 84). The Royal Collection © 2000. Her Majesty Queen Elizabeth II

130 Marie Bracquemond, *Woman at Easel*, c. 1890. Etching, 31.5 x 25 (12⅜ x 9⅞). Bibliothèque Nationale, Paris

132 Sarah Purser, *Standing Female Nude* (no. 3275), 1878–79. Charcoal on paper, 62.5 x 48 (24⅝ x 18⅞). National Gallery of Ireland, Dublin. Courtesy of the copyright holders of the works of Sarah Purser

132 Sarah Purser, *Seated Male Nude* (no. 3277), c. 1879. Charcoal on paper, 62.5 x 48 (24⅝ x 18⅞). National Gallery of Ireland, Dublin. Courtesy of the copyright holders of the works of Sarah Purser

133 Marie Bashkirtseff, *Life Class in the Women's Studio at the Académie Julian*, c. 1881. Engraving. Samuel Courtauld Trust © Courtauld Gallery. Courtauld Institute, London

134 Edouard Manet, *Eva Gonzalès in Manet's Studio*, 1869–70. Oil on canvas, 56 x 46 (22 x 18⅛). Private collection

134 Edgar Degas, *At the Louvre, (Mary Cassatt)*, c. 1879. Pastel on joined paper, 71 x 84 (21¼ x 28). Private collection

137 Giovanni Fattori, *The Young Student Corinna Cioelli at Her Easel by the Sea*, July 1893. Oil on wood, 25 x 15 (9⅞ x 5⅞). Violette Papetti Collection. Photo Scala

137 John Lavery, *Painting on a Summer's Day*, 1884. Oil on canvas, 81.3 x 54 (32 x 21¼). Private collection

138 Louise-Catherine Breslau, *Les Amies*, 1881. Oil on canvas, 85 x 160 (33½ x 63). © Musée d'Art et d'Histoire, Geneva. Photo Bettina Jacot-Descombes

138 Sarah Purser, *Le Petit Déjeuner*, 1881. Oil on canvas, 35 x 27 (13¾ x 10¼). National Gallery of Ireland, Dublin. Courtesy of the copyright holders of the works of Sarah Purser

138 Harriet Backer, *Portrait of Kitty Kielland*, 1883. Oil on canvas, 84 x 87 (33⅛ x 34¼). © Nasjonalgalleriet, Oslo. Photo J. Lathion. © DACS 2000

139 Kitty Kielland, *Studio Interior, Paris*, 1883. Oil on canvas, 42.5 x 36.8 (16¾ x 14½). Lillehammer Kunstmuseum

140 Auguste Rodin, *Muse for the Monument to Whistler in His Studio*, c. 1906 (detail). Musée Rodin, Paris. Photo Jacques-Ernest Bulloz

141 Cecilia Beaux, *Les Derniers Jours d'enfance*, 1883-85. Oil on canvas, 116.8 x 137.2 (46 x 54). Courtesy of the Pennsylvania Academy of the Fine Arts, Philadelphia. Gift of Cecilia Drinker Saltonstall

143 Louise Jopling, *Phyllis*, 1883. Oil on canvas, 53.3 x 44.5 (21 x 17½). Russell-Cotes Art Gallery and Museum, Bournemouth, UK. Bridgeman Art Library

143 Charles Shannon, *Portrait of Miss Bruce*, 1907. Oil on canvas, 115 x 110 (45¼ x 43¼). Musée d'Orsay, Paris. Photo © RMN/Jean Schormans

144 'The Mixed Antique Class at the Slade School of Art', from the *Illustrated London News*, 26 Feb. 1881

146 Gwen John, *The Artist in Her Room in Paris*, 1907–9. Oil on canvas, 27.3 x 22.9 (10¾ x 9). Private collection. Photo courtesy Anthony d'Offay Gallery, London. © Estate of Gwen John 2000. All rights reserved, DACS

146 Paula Modersohn-Becker, *View from the Artist's Studio Window*, 1900. Oil on canvas, 38 x 35.5 (15 x 14). Kunsthalle, Bremen

146 Alfred Stevens, *In the Studio*, 1888. Oil on canvas, 106.7 x 135.9 (42⅜ x 53½). The Metropolitan Museum of Art, New York

147 Asta Nørregaard, *In the Studio*, 1883. Oil on canvas, 65 x 48 (25⅝ x 18⅞). Private collection. Photo O. Vaering

148 Photograph of Rosa Bonheur, photographer unknown. Bibliothèque Nationale, Paris

148–49 Rosa Bonheur, *The Horse Fair*, 1853–55. Oil on canvas, 244.5 x 506.7 (96¼ x 199½). The Metropolitan Museum of Art. Gift of Cornelius Vanderbilt, 1887

150 Louise-Catherine Breslau, *Under the Apple Trees, Portrait of Mlle Julie Feurgard*, 1886. Oil on canvas, 171.5 x 186.5 (67½ x 73⅜). Musée Cantonal des Beaux-Arts, Lausanne. Photo J.-C. Ducret/MCBA

150 Anna Bilińska, *Self-portrait with Apron and Brushes*, 1887. Oil on canvas, 117 x 90 (46 x 35½). National Museum, Cracow. Photo Marek Studnicki

150 Alice Pike Barney, *Self-portrait in Painting Robe*, 1896. National Museum of American Art, Smithsonian Institution, Washington, D.C. Photo Art Resource, New York

151 John Singer Sargent, *The Fountain, Villa Torlonia, Frascati*, 1907. Oil on canvas, 28⅛ x 22¼ (71.4 x 56.5). The Art Institute of Chicago. Friends of American Art Collection

154 Peder Severin Krøyer, *Hip, Hip, Hurrah! Artists' Party at Skagen*, 1884–88. Oil on canvas, 134.5 x 165.5 (53 x 65⅛). Göteborgs Konstmuseum, Sweden

155 Berthe Morisot, *Mother and Sister of the Artist*, 1870. Oil on canvas, 101 x 81.8 (39½ x 32¼). National Gallery of Art, Washington, D.C. Chester Dale Collection

156 Harriet Hosmer, *Beatrice Cenci*, 1857. Marble, 43.8 x 104.7 (17⅛ x 41⅛). St Louis Mercantile Library

157 Susan Durant, *Harriet Beecher Stowe*, c. 1863. Marble. Harriet Beecher Stowe Center, Hartford, Connecticut

158 Henrietta Rae, *Songs of the Morning*, 1904. Oil on canvas, 184 x 115.5 (72½ x 45½). Private collection. Photo Sotheby's Picture Library, London

159 Berthe Morisot, *The Lake in the Bois de Boulogne (Summer Day)*, 1879. Oil on canvas, 45.7 x 75.3 (18 x 29⅝). © The National Gallery, London

159 Mary Cassatt, *Woman and Child Driving*, 1881. Oil on canvas, 89.5 x 130.8 (35¼ x 51½). Philadelphia Museum of Art, W.P. Wilstach Collection

160 Anna Bilińska, *Woman with Opera Glasses*, 1884. Oil on canvas, 91 x 72 (35⅞ x 28⅜). National Museum, Warsaw

160 Mary Cassatt, *At the Opera*, 1879. Oil on canvas, 80 x 64.7 (31½ x 25½). Courtesy Museum of Fine Arts, Boston

162 Marie Bashkirtseff, *A Meeting*, 1884. Oil on canvas, 20 x 174.9 (7⅞ x 68⅞). Musée d'Orsay, Paris

162 Theo van Rysselberghe, *Anna Boch*, c. 1889–90. Oil on canvas. Museum of Fine Arts, Springfield, MA

163 Elizabeth Nourse, *Les Volets Clos*, 1910. Oil on canvas, 100.5 x 100.5 (39⅝ x 39⅝). Musée d'Orsay, Paris. Photo © RMN, Paris

166–67 Grace Hartigan, *Months and Moons*, 1950 (detail). Oil and collage on canvas, 139.7 x 178.3 (55 x 70½). Collection of the artist. Courtesy Grace Hartigan and ACA Galleries, New York

168 Eileen Agar, *Self-portrait*, c. 1927 (detail). Oil on canvas, 76 x 63.5 (30 x 25). Private collection

168 Photograph of Isabel Bishop (detail). Peter A. Juley and Son Collection. National Museum of American Art. Smithsonian Institution, Washington, D.C.

168 Photograph of Grace Hartigan in her studio (detail). Photo Walter Silver. Reproduced by permission of the photographer's family